IMAGES
of America

IRISH ST. LOUIS

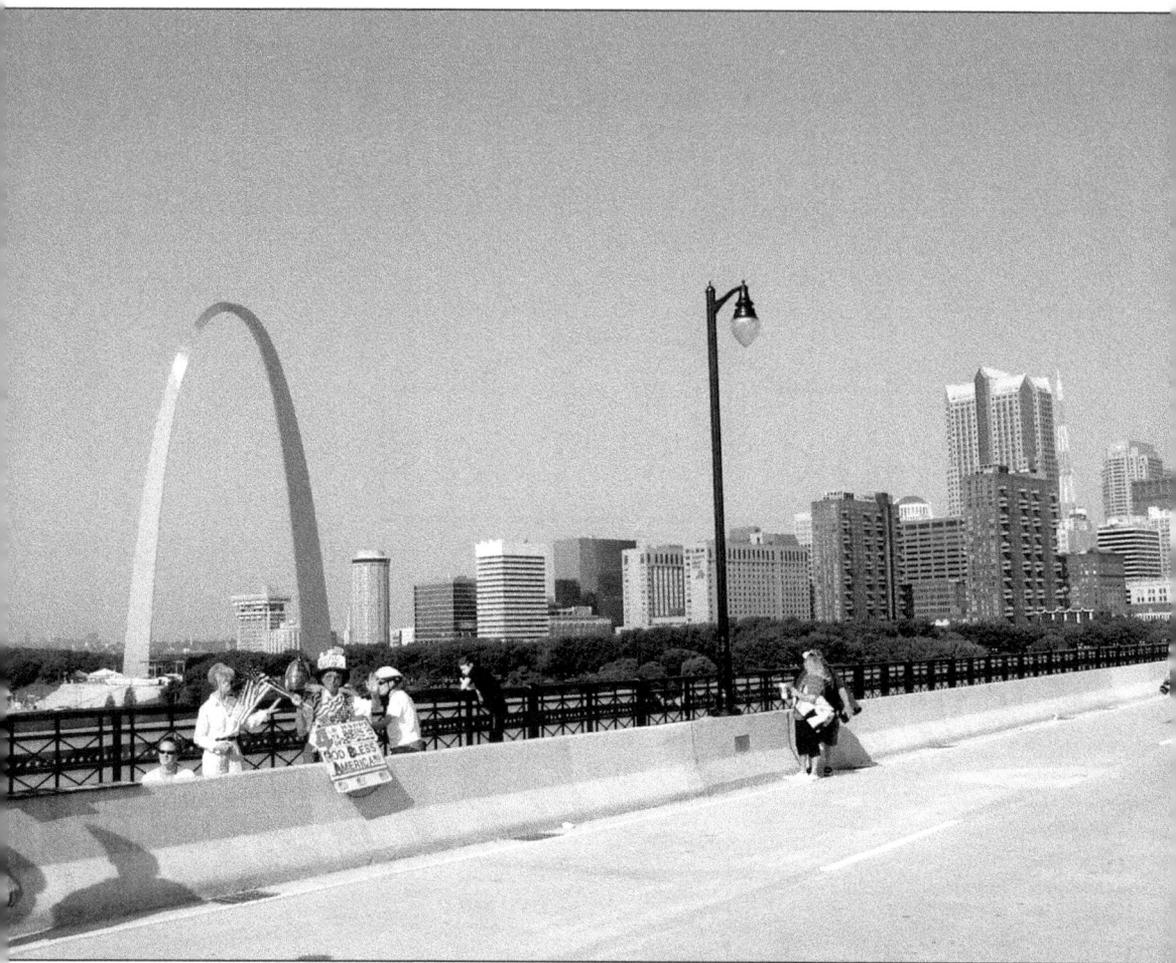

Today's St. Louis skyline is something that the early Irish immigrants could not have fathomed, in spite of the fact that many stood in exactly the same spot as I was when I took this photo. The Eads Bridge was completed in 1874, and, after years of being closed, this photo was taken at the grand re-opening celebration on July 4, 2003.

IMAGES
of America

IRISH ST. LOUIS

David A. Lossos

ARCADIA
PUBLISHING

Copyright © 2004 by David A. Lossos
ISBN 978-1-5316-1808-7

Published by Arcadia Publishing
Charleston, South Carolina

Library of Congress Catalog Card Number: 2003115615

For all general information contact Arcadia Publishing at:
Telephone 843-853-2070
Fax 843-853-0044
E-mail sales@arcadiapublishing.com
For customer service and orders:
Toll-Free 1-888-313-2665

Visit us on the Internet at www.arcadiapublishing.com

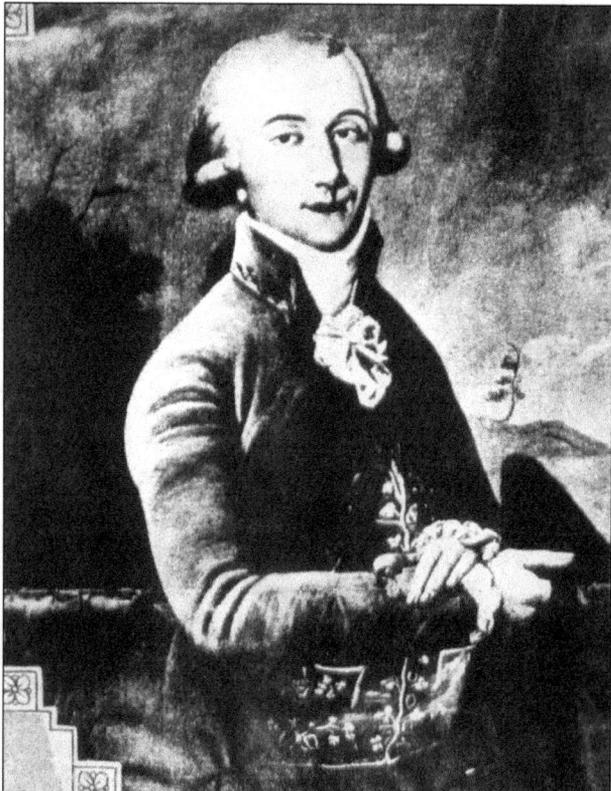

Pierre Laclede Ligest, who founded St. Louis in 1764, did not live long enough to see the influx of Irish immigrants into the St. Louis community. However, it wasn't long before his descendants began the Irish assimilation. Marie Antoinette Labbadie, the granddaughter of Pierre Laclede and Madame Chouteau, married John S. Little on June 19, 1816. John was born in 1775 in County Down, Ireland. This portrait of Pierre Laclede was painted in 1772, just six years before his death. (Courtesy of Saint Louis University, Pius XII Memorial Library, Archives.)

CONTENTS

FORWARD

In the following pages, Dave Lossos wonderfully captures the spirit and history of the Irish community of St. Louis. You will find many of the early Irish immigrants and see how they brought their religion and culture to their new home by the Mississippi River. You will see how the Irish community has influenced St. Louis politics and filled the city's neighborhoods. You will also get a good taste of how the cultural life of St. Louis has been enriched by Irish music and dance, as well as other celebrations and traditions.

I am proud to be part of St. Louis' Irish community. My husband, Patrick (P.J.) Gannon, and I clearly remember our own arrival here. On August 26, 1967, as a young Irish couple, we stepped off a plane at Lambert St. Louis International Airport and were met by the stifling heat of a St. Louis summer. It was an inauspicious start to what had seemed like an exciting venture. But looking back I am amazed, and blessed, by all that has happened since. We arrived with our two-and-a half-year-old son, Sean, four suitcases, and $50 in cash. I was pregnant with our second child. Somehow we found our way to the State Hospital on Arsenal Street where we would live until we could find our own way. P.J. was a physician, and had come to St. Louis to continue his medical training in psychiatry. I planned to patiently wait out the year before we returned home.

Our second child, Niall, was born a few months later and Liam arrived the following year as we tried to settle into our new culture. There seemed to be no Irish people to meet in St. Louis. Then a German couple, Florence and Bill Roth, befriended us. Florence took me in hand and tried to show me a way of life that I could live with so far away from family. The Roths, in fact, became our family.

Then in 1972, a traditional Irish concert came to St. Louis and, as they say, "the rest is history." We were so excited after the concert. For a few short hours, we had returned to Ireland. And we finally met other Irish families in St. Louis. We soon helped each other start a branch of Comhaltas Ceoltoiri Eireann. That link to our roots and culture made a world of difference and continues to do so today. St. Louis Irish Arts, Inc., is now one of the largest and most active CCE branches and proudly boasts the largest junior membership in North America.

In 1975 Patrick and I made the decision to become American citizens. Our only daughter, Eileen, was born two years later. It seemed our American dream, which started so painfully ten years earlier, was only just beginning. Our children grew up learning and loving Irish music and dance. Eileen is a World Champion Harpist.

Now 36 years after it began, life in St. Louis is good. We have lots of family and friends and a community that we are very much a part of. Our sons and daughter have become wonderful

American citizens with a fond love for Ireland and its culture. P.J. and I are very proud of our American family including our six grandchildren who are all of different cultures and yet all Irish.

Emigration and immigration are perhaps the most painful acts in life. When I think back to our forefathers and their inability to return home to Ireland, I am profoundly grateful that today we are able to return to Ireland for visits. It is a blessing to be part of these two great nations.

Mine is just one of the many thousands of stories of Irish coming to St. Louis. Our experiences have much in common, in the way we have brought our culture with us and preserved it in our new home. In these pages and pictures, I find much that is familiar and that resonates with my own experience as an Irish immigrant to St. Louis. I'm sure that you will as well.

Helen Gannon
President, St. Louis Irish Arts

INTRODUCTION

The Irish of St. Louis boast of their ancestors' role in St. Louis history, and rightfully so. Founded on the cornerstone of the Roman Catholic religion, St. Louis presented to the native Irishman a safe and friendly place to practice their religion without prejudice. Most casual observers assume that the influx of the Irish into St. Louis began with the famine and strife of the 1840–1850s, a time of great immigration from Europe. Surprisingly, as early as 1820 we find that nearly 15 percent of the population in St. Louis was of Irish descent. By 1850, 43 percent of all St. Louisans were born in either Ireland or Germany. Typically the Irish immigrants brought with them limited job skills. Irish immigrants in St. Louis centered mainly in two areas. Most lived in the "Kerry Patch" area on the near north side—an unsafe and impoverished neighborhood—while some lived in the Cheltenham neighborhood, today commonly referred to as Dogtown.

Although predominantly Catholic, St. Louis equally welcomed and assimilated both the Protestant and Catholic Irish. Nonetheless, the story of the Irish in St. Louis is mostly a story of the Catholic Church. Indeed, there were 29 parishes in St. Louis that were formed to minister to predominately Irish Catholic immigrants. It's a story of famous, and not so famous, men and women of Irish blood. It is the story of Charless, Mullanphy, Lane, McNair, but it is also the story of everyday men and women who adopted St. Louis as their home, and instilled the spirit of Ireland here in the Midwest.

This book is not intended to provide a complete history of Irish influence on the St. Louis area. Far from it. For every person of Irish descent pictured here, there are tens of thousands that are not.

Dave Lossos
2004

One

NOTABLE ST. LOUIS
IRISH

Joseph Charless was born on July 15, 1772 in Westmeath, Ireland. He took part in the ill-fated Irish rebellion of 1798. He married Sarah Jourdan in 1798 in Philadelphia, Pennsylvania. Settling in St. Louis, he initiated the first newspaper (*Missouri Gazette*) west of the Mississippi in 1808. He died on July 28, 1834 and is buried in Bellefontaine Cemetery. (Courtesy of Saint Louis University, Pius XII Memorial Library, Archives.)

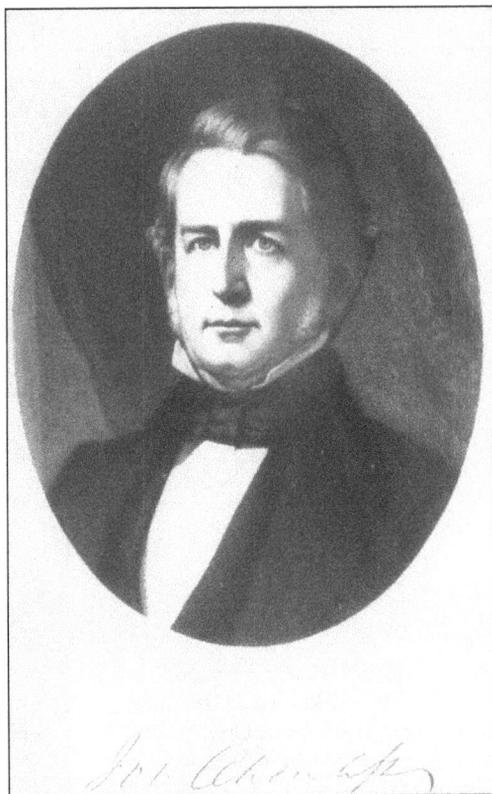

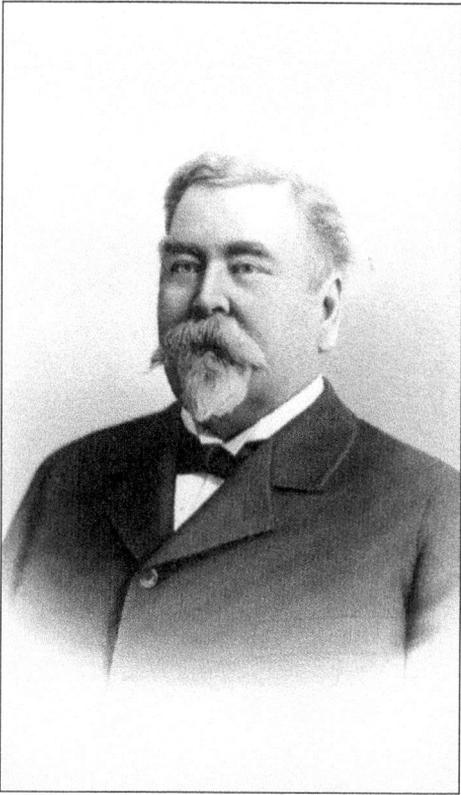

"John L. Boland, merchant, was born March 2, 1840, at Bolington, Loudoun County, Virginia, third son of Daniel and Eleanor (McElroy) Boland. His father was born in Ireland, but early in the present century came to this country, settling first at Savannah, Georgia, where he was engaged for some years in mercantile pursuits. In 1815 Mr. Boland (moved to) Loudoun County (where he resided) until his death—which occurred in 1862—and, being thoroughly identified with Southern interests, was a staunch adherent of the Southern cause at the beginning of the war, making many financial and other sacrifices in behalf of Southern independence, and giving three sons to fight its battles. John L. Boland entered the Confederate Army with all the enthusiasm of an ardent nature; he served to the end of the war. He came to St. Louis at the beginning of the year 1866. Here he began his commercial career as a clerk in the wholesale book and stationery trade, and four years later he was admitted to a partnership in the house with which he had become connected. Some time later he became sole proprietor of this establishment." (From *History of St. Louis*, Hyde, 1899.)

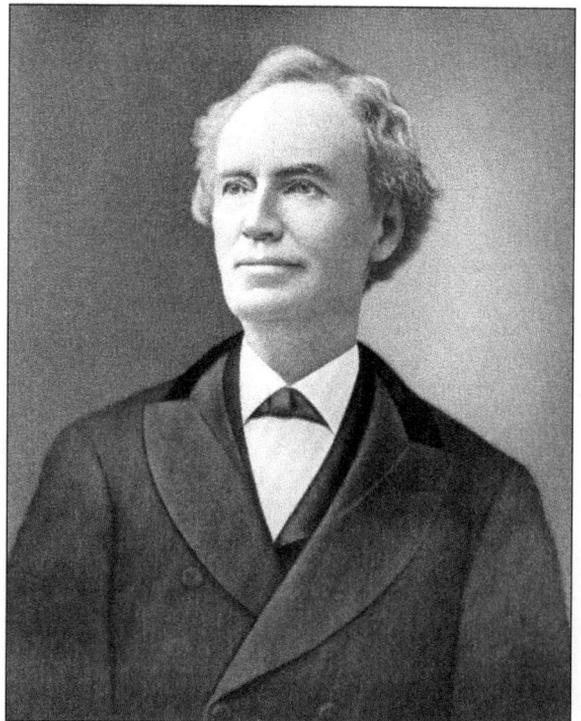

A Scotch-Irish lawyer, Alexander Hamilton is best known as the judge presiding in the famous Dred Scott trial. (Information from *St. Louis: History of the Fourth City, 1764–1909*.)

"Irish architects had their part in two of the area's finest churches. John Haynes, of the firm of Barnett, Haynes and Barnett (architects), worked with his partners on the New Cathedral on Lindell. John was born in St. Louis on March 1, 1861. His father, Thomas Haynes, was a native of England, and his mother was born in Ireland." (From *Old and New St. Louis*, Cox, 1894.)

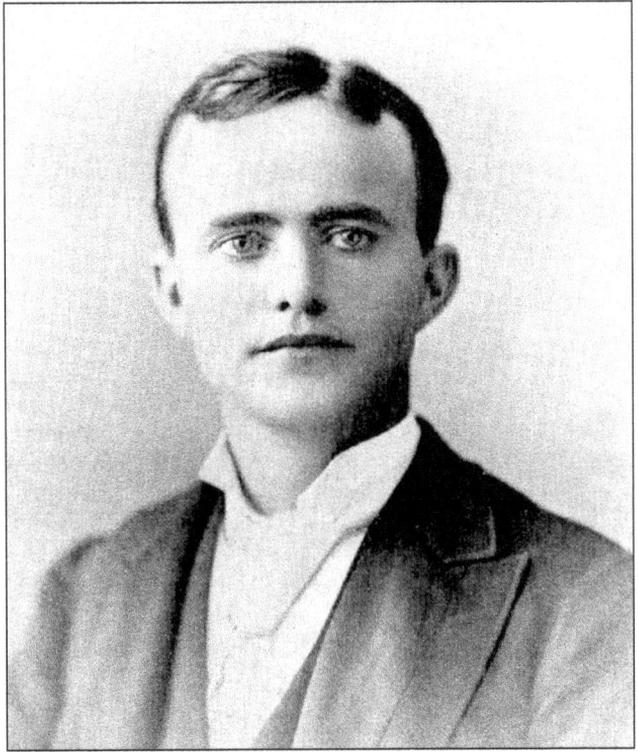

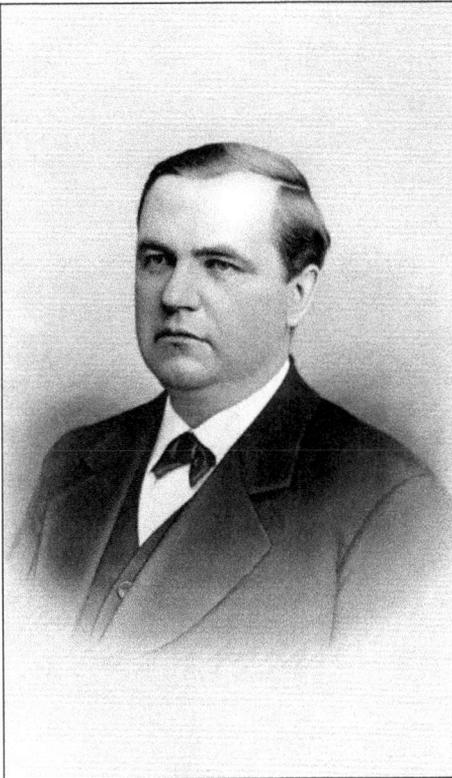

"John W. McCullagh was born in Dublin, Ireland, May 14, 1838, and died in St. Louis, August 22, 1891. After serving five years as a printer's apprentice, he was employed in the Dublin post office, under the postmastership of his father, John McCullagh, until 1861, when he decided to join his brother, Joseph, in the United States. Entering the services of the Cincinnati "Commercial" in its mechanical department, his connection with that newspaper continued for five years thereafter. He was then invited by Mr. J. M. Brunswick, the famous manufacturer of billiard tables, to become editor and manager of the "Billiard Mirror," a paper published in the interest of the Brunswick-Balke business. McCullagh made it much more than an advertising medium. He filled it with humorous sketches, sparkling witticisms and carefully selected miscellaneous matter, and thus popularized the journal with the general reading public. From the position of editor and manager of this paper he was transferred in 1867 to that of general traveling agent for the billiard manufacturers, and for three years thereafter he was remarkably successful in advancing their interests." (From *History of St. Louis*, Hyde, 1899.)

11

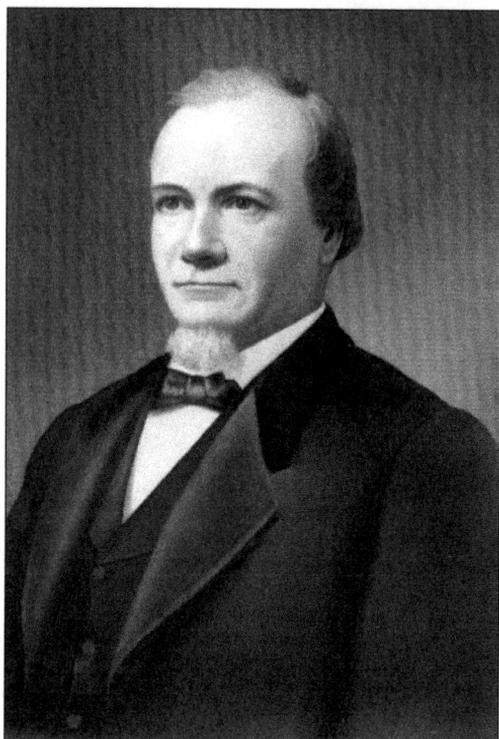

"Gerard B. Allen, manufacturer and financier, was born in the city of Cork, Ireland, November 6, 1813, and died in St. Louis, July 21, 1887. His father, Thomas Allen, was a well-to-do silk manufacturer of Cork. Gerard's ambitious nature prompted him, in his young manhood, to leave his early home and come to this country, and he landed in New York when he was twenty-three years of age. After remaining in New York a year he came to St. Louis, in 1837, and at once engaged in business here as a contractor and builder. Within a few years he became the owner of two sawmills. After manufacturing lumber for a time he disposed of his saw-mills and invested his capital in the iron business, becoming a member of the well-known and prosperous firm of Gaty, McCune & Co. He was a member of this firm until 1855, when he withdrew to establish the Fulton Iron Works." This industry gave employment to many St. Louis Irish immigrants. (Information from *History of St. Louis*, Hyde, 1899.)

"Among those that have been factors in the erection of the finest and most beautiful buildings of St. Louis Thomas Walsh was numbered. For many years he occupied an eminent place among the leading architects of this city, while his personal qualities, as manifest in his social relations, made him one of the popular residents of St. Louis. His birth occurred in Kilkenny, Ireland, July 16, 1827, his parents being William and Mary Lovey (Waryng) Walsh. Mr. Walsh was splendidly qualified for his life work when in October, 1849, he came to St. Louis. Many of the leading structures of the city stand as monuments to his enterprise, business judgment, and genius. These included the old custom house, Republic Building, the church of St. Francis Xavier, the St. Louis University, the old Everett House, the first Lindell Hotel, the Polytechnic Buildings, and many of the public school buildings and others." (From *St. Louis, The Fourth City*, Stevens, 1909.)

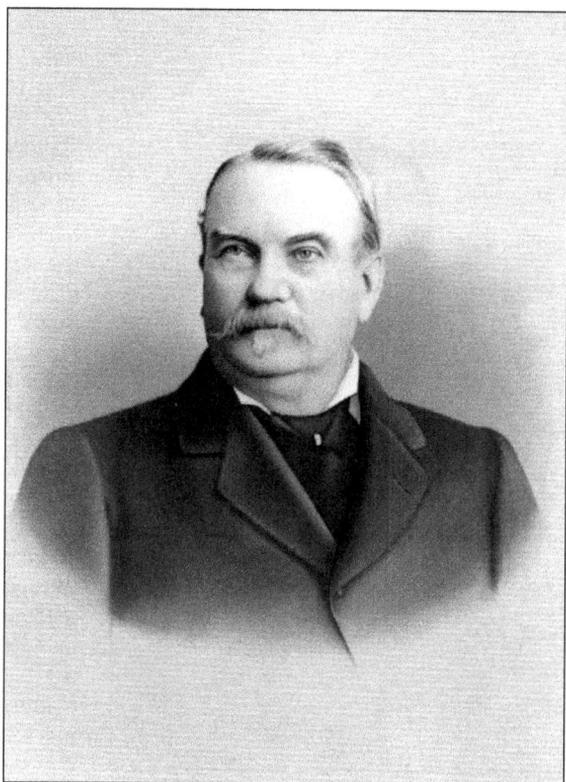

"Thomas M. Fleming has been continuously connected with the Scruggs Vandervoort Barney Dry Goods Company since November, 1883. He was born in St. Louis on Christmas day of 1870, a son of James P. and Mary Fleming, natives of Dublin, Ireland, who came to St. Louis from Montreal, Canada, in 1868. In November, 1883, Mr. Fleming obtained a position as cash boy with the Scruggs Vandervoort Barney Dry Goods Company, at that time conducting business at the northwest corner of Fourth and St. Charles streets. In January, 1898, he was promoted to the position of cashier and for eleven years has served in this capacity in one of the most extensive mercantile houses of St. Louis. On the 1st of June, 1897, Mr. Fleming was married to Miss Mae Lorette Maher, a daughter of Paul and Catherine Maher." (From *St. Louis: History of the Fourth City, 1764–1909*.)

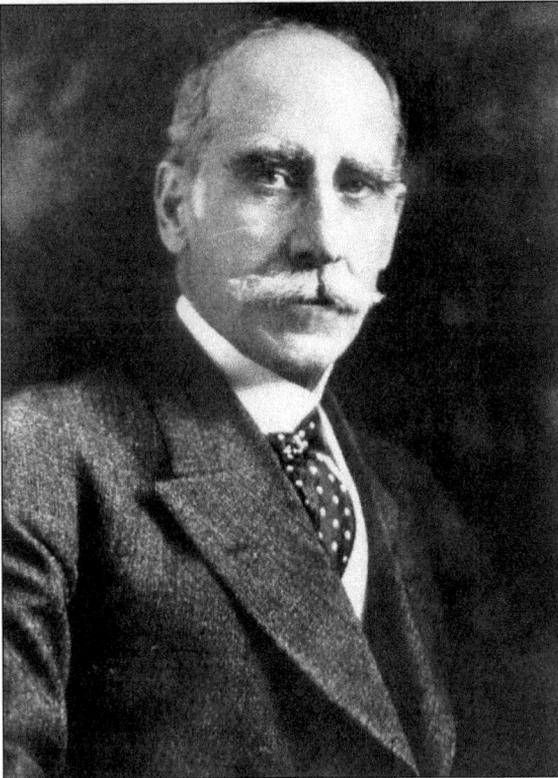

William Kinsella of County Carlow Ireland, developed a thriving coffee and spice business. (Courtesy of Saint Louis University, Pius XII Memorial Library, Archives.)

13

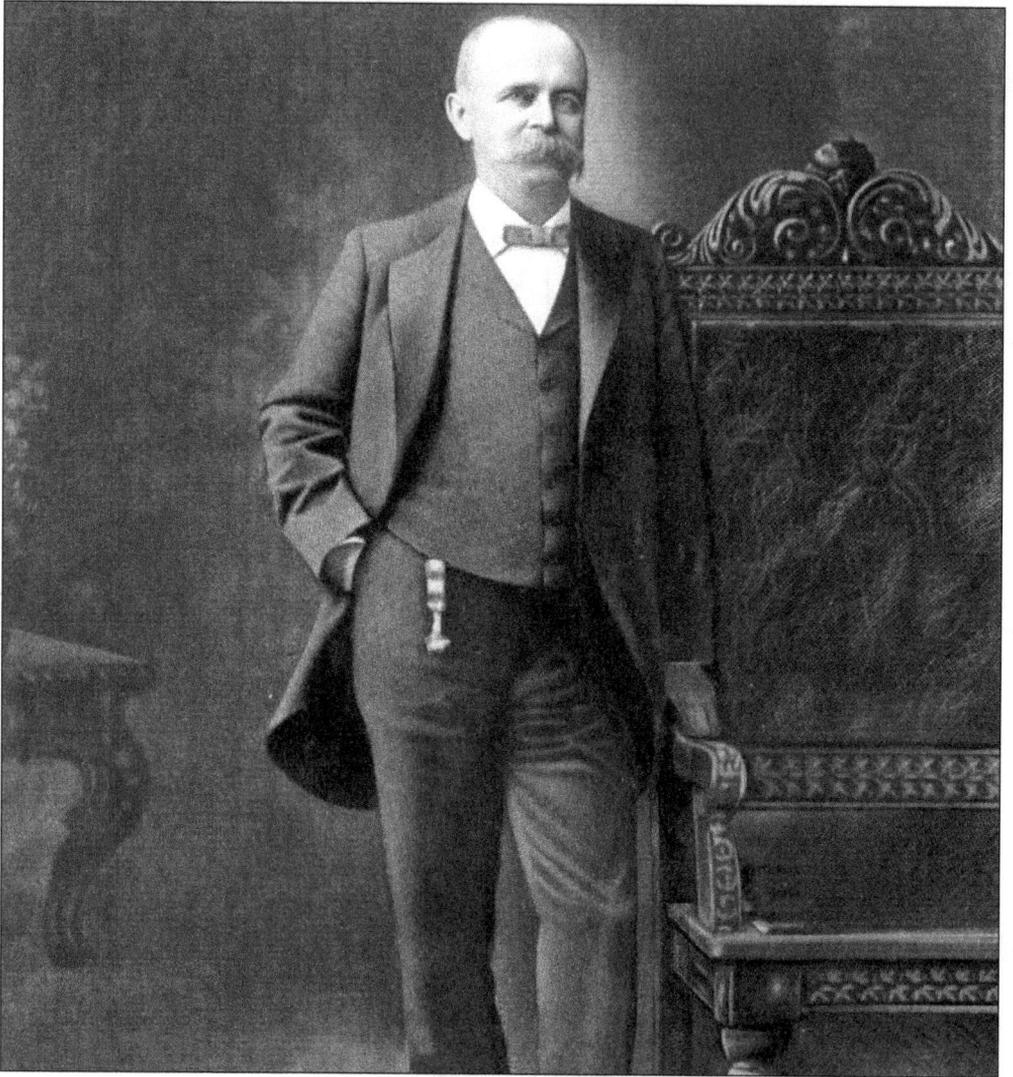

"Zach Mulhall, one of the celebrities of the far Southwest, and a man who has been truly a pathfinder for advancing civilization, is a native son of St. Louis, was reared in this city and still continues in close touch with its commerce and its people. There has been much of romance, much of adventure, much of thrilling experience in his life, and as the honorable accomplishments of a son reflect credit upon his father's household, so did the meritorious achievements of one who goes out from a city to become the founder of new communities reflect credit upon the city of his birth. Mr. Mulhall was born in St. Louis, September 22, 1845, and belongs to an old and well known family. His parents were Joseph and Susan Mulhall, and his father was 'long well-known throughout the West as a wealthy stock raiser, whose home, at the corner of Grand Avenue and Morgan Street, was an ornament to the city. The elder Mulhall was at one time president of the Butchers' & Drovers' Bank, and held other positions of honor and trust in this city. The son received his early education at the Christian Brothers' College, later attended St. Louis University, and completed his studies at Notre Dame College, of South Bend, Indiana. In 1875 he married Miss Agnes Locke, of St. Louis, and a few years later (in 1883) he removed with his family to what was then the Indian Territory, now a part of Oklahoma." (From *History of St. Louis*, Hyde, 1899.)

14

"Andrew J. O'Reilly, president of the board of public improvements, has done effective work for St. Louis in his official capacity and has manifested at all times a spirit of contagious enthusiasm because of his deep interest in the city and his desire for its substantial and progressive development. Moreover, he has the technical skill required in one who has supervision of public improvements, having had broad experience in construction and engineering lines were he entered upon his present business. Mr. O'Reilly was born in Montgomery county, Missouri, January 13, 1863, but has resided in St. Louis since infancy. His parents were Dr. Thomas and Helen B. (Dunlop) O'Reilly. The mother was a native of Belfast, County Antrim, Ireland." (From *St. Louis: History of the Fourth City, 1764-1909*.)

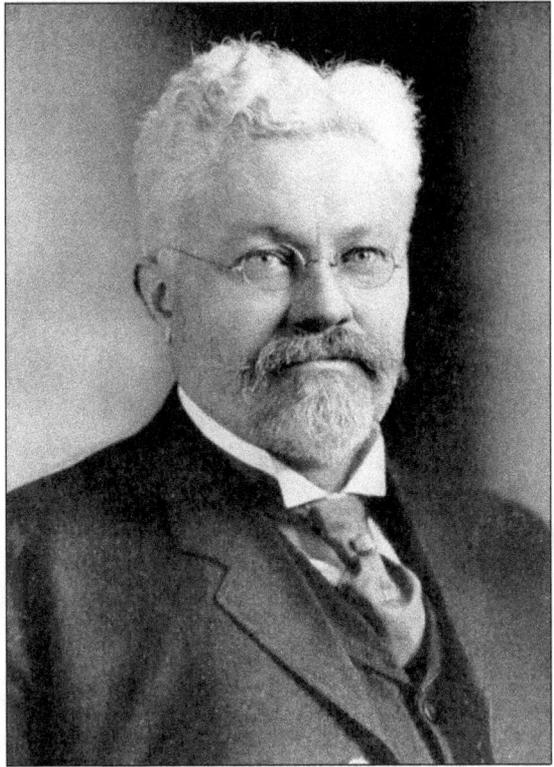

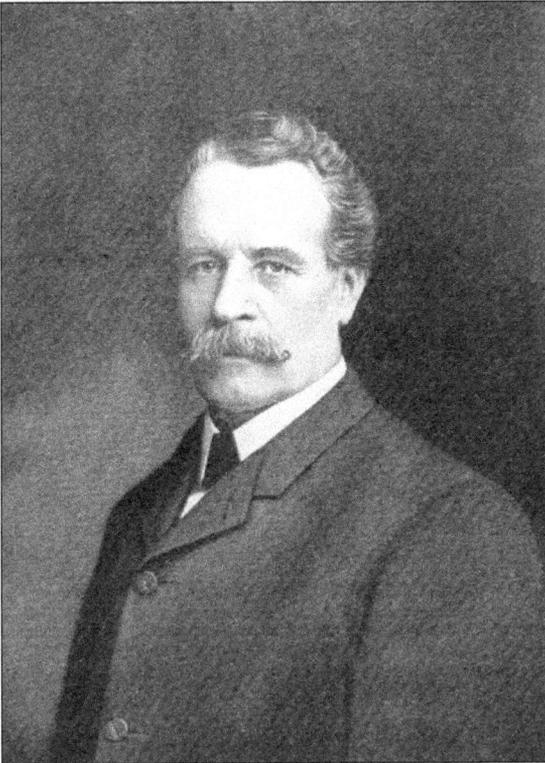

"The fame of Dr. Robert J. O'Reilly as a representative of the medical fraternity is not limited by the confines of St. Louis for he is widely known throughout the entire west. Born in Ireland on the 6th of October, 1845, he is a son of Michael and Mary (Smith) O'Reilly, who came to the United States in 1854 but after two years returned to the Emerald Isle. There the father died in the city of Dublin in 1856 at the age of 76 years." (From *St. Louis: History of the Fourth City, 1764-1909*.)

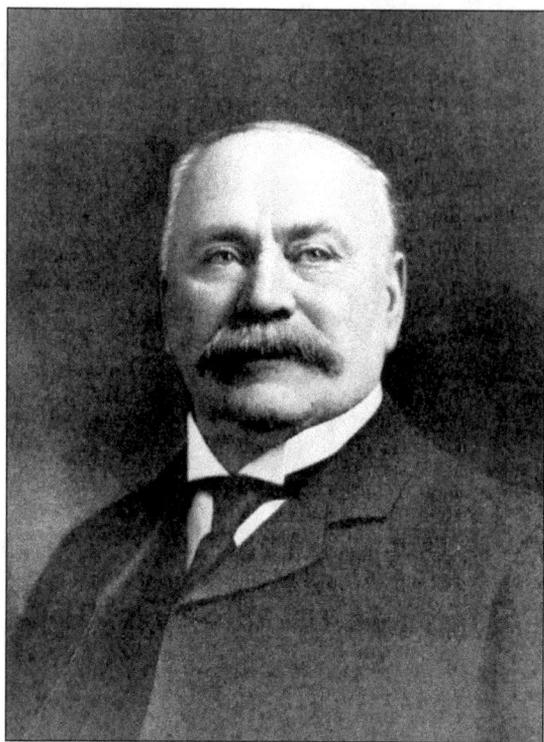

"John W. O'Connell was born in the city of Shangarry in County Cork, Ireland, October 7, 1843. His father, William O'Connell, was a farmer's son but, though reared to the occupation of the fields, became a contractor. The year 1848 witnessed his arrival in America, at which time he settled in St. Louis and turned his attention to railroad construction, building a large part of the Missouri Pacific Railroad. At the time of the Civil war Mr. O'Connell responded to the call for aid issued by the Confederacy and for seven months did active military duty with the southern army. In 1872 he became one of the organizers of the Knights of Father Matthew. In 1860 he helped to organize the first baseball club west of the Mississippi river, known as the Empire Baseball Club, and the first match game played in St. Louis was on the 27th of July, 1860." (From *St. Louis: History of the Fourth City, 1764–1909*.)

"Patrick Sarsfield O'Reilly, physician, was born in the County Cavan, Ireland, December 26, 1844, son of M.J. and Mary (Smith) O'Reilly. Dr. O'Reilly's grandfather, who lived about the time of the American Revolution, spent much time traveling in this country during that period, and rendered valuable assistance to the colonists in their efforts to establish their independence. Dr. O'Reilly came to St. Louis with his father shortly after the death of his mother, and as a youth was left in charge of his brother, Dr. Thomas O'Reilly, who had then established himself in the practice of his profession in this city, and who is now one of the most eminent of Western physicians. Shortly after his coming to St. Louis, Dr. Patrick S. O'Reilly matriculated in St. Louis University, and after being graduated from that institution, began the study of medicine. After obtaining his doctor's degree he studied for some months in New York City under the eminent Professor Draper, and from thence went to Dublin and London. He began the practice of medicine on the eve of the Civil War. He was placed in charge of a medical department, with field and regimental hospitals under his control. Returning to St. Louis at the close of the war, he resumed the civil practice of medicine, and was at once elected coroner of St. Louis city and county for the years 1865-6. He became a conspicuous figure in the Irish-American movement, which resulted in the Fenian invasion of Canada." (From *History of St. Louis*, Hyde, 1899.)

16

Julius S. Walsh may justly be classed with the "captains of industry." Born in St. Louis on December 1, 1842, Mr. Walsh is a son of Edward and Isabella (de Mun) Walsh, who were of Irish and French extraction, respectively. The father came from Ireland to America in 1815, and from Louisville, Kentucky, removed to St. Louis in 1818, here organizing the firm of J.&F. Walsh, with which he was connected until his death in 1866. Julius S. Walsh attended the St. Louis University and St. Joseph's College at Bardstown, Kentucky, being graduated from the latter with the class of 1861. He earned his law degree at Columbia College of New York city in 1864. The following year St. Louis University honored him with the degree of Master of Arts and later, in 1904, with the degree of LL. D. He was president of the Citizens' Railway Company and of the Fair Grounds & Suburban Railway Company, Union Railway Company, the People's Railway Company, the Tower Grove & Lafayette Railway Company and the Cass Avenue & Fair Grounds Railway Company. He also projected and built the Northern Central Railway. His work in behalf of the St. Louis Agricultural & Mechanical Association, of which he was elected president in 1874, is particularly notable. From 1875 until 1890 he was the president of the St. Louis Bridge Company. In 1890 he organized the Mississippi Valley Trust Company. He was first president of the Trust Company, which office he occupied until January, 1906, when he resigned to become chairman of the board of directors. He is also president of the Mississippi Glass Company and vice president of the Union Electric Light & Power Company, and a member of the board of commissioners of Tower Grove Park. Mr. Walsh was one of the directors of the Louisiana Purchase Exposition Company. He has served as vice president of the Mercantile Library Association and as president of the St. Louis Association of the Columbia (New York) University Alumni. He is a member of the St. Louis, University, Kinloch, Noonday and Country Clubs of St. Louis and the Union Club of New York. (From *St. Louis: History of the Fourth City, 1764–1909*.) (Photo courtesy of Saint Louis University, Pius XII Memorial Library, Archives.)

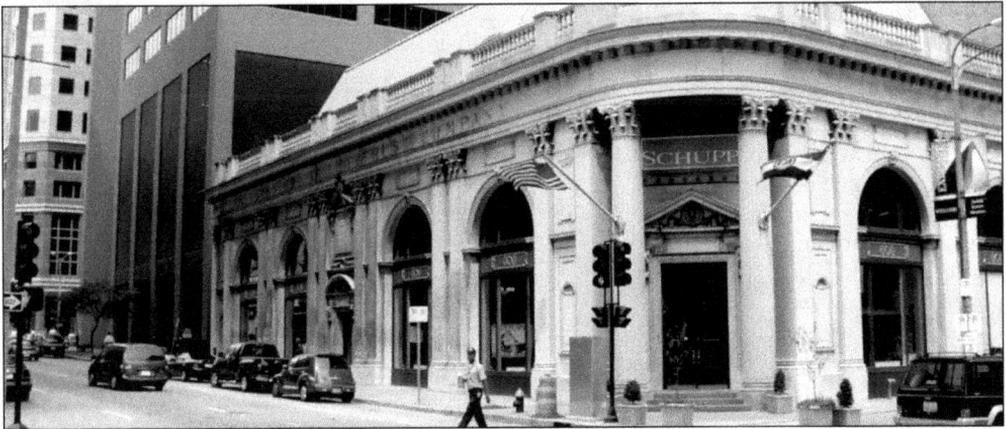

Picture of Mississippi Valley Trust Company building today. This is the northwest corner of Fourth Street and Broadway in downtown St. Louis. (Photo by Dave Lossos.)

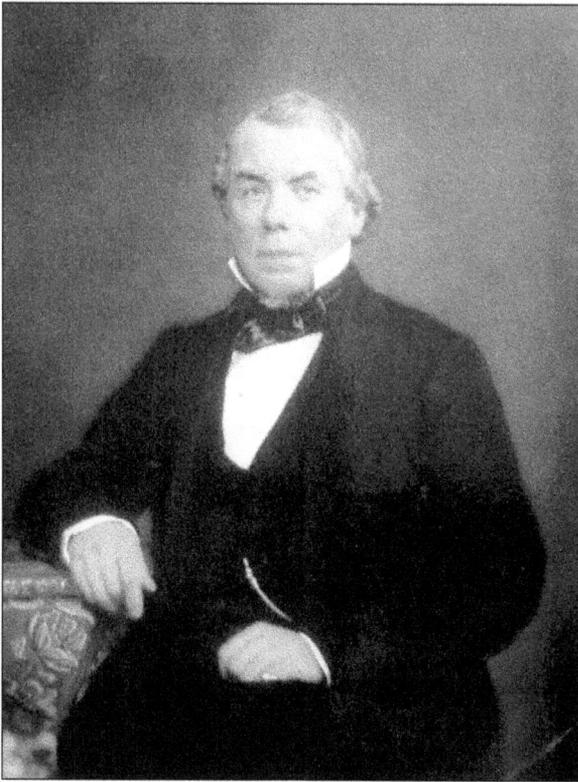

Robert Campbell was born in Aughlane, County Tyrone, Northern Ireland on February 12, 1804. His parents were yeoman farmers. Robert left his home in Ulster and arrived in St. Louis in 1823. He soon became a highly respected fur trader and businessman. Campbell also had banking interests and owned a large amount of property in St. Louis, including the Old Southern Hotel. A Presbyterian, Robert assimilated into the religious, cultural, and social life of St. Louis' Anglo-Americans. When Robert died in 1879 his estate was valued at nearly three million dollars. (Photo of portrait in Campbell House Museum by Dave Lossos.)

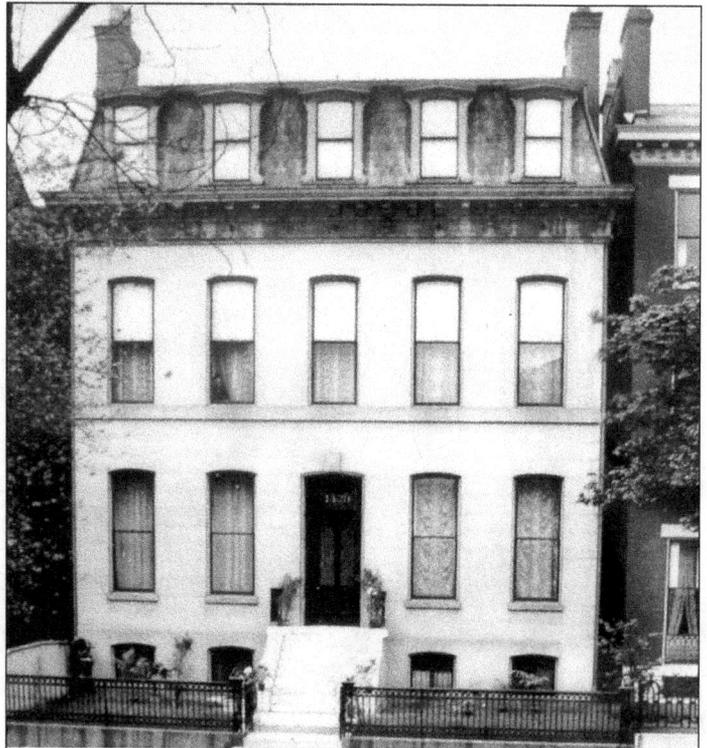

The Robert Campbell home, the sole survivor of the former stylish Lucas Place, was built in 1850 and purchased by Campbell in 1854. This house was the scene of many elaborate social events, including guests such as President Ulysses S. Grant and Father DeSmet. The property is preserved through the Campbell House Foundation and is available for tours. (Photo of image in Campbell House Museum by Dave Lossos.)

Festus John Wade is a "Limerick man," born in Ireland on the 14th of October, 1859. His father and mother were Thomas and Catharine (McDonough) Wade. Mr. Wade was a key contributor to the organization of the 1904 World's Fair. One of the practical achievements which came of Mr. Wade's connection with the Worlds Fair was the building of the Jefferson Hotel. Wade became prominent in the great Catholic temperance organization of St. Louis, the Knights of Father Matthew, of which he was supreme secretary. On the 28th of August, 1883, Festus J. Wade was married to Miss Kate V. Kennedy. The children are Stella Marie (wife of Charles L. Scullin), Marie L. Wade, Florence F. Wade, and Festus J. Wade, Jr. Mr. Wade is a member of the St. Louis, Commercial, Mercantile, Noonday, and Glen Echo Clubs of St. Louis, and the Railroad and Midday Clubs of New York, and an officer or director in more than twenty St. Louis corporations. (Information from *St. Louis: History of the Fourth City, 1764–1909*.) (Photo courtesy of Saint Louis University, Pius XII Memorial Library, Archives.)

Edward and his brother John were both natives of County Tipperary, Ireland. Arriving in St. Louis before 1818, Edward Walsh had a profitable milling company running by 1824. He went from milling to merchandising to steamboating (having over 20 steamboats at one time). His later ventures took him to railroading and banking. (Courtesy of Saint Louis University, Pius XII Memorial Library, Archives.)

19

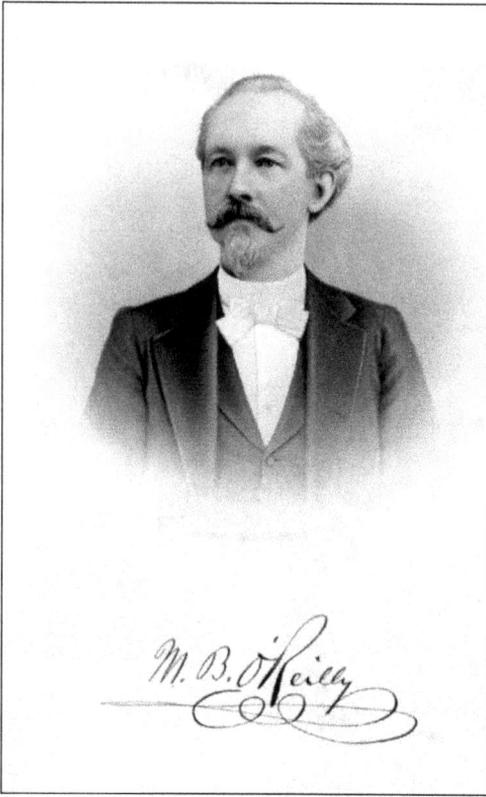

Attorney M. B. O'Reilly was one of the leading investigators to titles of real estate in the city, and his is the oldest house in that line in St. Louis. He was foremost a successful land law counselor. Mr. O'Reilly was born at Rathdawgau, in the Parish of Hacketsown, County Wicklow, Ireland, on May 10, 1839. His father was Michael O'Reilly, a native of Camolin Parish, County Rexford. His mother, Mary Byrne, of Bernia, County Wicklow, was of the famous Byrne Clan of that county. It was in October, 1848, that Mr. O'Reilly's parents left Ireland for St. Louis, embarking in the sailing vessel Anne McLester, bound from Dublin to New Orleans. The vessel reached its destination within eight weeks and three days and after a voyage varied by much rough weather. After a stay of a few days the family proceeded from New Orleans to St. Louis in the steamboat Aleck Scott, which was in the first days of the war converted into the first ironclad—the handiwork of Captain Eads. (Information from *Old and New St. Louis*, Cox, 1894.)

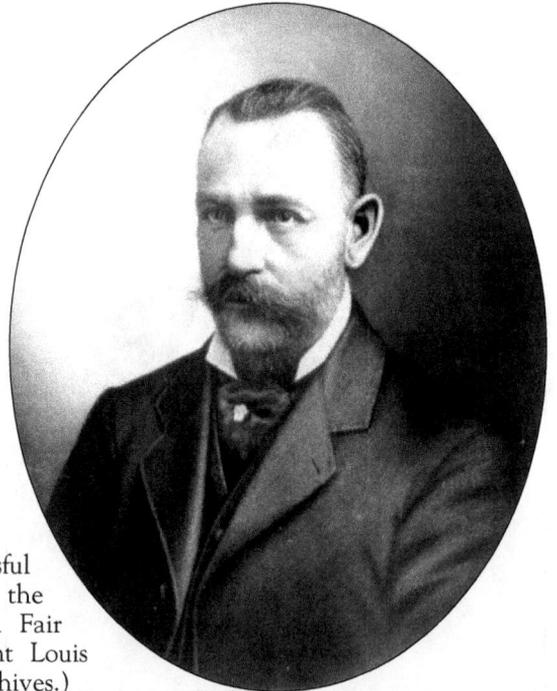

Charles Green of Galway was a successful businessman who became President of the St. Louis Agricultural and Mechanical Fair Association in 1880. (Courtesy of Saint Louis University, Pius XII Memorial Library, Archives.)

20

Medical missionary Tom Dooley was an Irish-American who had attended Notre Dame and graduated from the Jesuit-run St. Louis University Medical School. He wrote letters to his mother about Vietnam, some of which were published in newspapers at home. He was a dynamic speaker who captivated audiences with his stories of the refugees and their sufferings. Eventually he wrote a book about his experiences, *Deliver Us From Evil*, which became a bestseller in 1956. (Courtesy of Saint Louis University, Pius XII Memorial Library, Archives.)

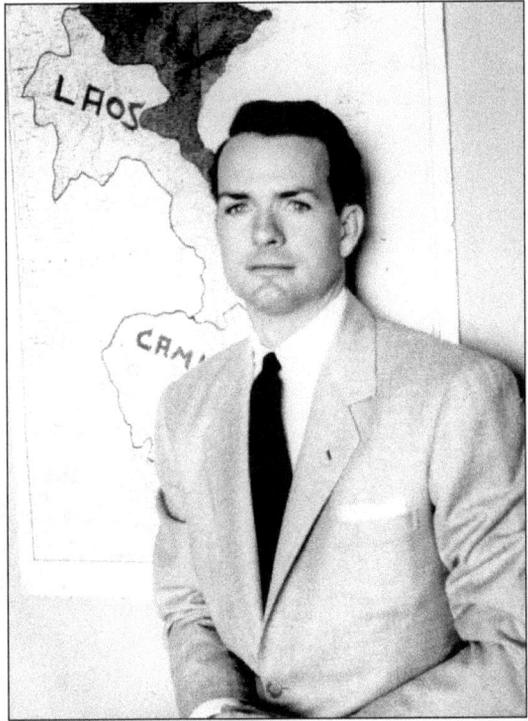

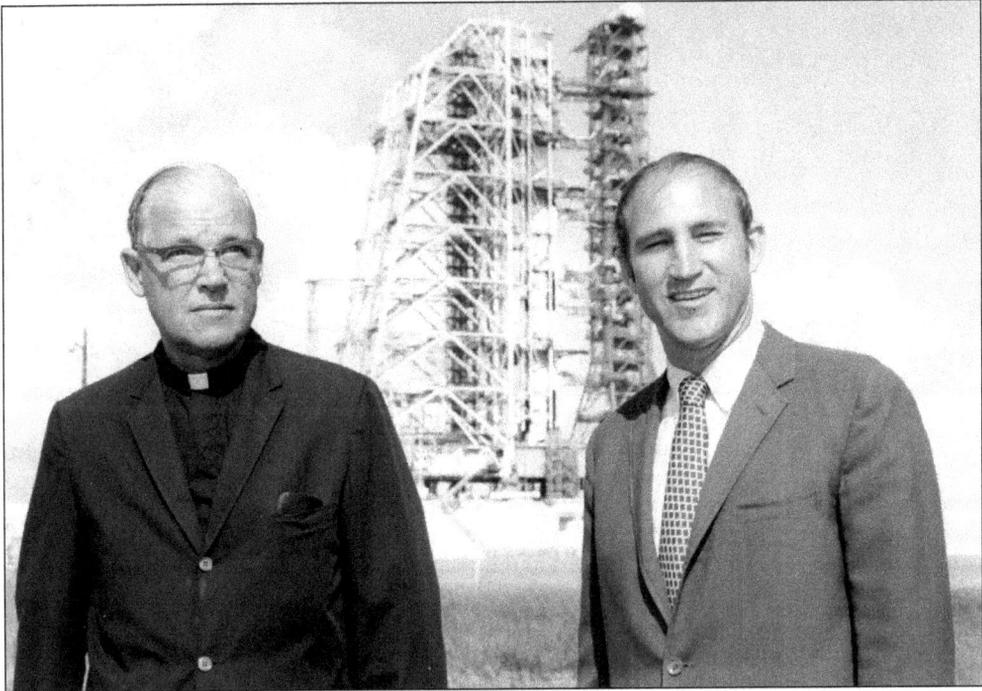

Historians William Barnaby Faherty, S.J., Saint Louis University, and Charles Benson of the University of Florida stand before the launch pad at Kennedy Space Center while engaged in research for their highly acclaimed work MOONPORT, commissioned by NASA in 1976 and published in 1978. (Photo courtesy of Faherty family collection.)

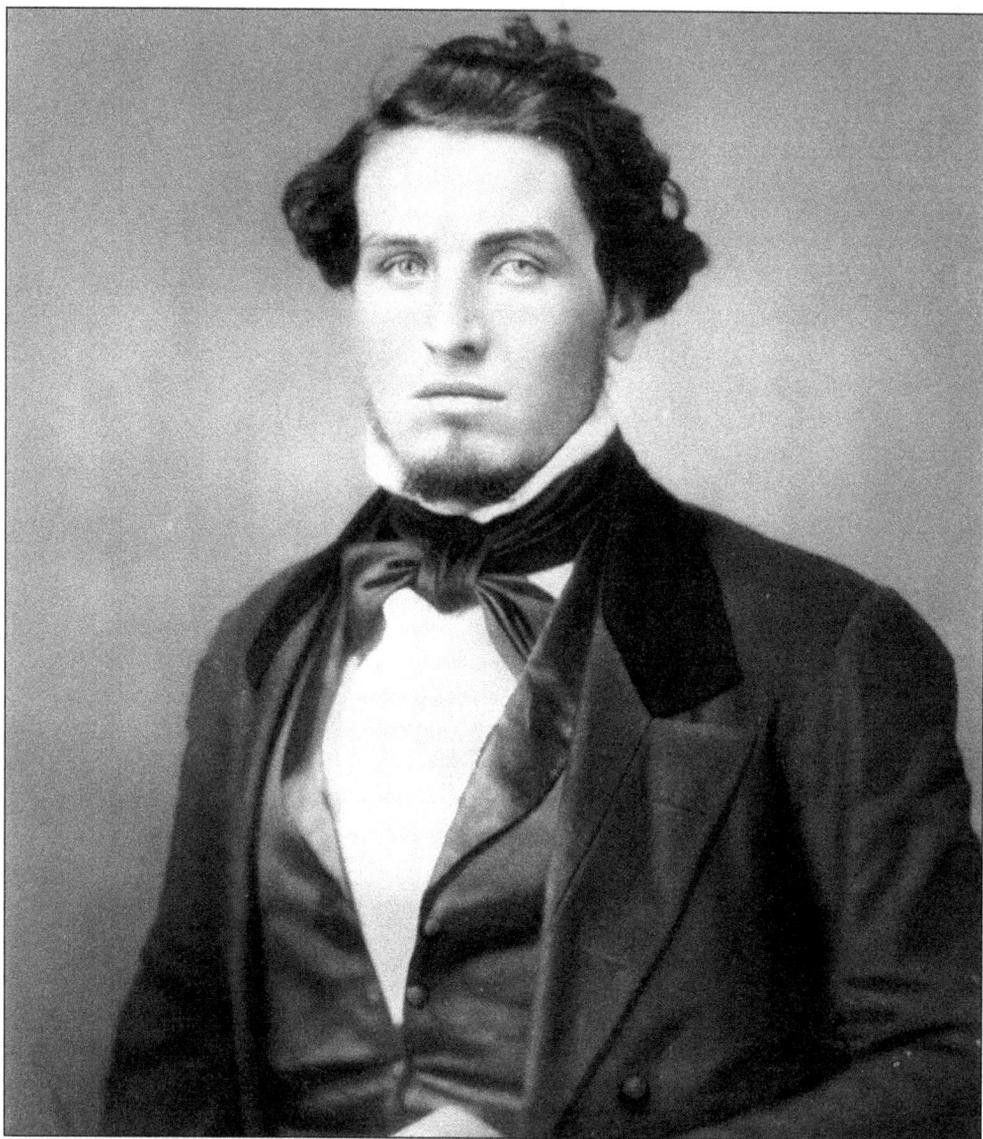

Thomas O'Reilly was born in Virginia, County Cavan, Ireland on February 11, 1827, son of M. J. (Michael) and Mary (Smith). The family came to St. Louis shortly after the death of his mother. Thomas was a precocious youngster. Before he was 13 years old he read and translated from the Latin—Ovid, Vergil, and Cicero. In his teenage years he read the New Testament in Greek. He mastered Algebra and Geometry and began to study medicine. After serving some time in an apothecary, he became assistant to the celebrated Dr. John Francis Purcell, of Carrick-on-Suir, Ireland, in Dublin. Beginning in 1845, during his term of service in a hospital, Ireland experienced four years of famine. In 1848 Dr. O'Reilly was one of the Dublin students who, fired by the French Revolution, sought to arouse the Irish patriots and induce them to throw off the British yoke, and he temporarily abandoned his studies with that object in view. When, however, it became evident that there could be no successful uprising of the Irish people against their oppressors, he resumed his studies and was graduated from the College of Surgeons of London in 1849. Continued on next page. (Extract from article in *St. Louis Metropolitan Medicine*, April 24, 1985, by Samuel D. Soule, M. D. Photo provided by Mary Elliott O'Reilly.)

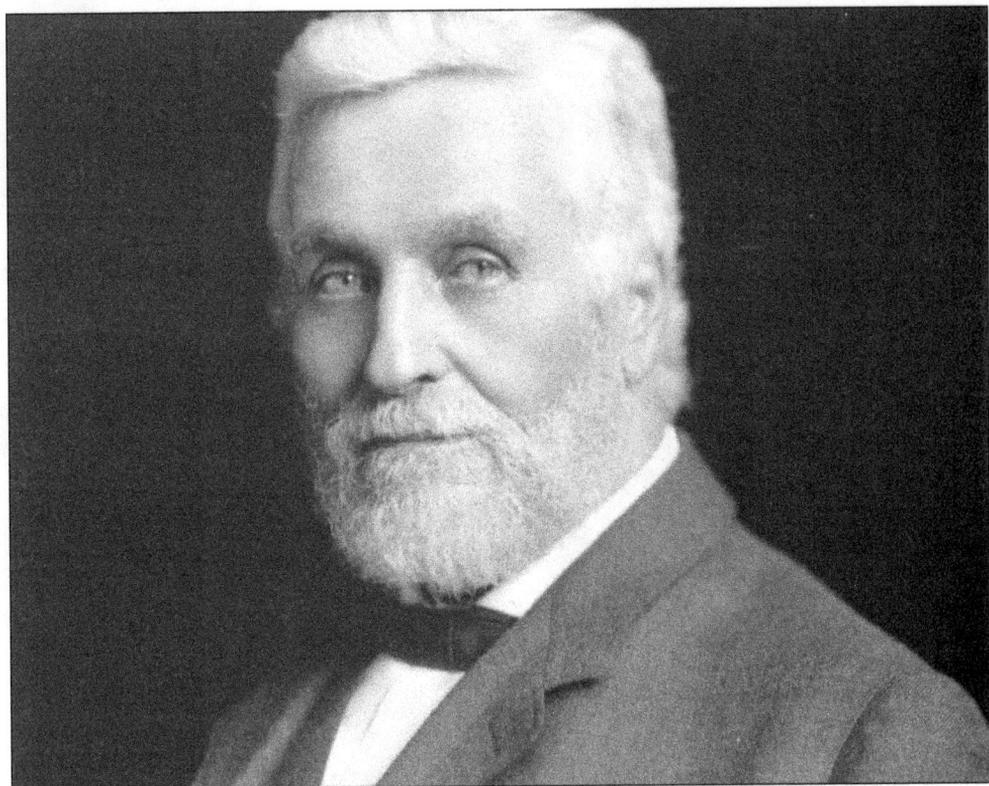

(Continued from previous page—Dr. Thomas O'Reilly) Soon afterward, in 1849, he sailed for America, and while in mid-ocean cholera developed on the ship in which he was a passenger. Six persons died within eight hours of the appearance of the disease, and within ten days 125 of the steerage passengers had been attacked by it. During this terrible ordeal Dr. O'Reilly was unceasing in his efforts to mitigate the pestilence, to lessen suffering and save lives. Fortunately, when the ship entered the gulf stream the sickness ceased as suddenly as it had broken out, and there was not a case of cholera on board when the vessel landed at New York. Appreciating his services, the grateful passengers presented him with a well-filled purse and a flattering address of thanks. The newspaper mention which he received in this connection would have given him much prestige had he been inclined to begin practicing in New York. He was determined, however, to come to that part of America where his famous relative, Count Alexander O'Reilly, had been governor when Spain dominated the area then known as Louisiana. When he finally traveled as far as St. Louis he found himself without friends, without money. He began practicing medicine here in St. Louis. The next decade and a half was a period of developing a large and demanding practice.

He had a devout love for the land which was his refuge. At the beginning of the Civil War he was revisiting his native land. Realizing that St. Louis would be the theater of great events, he hurried home to throw all the weight of his great influence against the secession movement. Thereafter, until the close of the war, he was at the disposal of the government, and was employed in many important missions. Outside of his profession he has been an exceedingly useful citizen of St. Louis. Among the earliest advocates of public park improvements in St. Louis, his personal persuasion had much to do with inducing Henry T. Shaw to donate Tower Grove Park to the City. He was one of the first Commissioners appointed to lay out Forest Park. He was one of the first members of the Board of Directors of the Free Library. (Extract from article in *St. Louis Metropolitan Medicine*, April 24, 1985, by Samuel D. Soule, M.D. Photo provided by Mary Elliott O'Reilly, great-granddaughter of Dr. Thomas O'Reilly.)

23

John Mullanphy, perhaps the most philanthropic Irishman St. Louis has ever known, was born in 1758 near Inniskillen, County Fermanagh, Ireland. At the age of 20 he entered the Irish Brigade as ensign. In 1789, he married Miss Elizabeth Browne of Youghal, County Waterford. In 1792 he and Mrs. Mullanphy, with one child, sailed for America, landing in Philadelphia, which, with Baltimore, became their home from 1792 to 1798. In 1804 the Mullanphys moved to St. Louis. He died at St. Louis on August 29, 1833. (Information from *History of St. Louis*, Hyde, 1899.)

William Marion Reedy achieved international renown as a literary patron, humorist, and publisher of *Reedy's Mirror*. He was born in the Kerry Patch in 1862 and baptized at St. Lawrence O'Toole Church. His father Patrick, from Clonmel, County Tipperary, Ireland, was a police captain. (Courtesy of Saint Louis University, Pius XII Memorial Library, Archives.)

Two

IRISH POLITICIANS OF ST. LOUIS

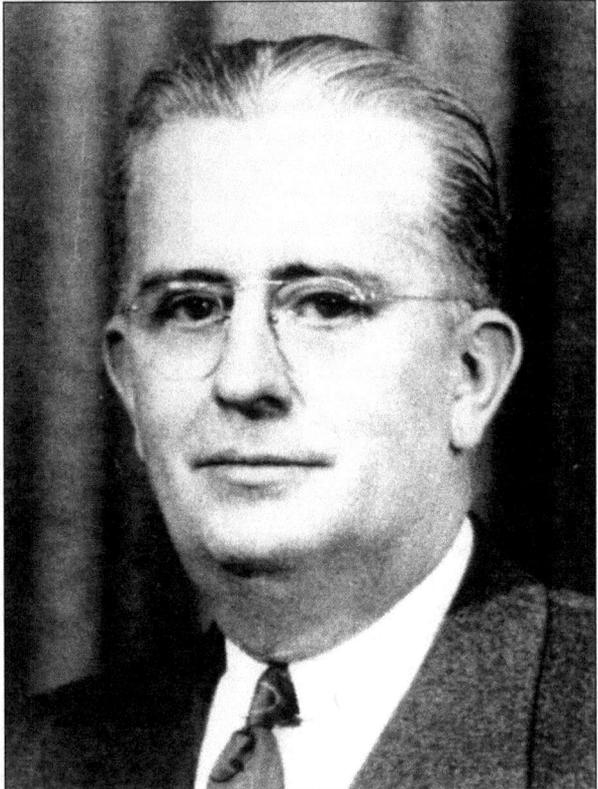

Raymond R. Tucker, of Irish descent, was Mayor of St. Louis from 1953–1965. Mayor Tucker was born in St. Louis, December 4, 1896. He received degrees at St. Louis University in 1917, and Washington University in 1920. He married Miss Mary Edythe Leiber in 1928 and they raised a son and daughter. From 1921 to 1934 he taught mechanical engineering at Washington University, and was chairman of the department from 1942 to 1951. Much of his time in office was devoted to the Riverfront Memorial, Downtown Stadium, and urban renewal programs. Raymond R. Tucker died on November 23, 1970, and is buried in Calvary Cemetery. (Courtesy of Saint Louis University, Pius XII Memorial Library, Archives.)

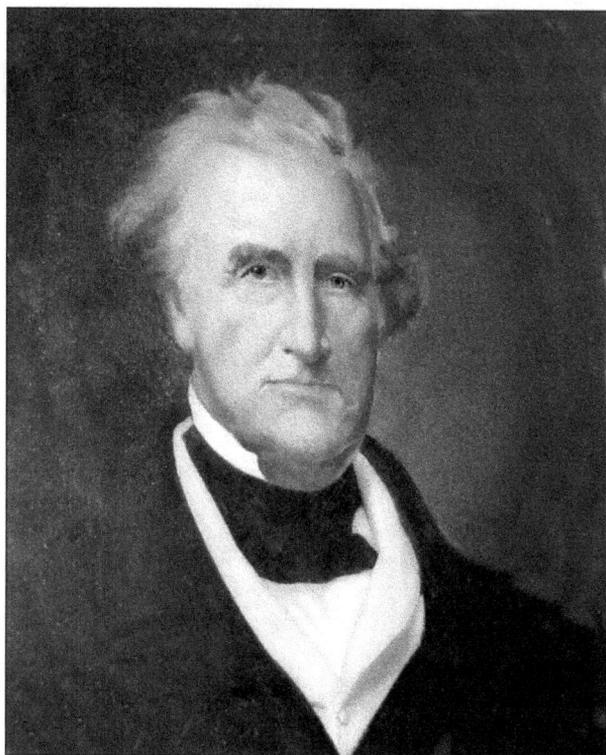

Dr. William Carr Lane was born in 1789 in Pennsylvania. At least one source states that he was of Irish descent. He was a medical surgeon by trade. Dr. Lane came west to St. Louis in 1818 as post surgeon at Fort Bellefontaine. He became the first mayor of St. Louis in 1823, and was elected to six consecutive terms, followed nine years later by three more terms. In 1852 President Millard Fillmore appointed Dr. Lane Governor of the New Mexico Territory. He later returned to St. Louis and continued to practice medicine until his death in 1863. He is buried in Bellefontaine Cemetery. (Photo of portrait in St. Louis City Hall by Dave Lossos.)

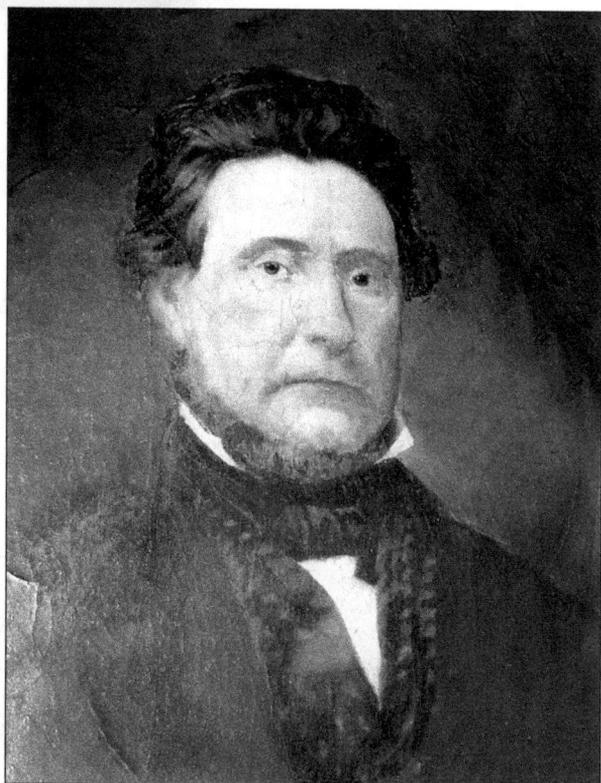

James G. Barry was born in Ireland in 1800. His educational advantages in early life were limited. The greater part of his life was spent in St. Louis. He and his wife, Elizabeth, had one child, Frances Angela, born in 1842. Mr. Barry was a member of the Board of Alderman in 1840, 1842, 1845, and 1846. James G. Barry was elected Mayor of St. Louis in 1849, serving one two-year term. Two St. Louis catastrophes took place during his administration. In 1849 fire broke out on steamboats on the Mississippi levee. When the smoke cleared, much of downtown St. Louis was in ruins. Estimates of damage exceeded $5,000,000. Also in 1849 the cholera epidemic was at it's worse. As much as one percent of the population was dying weekly—about 640 people. (Photo of portrait in St. Louis City Hall by Dave Lossos.)

George Maguire was born in Omagh, County Tyrone, Ireland in 1796 and was the first foreign born Mayor of St. Louis, serving in that position from 1842–1843. He came to America at a young age with his parents. About 1820 he moved from Virginia to St. Louis, and in 1833 he married Mary Amelia Provenchere. He was Mayor during a decade of rapid growth for St. Louis (1840 population of 16,000 grew to 77,000 by 1850). Mr. Maguire died in St. Louis in 1882 and is buried in Bellefontaine Cemetery. (Photo of portrait in St. Louis City Hall by Dave Lossos.)

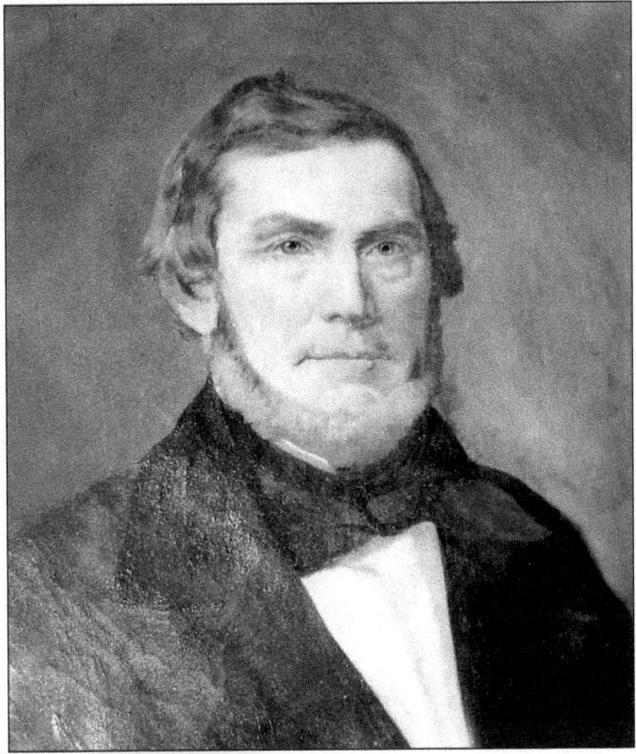

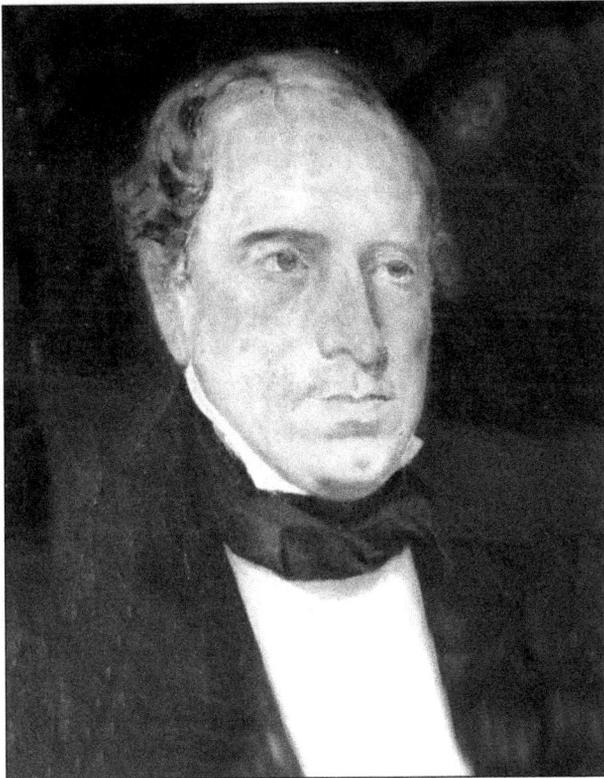

Bryan Mullanphy was born in Maryland in 1809, son of wealthy philanthropist John Mullanphy. In 1792 John Mullanphy came to America from Ireland. Bryan was the City's first bachelor Mayor, elected in 1847. Bryan Mullanphy was a wealthy man noted for his many charities as well as his many eccentricities. Mr. Mullanphy died in 1851 at the age of only 42. He is buried at Calvary Cemetery. His will left one-third of his estate (about $200,000) as a trust fund "to furnish relief to all poor emigrants passing through St. Louis to settle in the West." (Photo of portrait in St. Louis City Hall by Dave Lossos.)

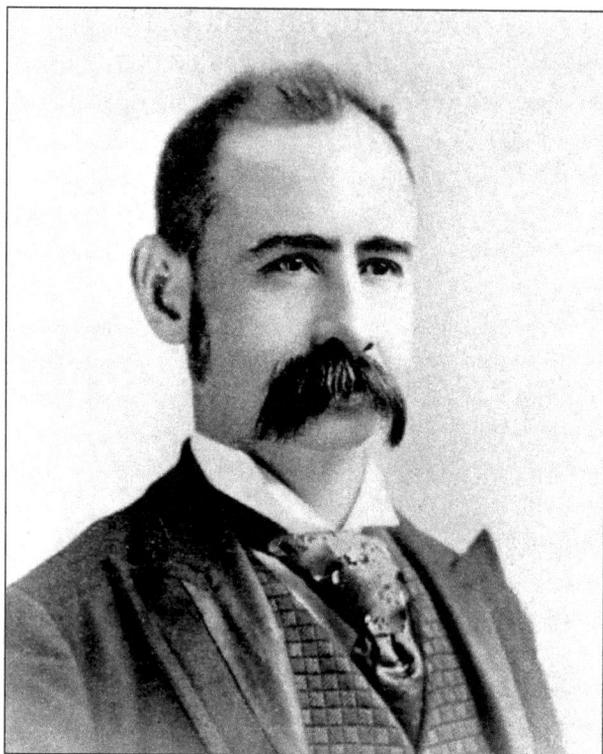

"Ed" Noonan was born in December, 1849 in Reading, Pennsylvania. His father, Martin, and his mother, Johanna (Nagle) Noonan, were both natives of Ireland, who came to this country in their childhood and located in Pennsylvania. A noted Democrat, Edward Aloysius Noonan, attended law school in Albany and moved to St. Louis. Twice assistant circuit attorney and twice judge of the Court of Criminal Correction, he was the Mayor of St. Louis from 1889 to 1893. During his term Union Stationrom *Old and New St. Louis, Cox, 1894.*)

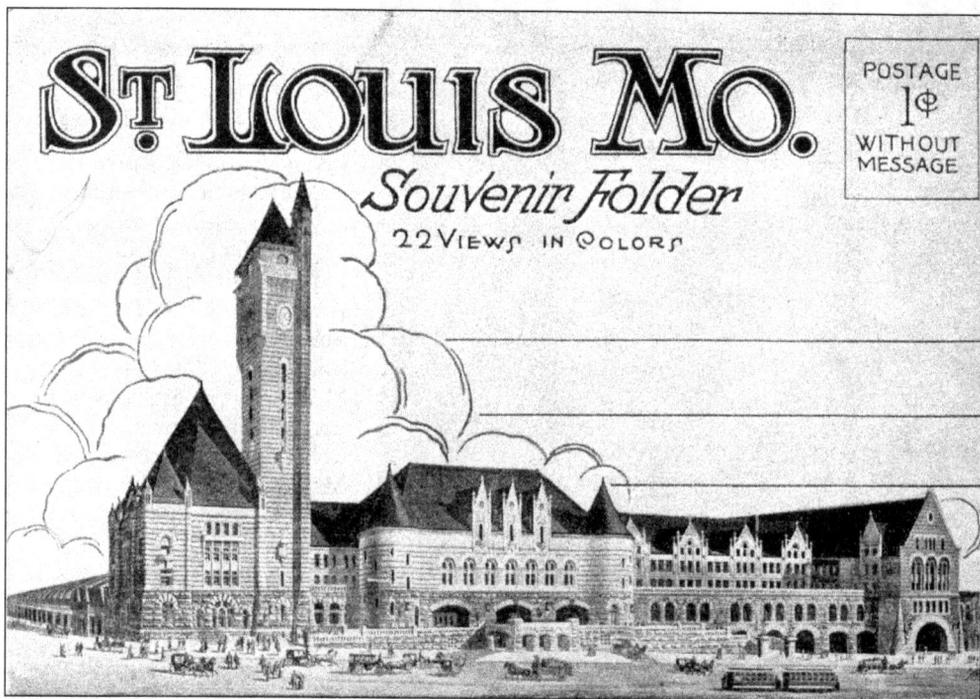

This is a depiction of the St. Louis Union Station in the era of Edward Noonan's term as Mayor of St. Louis. (Postcard Folder from Dave Lossos' Collection.)

Alexander McNair was born in Pennsylvania in 1776. His grandfather came from County Donegal, Ireland. His father, serving in Washington's army, suffered mortal wounds at Trenton. McNair became the first Governor of the State of Missouri in 1820 (a year before Congress authorized statehood for Missouri). (Courtesy of Saint Louis University, Pius XII Memorial Library, Archives.)

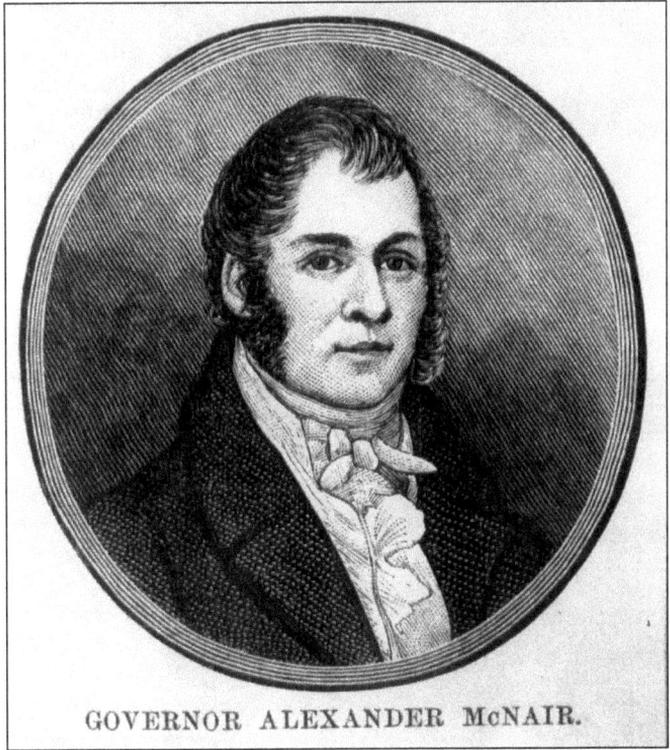

GOVERNOR ALEXANDER McNAIR.

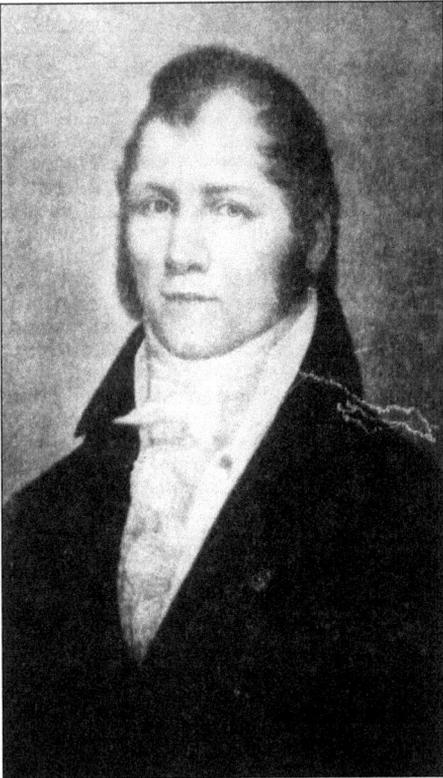

Governor Alexander McNair served in the State Capitol until 1824, and died just a few years later. (Courtesy of Saint Louis University, Pius XII Memorial Library, Archives.)

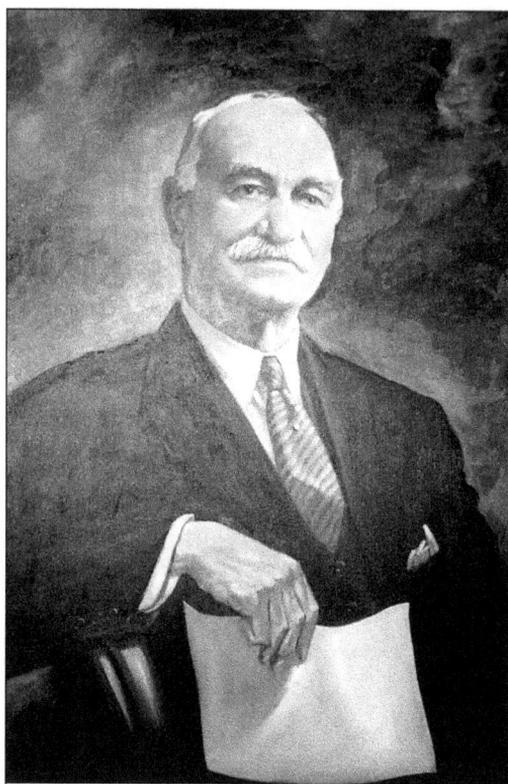

William Matthew Daly served two terms as the Mayor of Kirkwood from 1900–1904. He then was elected to four successive two-year terms as Alderman. During his administration as Mayor, Kirkwood built a municipal electric plant, its water system and a sewer system. For 35 years Mr. Daly was the vice president and a director of the Kirkwood Trust Company. For 48 years he conducted a plumbing and business. Born shortly after the end of the Civil War, Daly was the son of Irish immigrant parents. (Photo taken by Dave Lossos of portrait hanging in Kirkwood City Hall Building.)

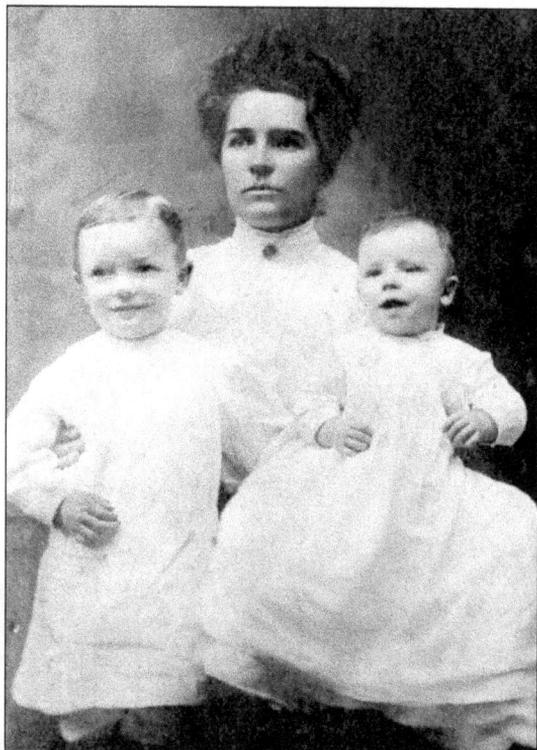

The wife and children of William M. Daly are pictured in this photo taken in 1909. Mary Ellen "Nellie" McLoughlin was a descendant of the line of Irish McLoughlins that first showed up in the Kirkwood area around the time of Missouri's statehood in 1821. The child on the left, John F. Daly, became a Roman Catholic priest, and the son on the right, William M. Daly, Jr., was a member of the Missouri House of Representatives. (Photo courtesy of Barry Kane.)

Settled in St. Louis in 1815, Thomas H. Benton was active in law and politics, and editor of *The Missouri Enquirer*. In the famous Missouri Compromise of 1820, admitting Missouri to the Union as a state, Benton was elected the state's first U.S. Senator. He was the first man to serve 30 years in the U.S. Senate. His position on key issues made him very popular in the Irish community. (Courtesy of Saint Louis University, Pius XII Memorial Library, Archives.)

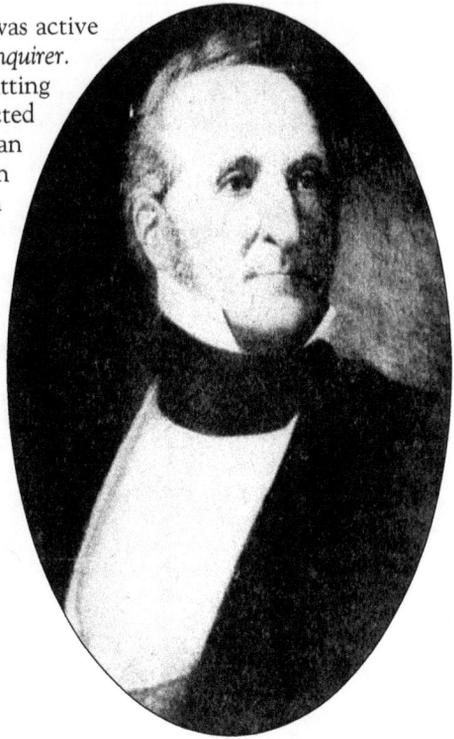

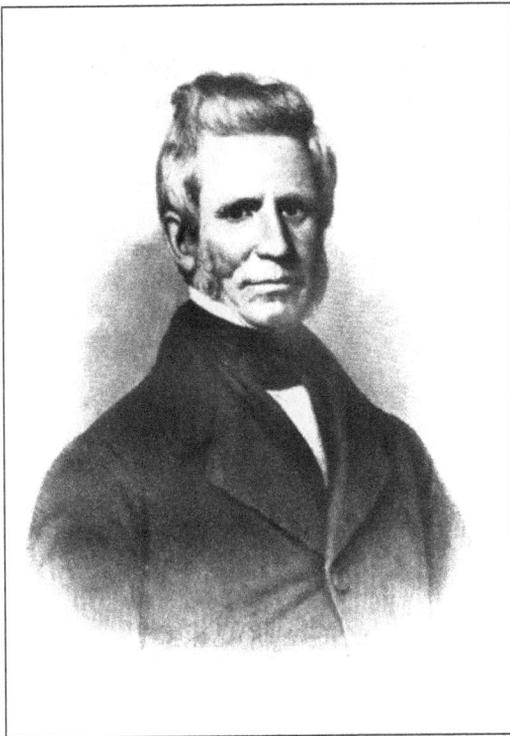

John O'Fallon fought in the War of 1812. His Irish born father fought with distinction with Washington in the Revolutionary War. In 1821 John O'Fallon was elected a member of the first Missouri State Legislature. He was also the first president of the United States Bank in 1828. (Courtesy of Saint Louis University, Pius XII Memorial Library, Archives.)

31

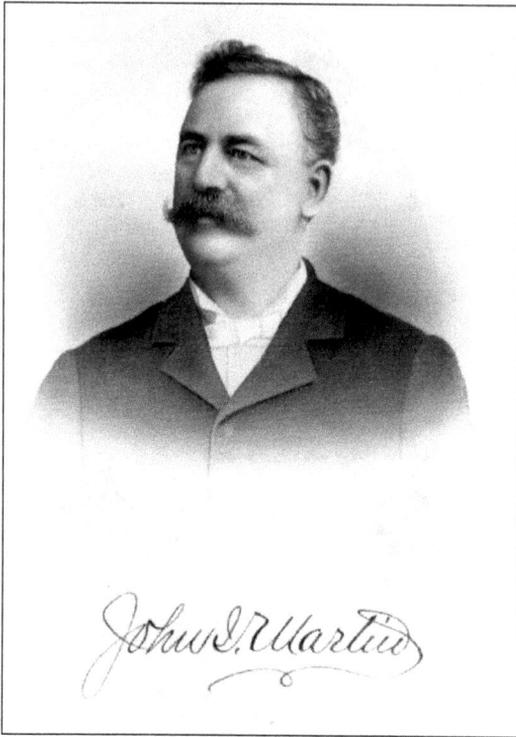

John I. Martin, prominent as a lawyer and in public life, was born May 24, 1848, in St. Louis, the son of William and Frances Irwin Martin, who came to St. Louis from the North of Ireland. He served three terms as a member of the Missouri House of Representatives, and in 1874 was unanimously elected speaker of that body. In 1879 he had the honor of being enrolled as a member of the United States Supreme Court bar, upon motion of Honorable Montgomery Blair. In 1888 he was grand marshal of the great Democratic parade given in St. Louis during the session of the Democratic National Convention of that year, and directed the movement of 50,000 men who were in line on that occasion. In 1896 he was sergeant-at-arms of the Democratic national committee. (Information from *History of St. Louis*, Hyde, 1899.)

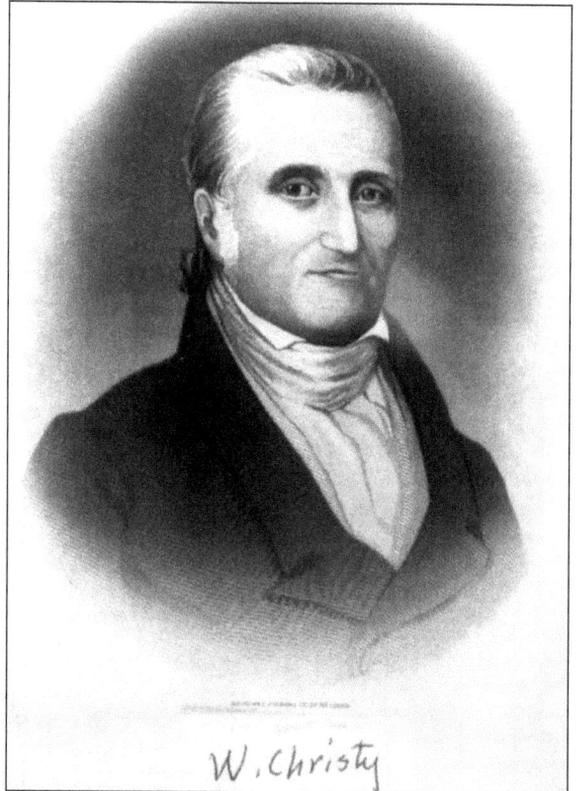

A descendant of a County Down family, William Christy was the first State Auditor of Missouri in 1820. He was also a founder of the *St. Louis Enquirer*, a competitor's of Charless' *St. Louis Gazette*. (Courtesy of Saint Louis University, Pius XII Memorial Library, Archives.)

Three

IRISH CLERGY

John J. Glennon, a name well-known to St. Louisans, was born June 14, 1862 in Kinnegad, County Westmeath, Ireland. He became Archbishop of St. Louis in 1903 and was the first Cardinal of the Catholic Church from an Episcopal see west of the Mississippi. Traveling to Rome in 1946 to receive his Cardinal's "red hat," he ironically died in Dublin on his return trip to St. Louis. This picture was taken in 1905 when he was Most Rev. Glennon. (Courtesy of Saint Louis University, Pius XII Memorial Library, Archives.)

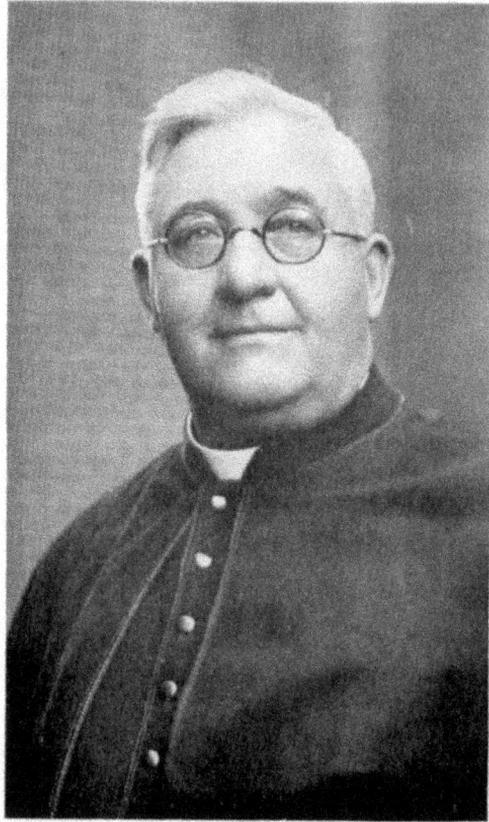

IN PIOUS MEMORY OF

Rt. Rev. Msgr. Timothy Dempsey

Born October 21st, 1867
Cadanstown, Offaly, Ireland

Ordained June 14th, 1891
St. Patrick's College,
Carlow, Ireland

Died April 6th, 1936
St. Louis, Mo.

Rev. Timothy Dempsey was undoubtedly one of the best known priests of St. Louis. As pastor of St. Patrick's Church in the late 1800s, Father Dempsey initiated "Father Dempsey's Hotel," a temporary home for indigent and poor men of St. Louis. This was but the first of his undertakings as a social reformer. (Courtesy of the Archdiocese of St. Louis Archives.)

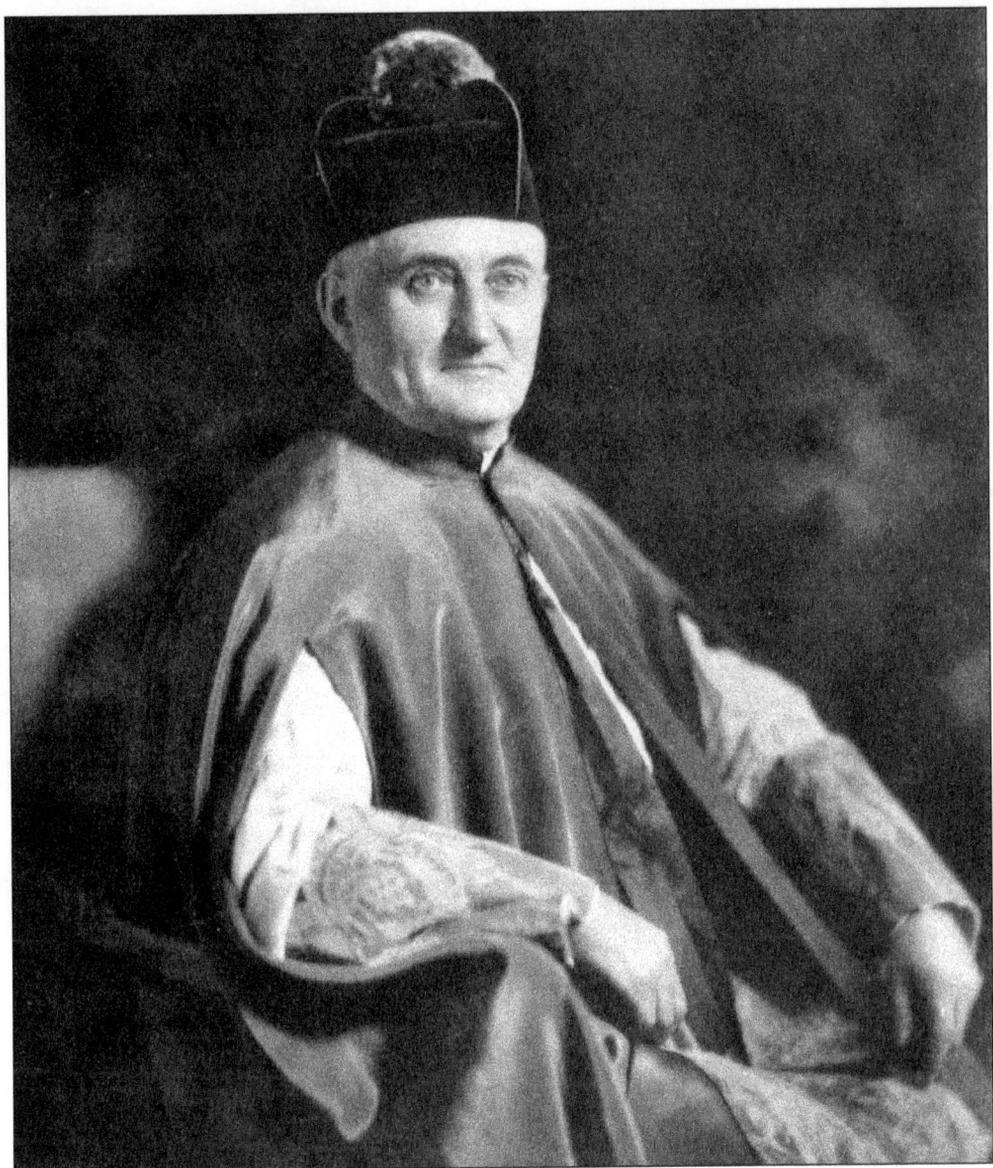

"Rev. John Lyons is pastor of St. Pius' Catholic church. The parish was organized in the year 1905. At present the property consists of a large school building that serves both for divine services and as a place of instruction for the children of the parish. He was born in County Cork, Ireland, November 6, 1867. After his ordination he came to the United States and was appointed an assistant to Father Fenlon at Visitation Parish in St. Louis, Missouri. Here he remained until July, 1895, when he was assigned as assistant to Father J. G. Harty, now archbishop of Manilla, Philippine Islands. In the year 1905 he was called to the parish over which he now presides. He was appointed by Archbishop Glennon. Father Lyons was instrumental in founding this parish. He laid the cornerstone of the church building on June 3, 1906. When he began his work in the parish he had enrolled but 120 families. The present enrollment numbers 300 families. During his incumbency the enrollment of children has increased from 75 to 200." Rev. Lyons was pastor at St. Pius V from 1905 until 1940. (From St. Louis: History of the Fourth City, 1764–1909, photo courtesy of the Archdiocese of St. Louis Archives.)

35

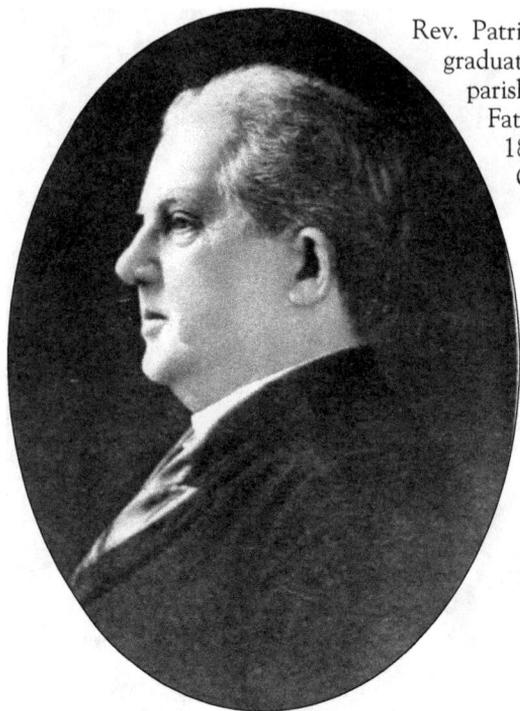

Rev. Patrick Francis O'Reilly, Saint Louis University graduate and Pastor of Immaculate Conception parish, was the spiritual leader of the Knights of Father Matthew temperance group formed in 1872. Father O'Reilly was a brother of M.B. O'Reilly. (Courtesy of Saint Louis University, Pius XII Memorial Library, Archives.)

American born but of Irish ancestry, Rev. William Banks Rogers, S.J., was president of Saint Louis University from 1900 thru 1908. (Courtesy of Saint Louis University, Pius XII Memorial Library, Archives.)

Father Eugene Murphy, S.J., was the assistant superior of the Jesuit priests when he was asked to speak on a Catholic radio program. He went on to head up the "Sacred Heart Program," which was broadcast nationwide and also on the Armed Services Network during World War II. (Courtesy of Saint Louis University, Pius XII Memorial Library, Archives.)

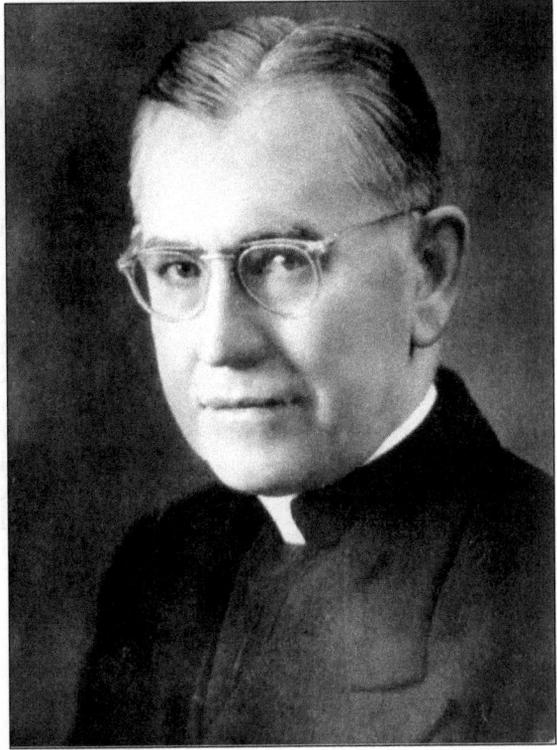

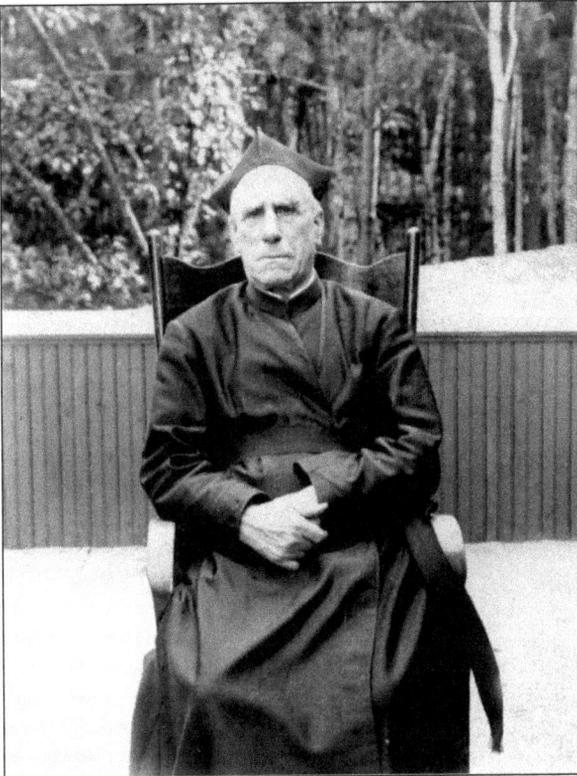

Rev. Thomas O'Neil, S.J., was born in Ireland January 24, 1822. He became the first Irish born President of Saint Louis University, serving in that position from 1862 through 1868. Father O'Neil died in 1895. (Courtesy of Saint Louis University, Pius XII Memorial Library, Archives.)

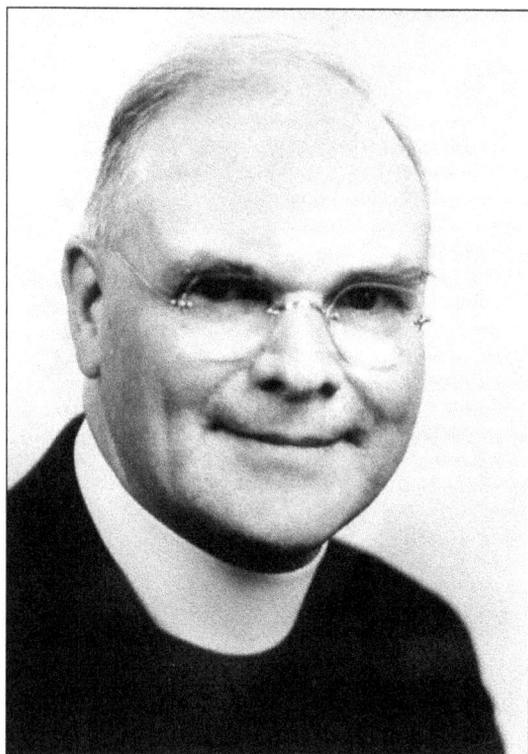

James B. Macelwane was born in Ohio in 1883, son of a fisherman and farmer from Ulster, County Tyrone. He joined the Society of Jesus and took his vows as a Jesuit on September 8, 1905. He then began the long course of studies in the classics, science, and theology required by Jesuits preparing for the priesthood. In 1908, Macelwane's studies brought him to Saint Louis University. He was ordained a priest in 1918 and continued to study theology and teach physics at Saint Louis University until 1921. At that time he went to the University of California, where he received his Ph.D. in physics, with a seismological dissertation, in 1923. (Courtesy of Saint Louis University, Pius XII Memorial Library, Archives.)

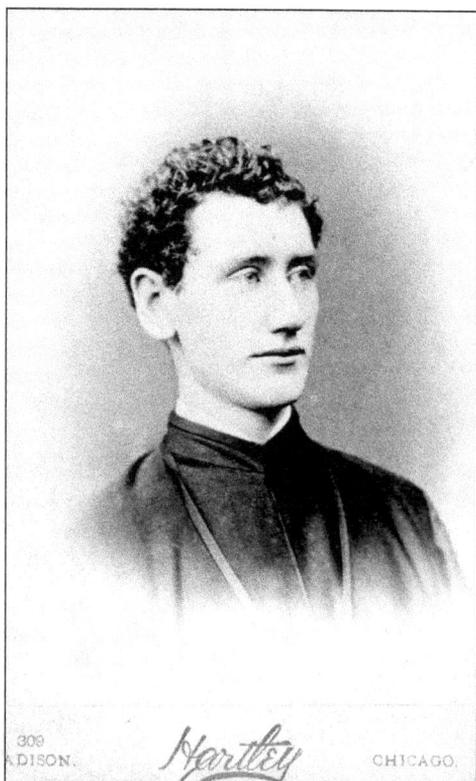

Father William Fanning was the noted author of scholarly works of both theology and history, including the 75th History of St. Louis University. (Courtesy of Saint Louis University, Pius XII Memorial Library, Archives.)

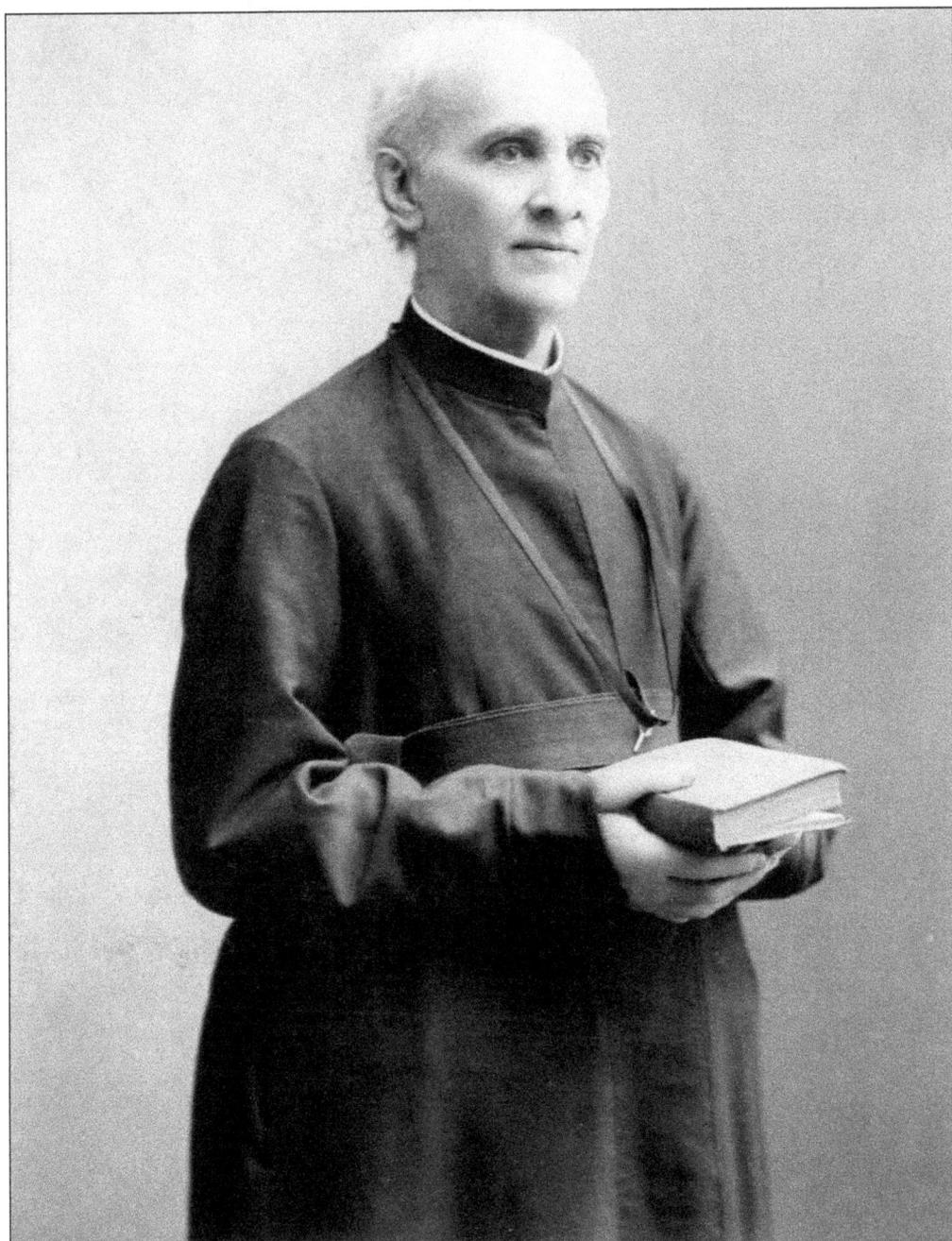

Fw. Guerin ST. LOUIS

Father John Verdin, S.J., son of French-Irish parents, was born in St. Louis on February 1, 1822. He was the first St. Louis born President of Saint Louis University, serving in that position from 1854 through 1859. (Courtesy of Saint Louis University, Pius XII Memorial Library, Archives.)

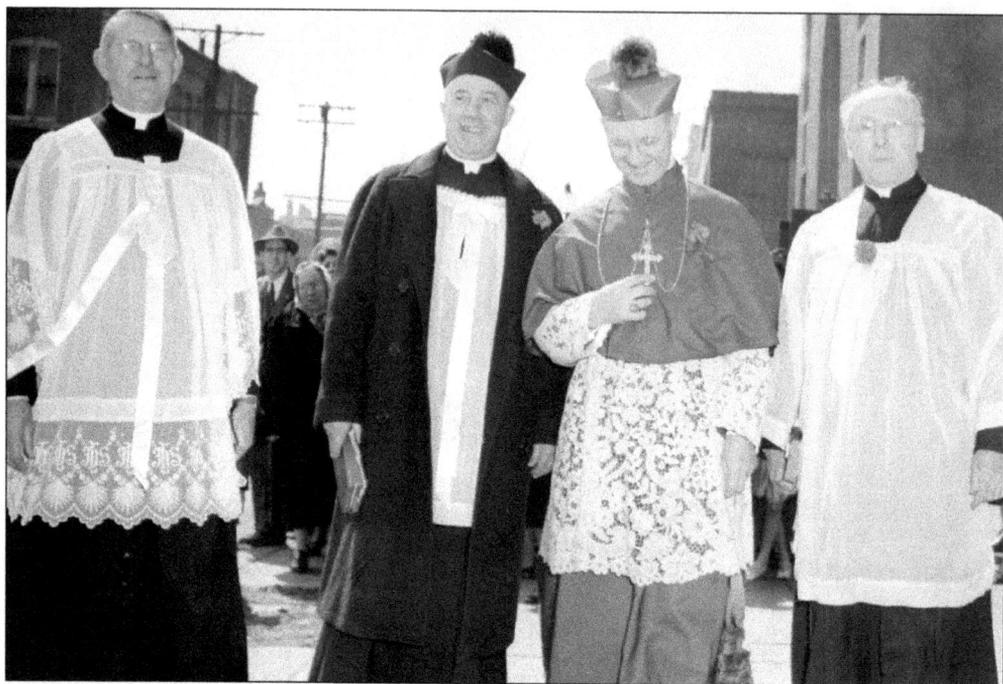

Pictured from left to right are Rev. Patrick J. O'Connor (pastor at St. James Church), Msgr. Jim Johnston, Cardinal Ritter, and Msgr. Joseph A. McMahon. (Courtesy of the Archdiocese of St. Louis Archives.)

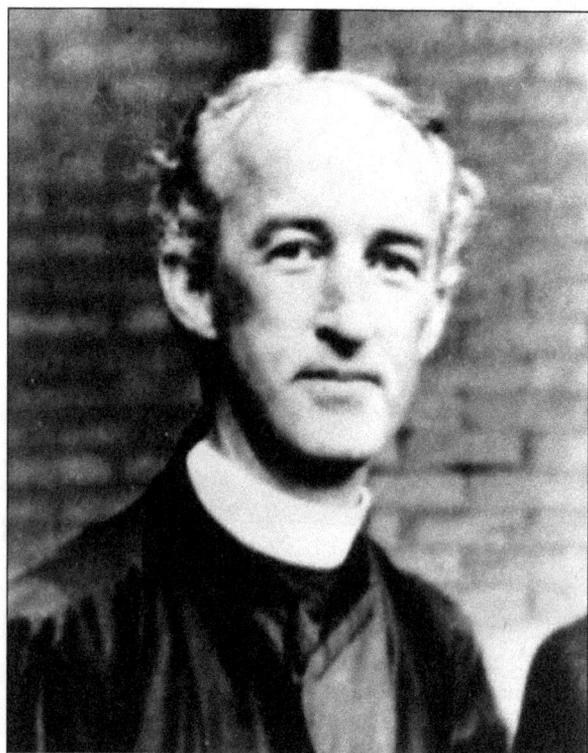

Father Laurence Kenney, S.J., was a revered history teacher at St. Louis University. (Courtesy of Saint Louis University, Pius XII Memorial Library, Archives.)

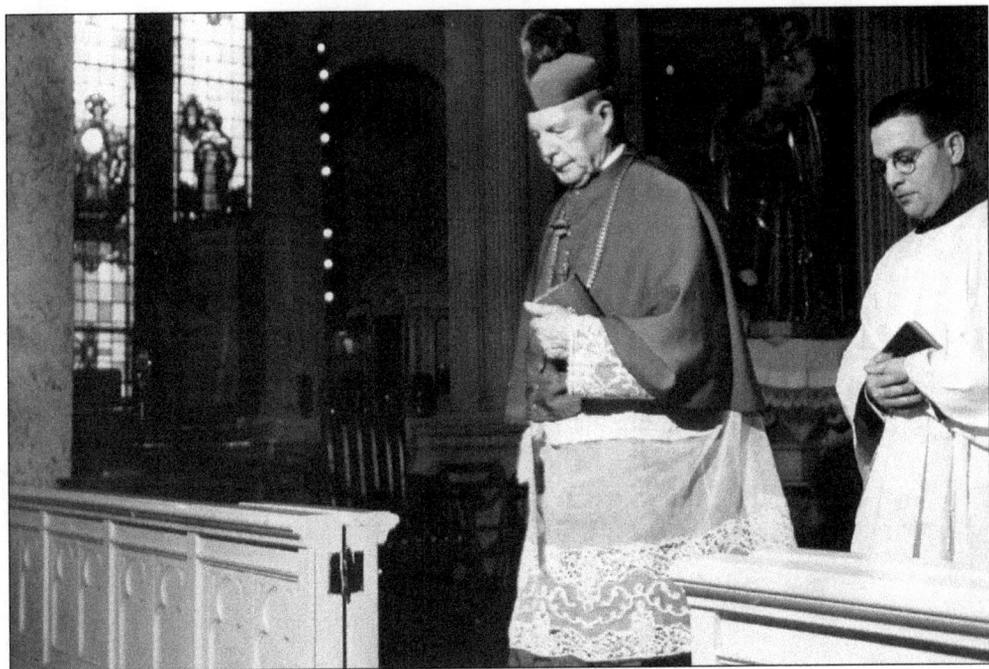

Archbishop John Glennon is pictured here leaving St. Patrick's after Mass on St. Patrick's Day, March 17, 1945. (Courtesy of the Archdiocese of St. Louis Archives.)

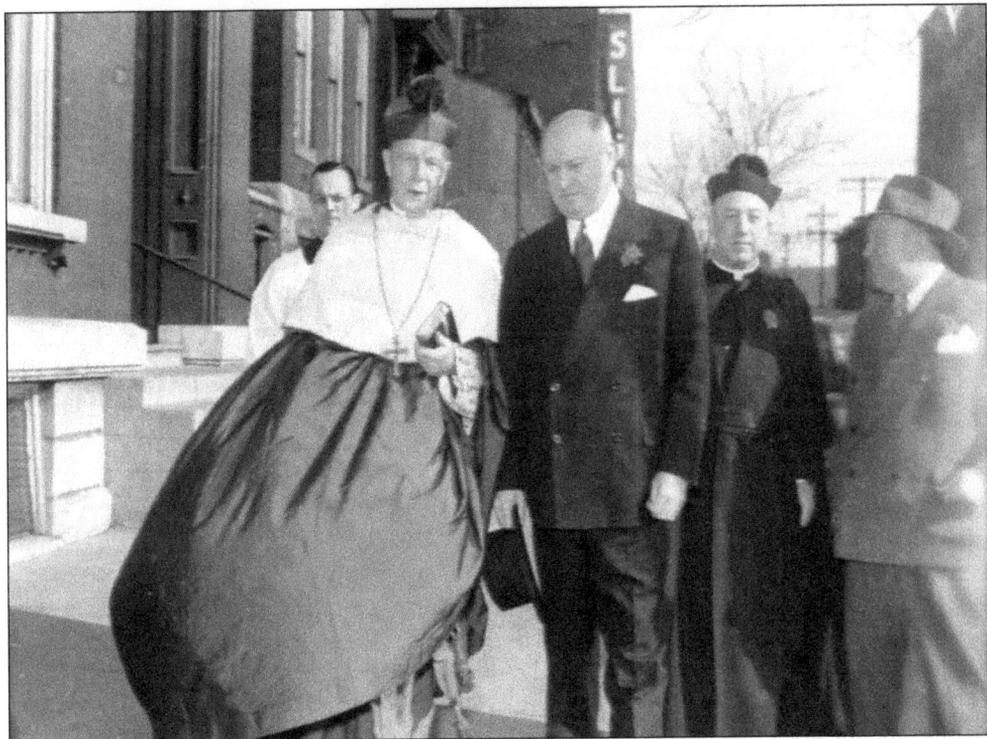

Pictured on St. Patrick's Day 1945 are Father Thomas Butler, Archbishop Glennon, Jim Farley, and Msgr. Jim Johnston. (Courtesy of the Archdiocese of St. Louis Archives.)

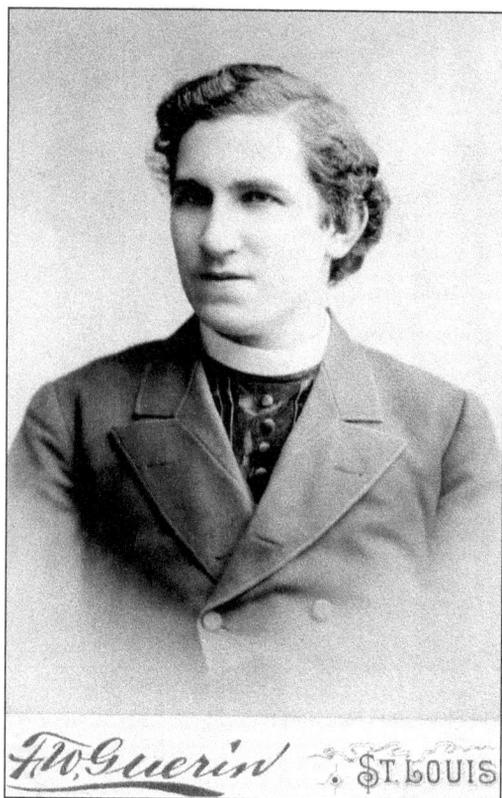

Arriving in St. Louis as a seminarian before the Civil War, Father Patrick Ryan was born in the town of Thurles in County Tipperay, Ireland. Ryan was a renowned orator. (Courtesy of the Archdiocese of St. Louis Archives.)

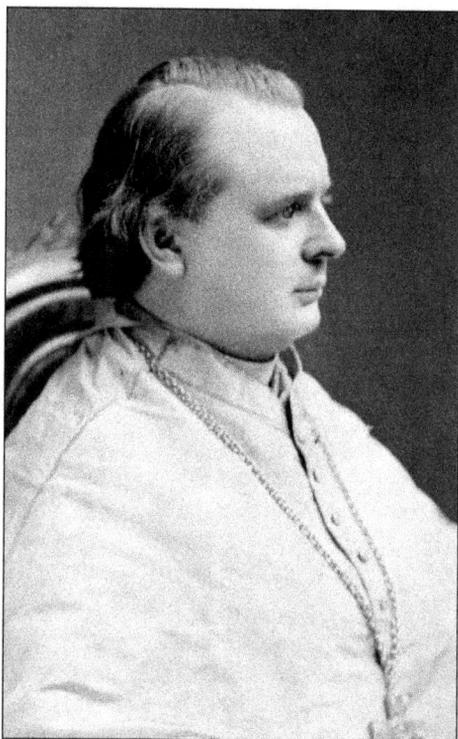

Rev. Patrick Ryan accompanied Archbishop Kenrick to Dublin in 1866. He was pastor at Annunciation parish prior to taking the same position in St. John's parish in 1868. He was consecrated Bishop in St. Louis in 1872. He left St. Louis in 1884 when Pope Leo XIII named him Archbishop of Philadelphia. (Courtesy of Saint Louis University, Pius XII Memorial Library, Archives.)

Born in America on June 13, 1803, Father George Carrell was the first President of Saint Louis University that was of Irish ancestry. He held the office of President from 1843 through 1847. (Courtesy of Saint Louis University, Pius XII Memorial Library, Archives.)

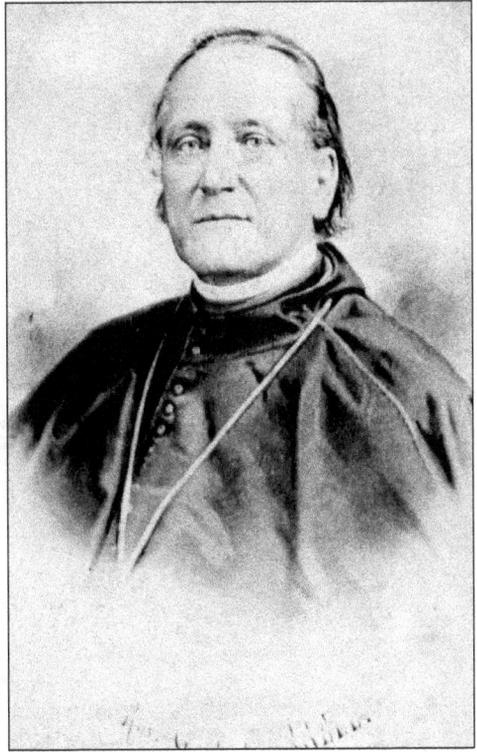

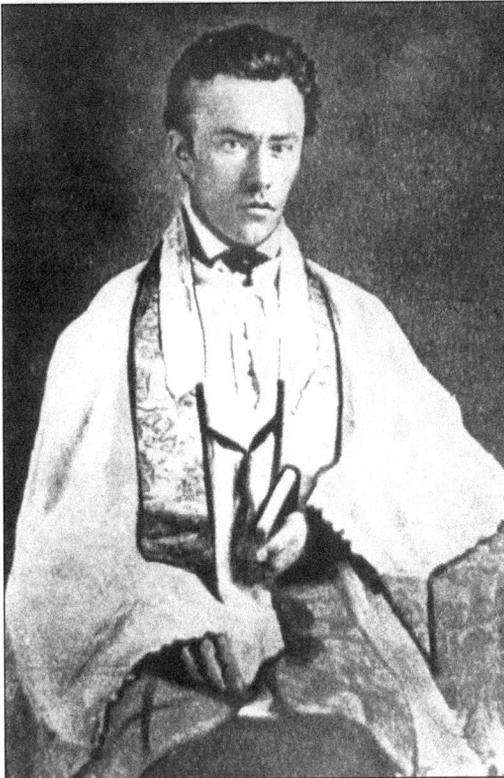

The Jesuit pastor of St. Francis Xavier Church, Fr. Arnold Damen (1815–1890) (with the help of Archbishop Kenrick), recruited a group of Sisters of Mercy (founded in Ireland) to come to St. Louis in 1856 to administer to the sick and poor. (Courtesy of Saint Louis University, Pius XII Memorial Library, Archives.)

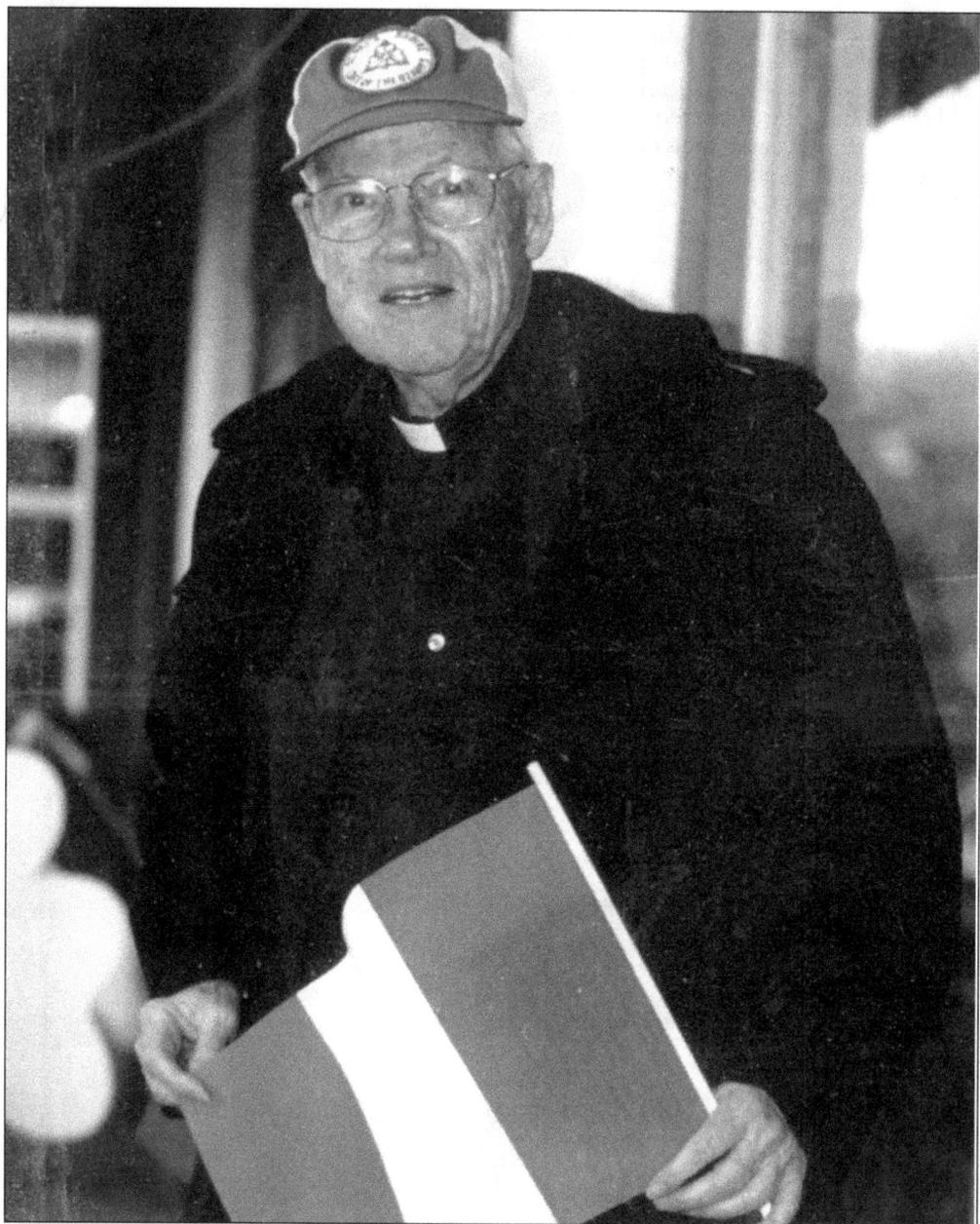

The ultimate St. Louis Irishman, Father William Barnaby Faherty, S.J., dons his Irish cap and waves his Irish flag at a recent St. Patrick's Day celebration. Father Faherty is best summed up in an article written for the *St. Louis Journal* (April 7, 1982) by Joan Elliott: "Jesuit Priest . . . Historian . . . Scientist . . . Author. For over 50 years Father William Barnaby Faherty of St. Louis has worn all these hats . . . and worn them well. He has involved himself with such social issues as women's rights, Indian affairs, space exploration as well as man's relationship with God, his neighbors and himself. The product of a quiet yet sensitive Irish Catholic father; and an outgoing, fun-loving German-French mother, Father Faherty assimilated qualities of both." Father Faherty's *The St. Louis Irish—An Unmatched Celtic Community*, published in 2001, is the definitive account of Irish immigration and influence in St. Louis. (Photo courtesy of Faherty family collection.)

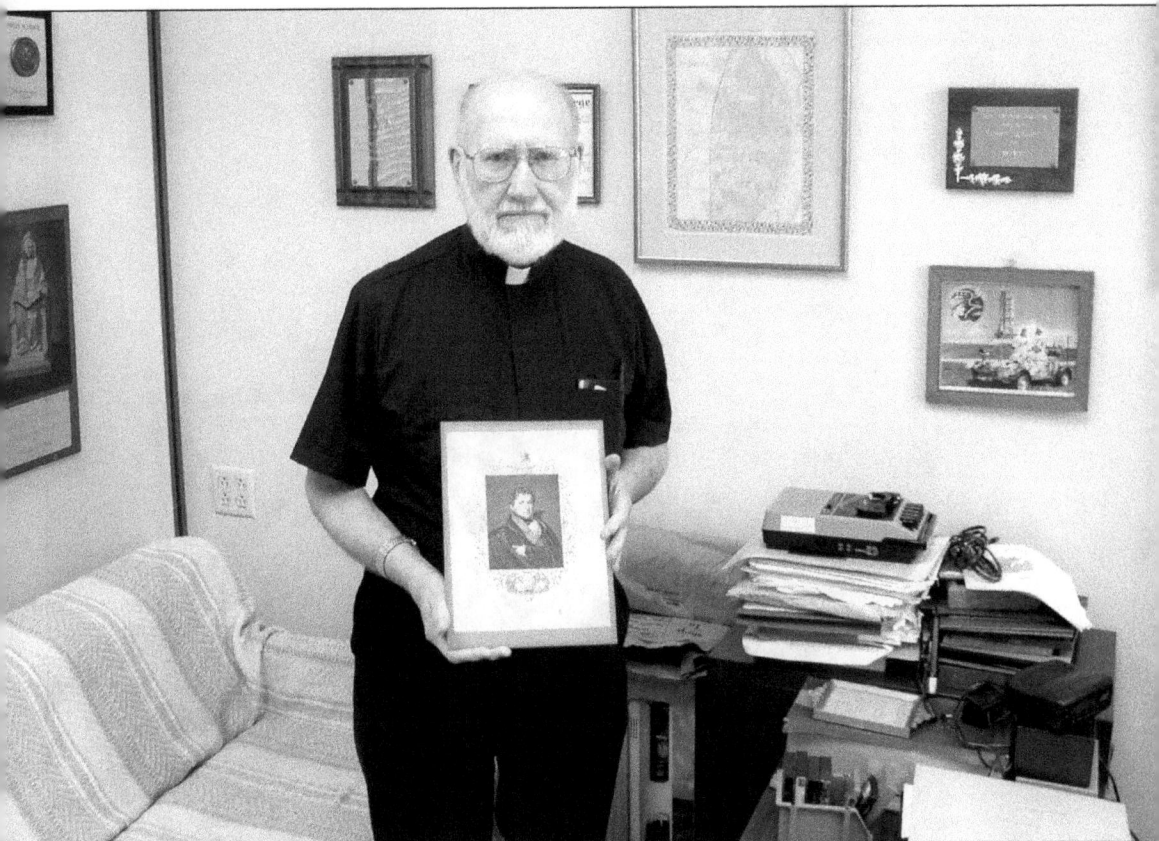

Here Fr. Daniel C. O'Connell, S.J. is seen communing with an image of the "original and famous" Daniel C. O'Connell. He, of course, is the Great Emancipator of Ireland, having succeeded in getting the British to alter the laws that had subjugated the Irish Catholics for centuries. This was exactly a century before the good father was born in 1928. When Fr. O'Connell's father died in 1932, the family moved to Texas for two years and then returned to St. Louis. So young Dan grew up in St. Louis from the ripe old age of six. He attended St. Rose of Lima and, after sixth grade, St. Mark's Grade School, and then went on, as had his brother John before him, to St. Louis University High School. He joined the Missouri Province of the Society of Jesus at St. Stanislaus Seminary, in Florissant. After novitiate he moved on to the main campus of St. Louis University for a master's degree in psychology. He was ordained in June of 1958. After a brief time in Austria, Fr. O'Connell received his doctorate in experimental psychology at the University of Illinois (Champaign-Urbana) followed by two years of post-doctoral studies at Harvard University. Following a two year Humboldt Foundation Fellowship in the late 1960s, Fr. O'Connell "jumped out of the fire" (Rector of the Jesuit Community at St. Louis University) and "into the fire" (President of St. Louis University). As Fr. O'Connell would say, the next four years were difficult. But these became the years of maximum commitment to St. Louis and St. Louis University. He joined the Ancient Order of Hibernians and helped to lead the St. Patrick's Day parade, cried sentimental tears at the Irish Dancers, and began to realize his Irish heritage to the full. In early 1978 Fr. O'Connell accepted a Professorship at the University of Kansas and then a Fulbright Lectureship to Kassel, Germany. The 1980s were spent at Loyola University of Chicago and the 1990s at Georgetown University, where he was also Chairman of the Psychology Department. In 2003, he finally retired and took up the role of research and writing at Jesuit headquarters in St. Louis. (Photo taken by Dave Lossos September 15, 2003.)

45

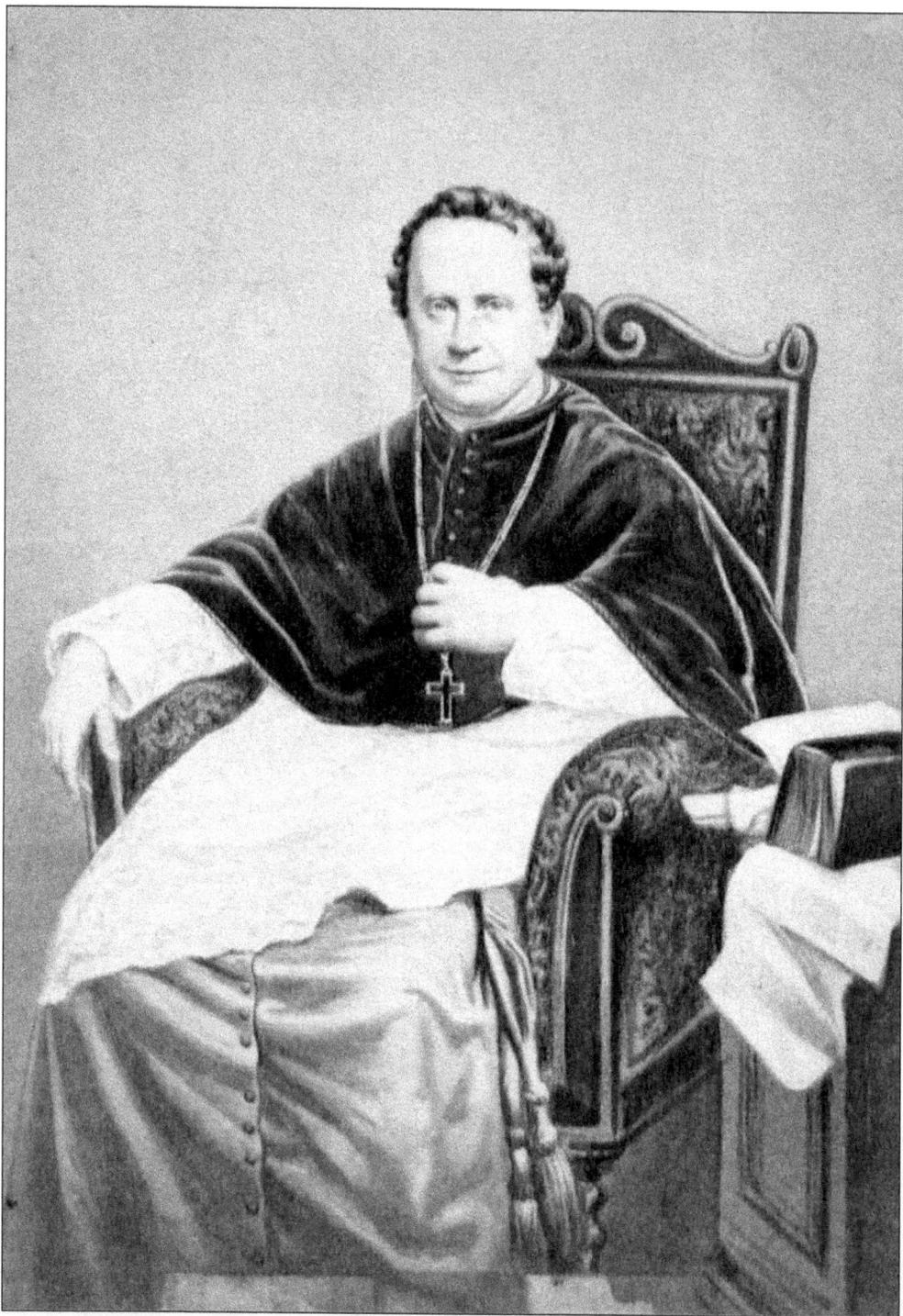

The Very Rev. Peter Richard Kenrick, for whom the St. Louis Seminary is named, was born in Ireland on August 17, 1806. Ordained in 1832, he was appointed Archbishop of Saint Louis, Missouri in 1847. Retiring in 1895, he died the following year. (Courtesy of Saint Louis University, Pius XII Memorial Library, Archives.)

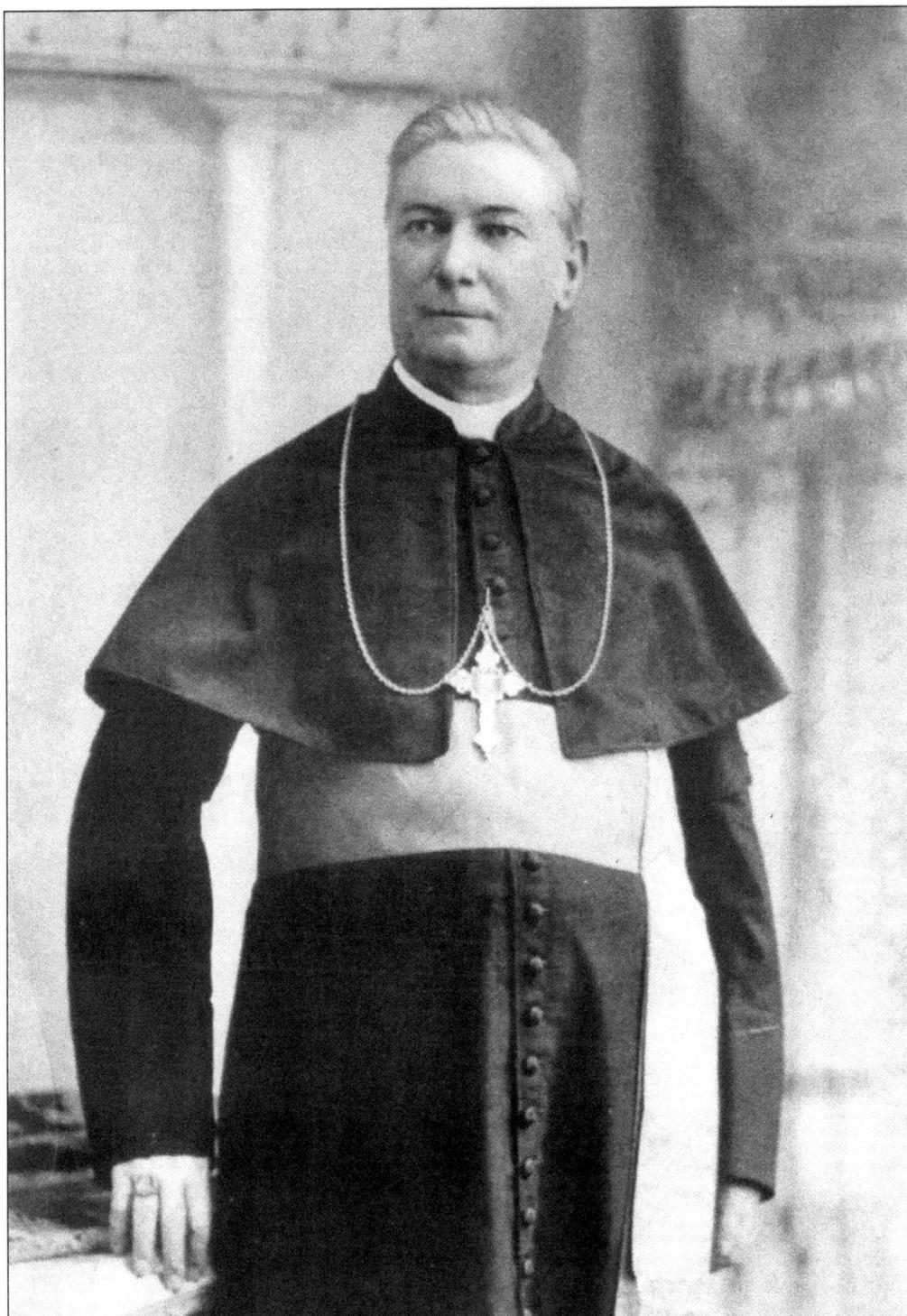

With popular Irish support, and against Archbishop Kenrick's recommendation, Very Rev. John J. Kain was appointed Archbishop in 1893. (Courtesy of Saint Louis University, Pius XII Memorial Library, Archives.)

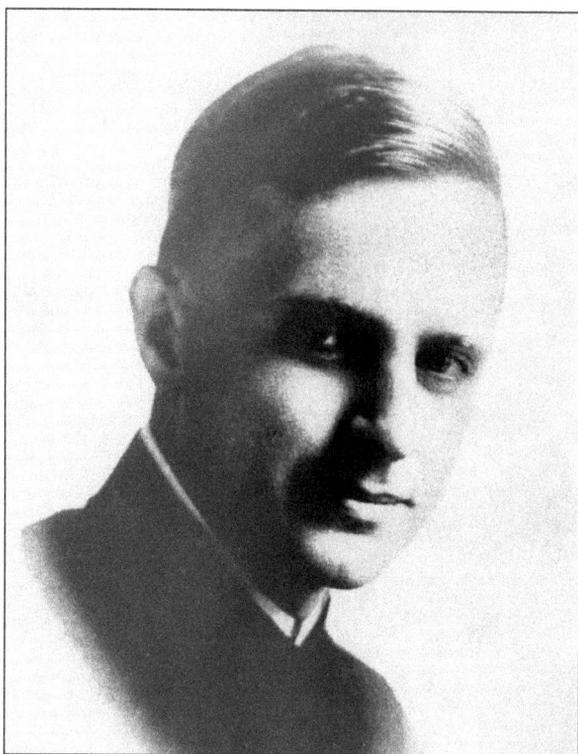

Daniel A. Lord, S.J. was a prolific writer whose work reflected and responded to changing social and moral issues. Born in Chicago April 23, 1888, Lord graduated from Loyola University in 1909 and immediately entered the Society of Jesus at St. Stanislaus Seminary in Florissant, Missouri. After having obtained his M.A. in philosophy from St. Louis University, he taught English there from 1917–1920. He was ordained in 1923. (Courtesy of Saint Louis University, Pius XII Memorial Library, Archives.)

Francis Finn attended St. Louis University and the Jesuit Seminary at Florissant. He is the author of numerous novels, including *Tom Playfair*, set in St. Louis. Francis was the son of a St. Louis Alderman. (Courtesy of Saint Louis University, Pius XII Memorial Library, Archives.)

Four

IRISH SPORTS

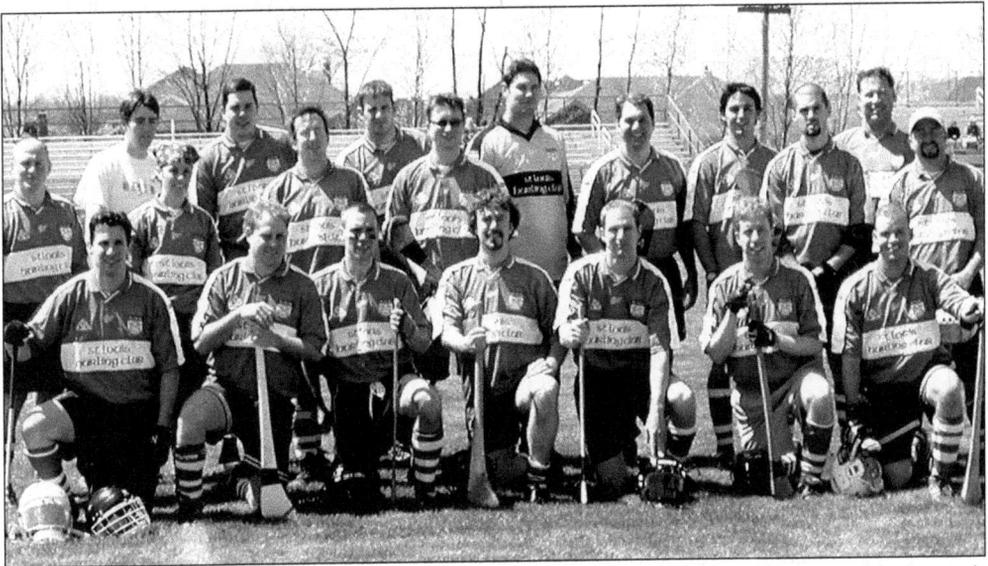

The St. Louis Hurling team in a photo taken April 26th, 2003 before their inaugural match against the University of Notre Dame. They went on to defeat Notre Dame by a score of 19-9. Pictured from left to right are: (front row) Dan Backman, Brendan Moore, Patrick O'Connor, David Rowntree, Brian Spencer, Mike Dolan, and Kevin Meredith; (back row) Chris Carter, Patrick Duffy, Anne Kinsella, Ryan Barry, Dan Lapke, Ryan Kelly, Dave Raczkowski, Patrick Brown, Paul Rohde, Mike Hill, Pete Gilchrist, Liam Coonan, and Jim Schaft. (Photo courtesy of Paul C. Rohde.)

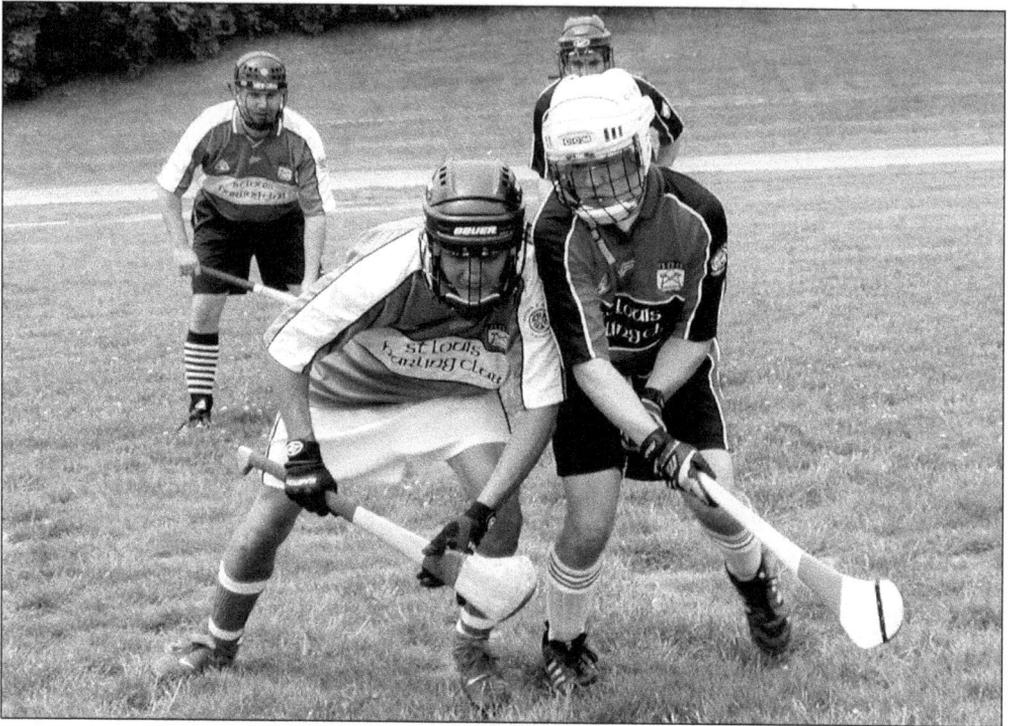

The St. Louis Hurling Club in action. In the foreground are Mike Hill and Kevin Meredith, and in the background are Paul Rohde and Pete Gilchrist. (Photo courtesy of Paul C. Rohde.)

ARD-CHONSALACHT NA HÉIREANN
TELEPHONE (312) 337.1868
FAX (312) 337.1954
E-Mail Irishconsulate@sbcglobal.net

CONSULATE GENERAL OF IRELAND
400 NORTH MICHIGAN AVENUE
CHICAGO, ILLINOIS 60611

It is my great pleasure, on behalf of the Government and People of Ireland, to send warm greetings and congratulations to the St. Louis Hurling Club.

Ireland recognises the efforts of the St. Louis Hurling Club in bringing the ancient sport of hurling to St. Louis, and in bringing St. Louis hurlers to the North American Gaelic Athletic Association. In devoting such time and effort to the organisation of the club, and the promotion of hurling, the members of the St. Louis Hurling Club do this ancient and honourable sport a great service.

I have no doubt that the St. Louis Hurling Club will continue to prosper and grow in the coming years. It is my great honour to salute the members of the St. Louis Hurling Club and to wish them every success in the North American Gaelic Athletics Association.

Le gach dea-ghuí

Charles Sheehan
Consul General

September 2003

The St. Louis Hurling Club received official recognition in September 2003 from the Consul General of Ireland. Part of the letter reads: "Ireland recognizes the efforts of the St. Louis Hurling Club in bringing the ancient sport of hurling to St. Louis, and in bringing St. Louis hurlers to the North American Gaelic Athletic Association. In devoting such time and effort to the organization of the club, and the promotion of hurling, the members of the St. Louis Hurling Club do this ancient and honourable sport a great service." (Copy of letter courtesy of Paul C. Rohde.)

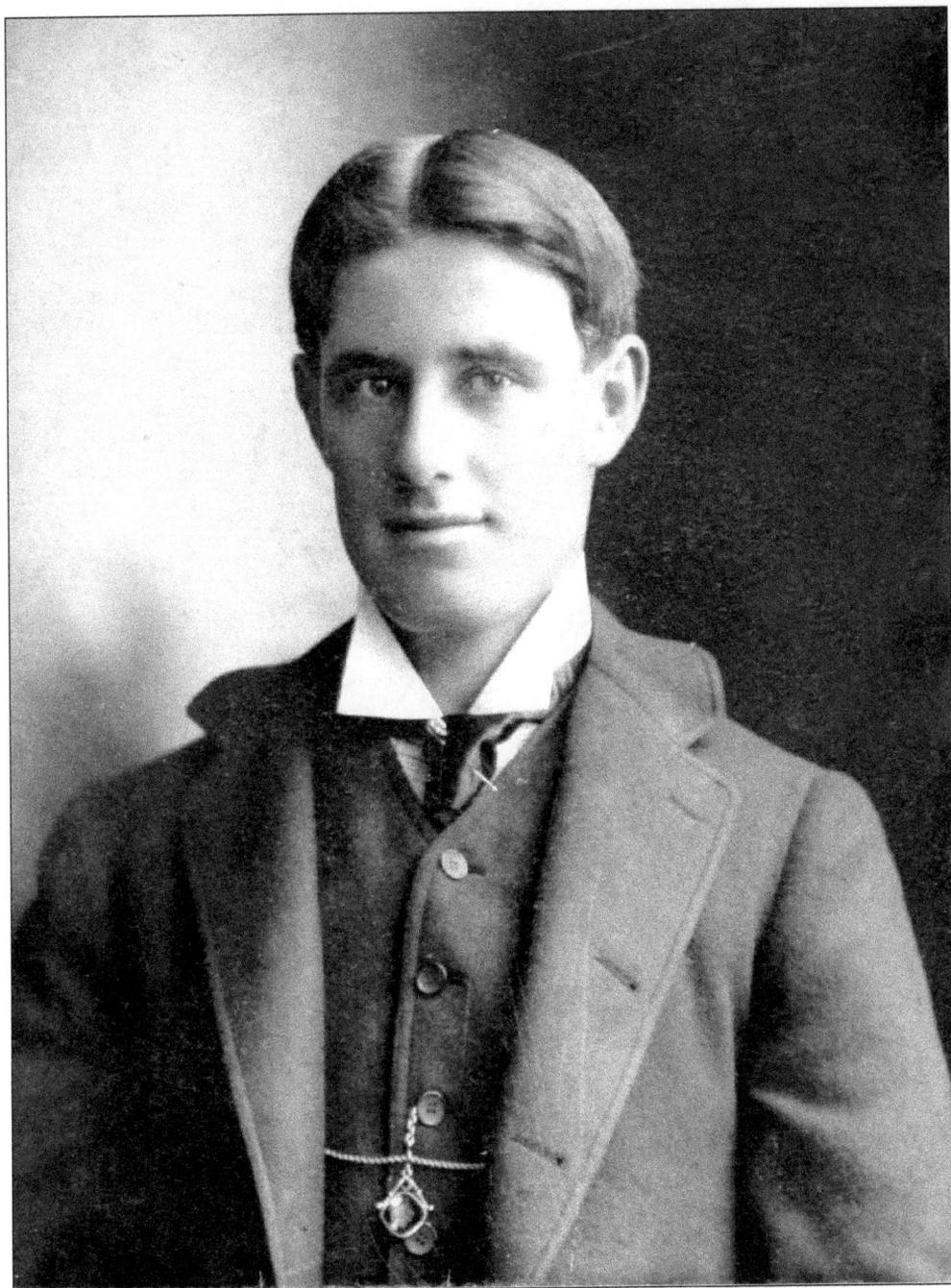

Billy Kane, one time great baseball and football player, died at the age of 65 in 1938. His solemn Mass at St. Leo's Church was celebrated by the Rev. M. J. Bresnahan, S.T.D., Rev. Thomas Hayes of St. Leo's, Rev. John H. Smith of the Visitation, Rev. Joseph Dwyer of St. Luke's, Rev. John J. Butler (pastor of St. Leo's), and the Rev. John N. McCormack, C. SS. R., of St. Joseph's College, Kirkwood. In the sermon by Rev. B.X. O'Reilly, Billy Kane was eulogized with the comment that many "remember the day when the name of Billy Kane stood for all that is high and clean in Catholic athletics." (Photo courtesy of Barry Kane.)

Pictured here c. 1905 are teammates McCormack and Kane, proudly proclaiming their Irish heritage in their athletic uniforms. (Photo courtesy of Barry Kane.)

Nothing in recent sports history captured the imagination of St. Louis and the nation as did the home run race in 1998. Not only was the long-time Roger Maris record passed, but the friendly competition between Sammy Sosa and Mark McGwire kept everyone in suspense until the very end. (From Dave Lossos personal Topps baseball card collection.)

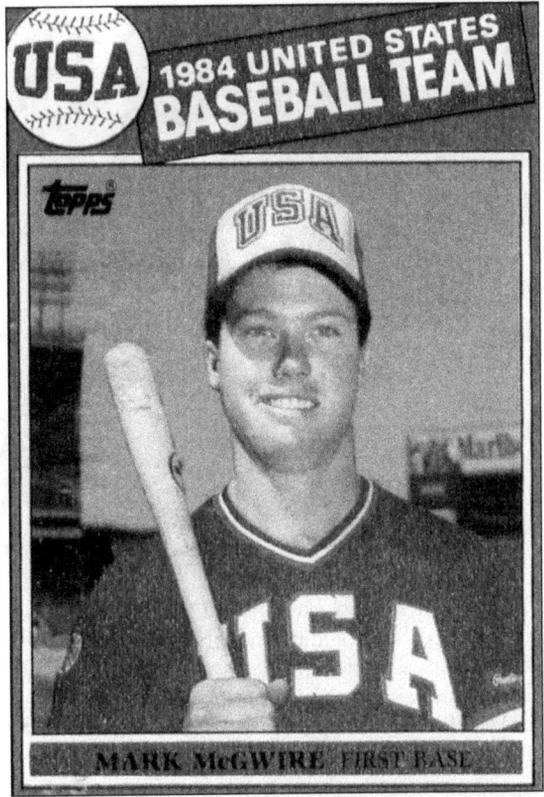

USA 1984 UNITED STATES BASEBALL TEAM

MARK McGWIRE FIRST BASE

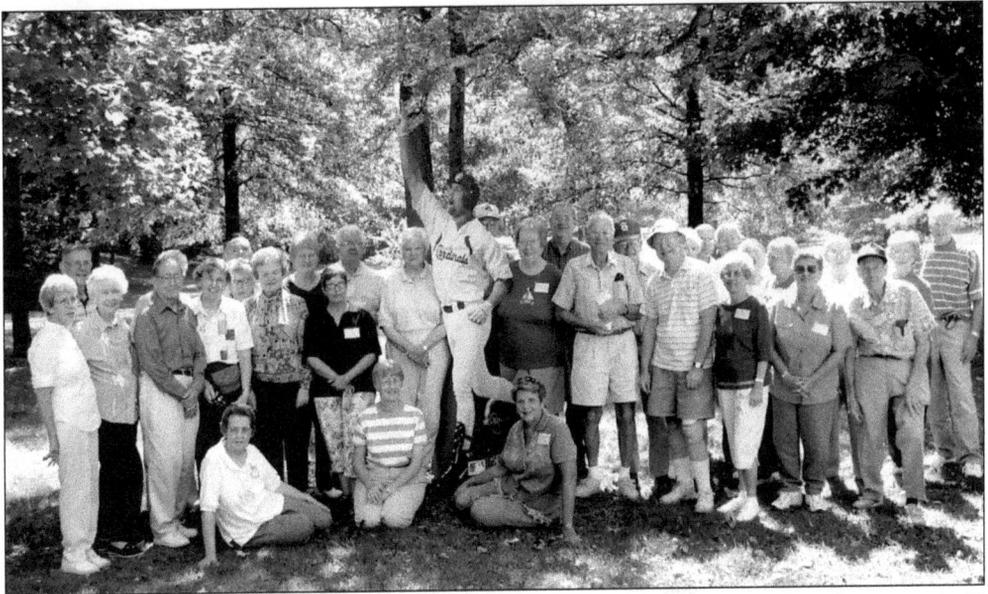

Gone but still not forgotten, this Mark McGwire poster attracted a crowd at the picnic held by the (St. Louis) South County Older Residents Computer Club on September 18, 2003 in Bohrer Park. All those pictured are either of Irish descent or enjoy having their pictures taken. (Photo by Dave Lossos.)

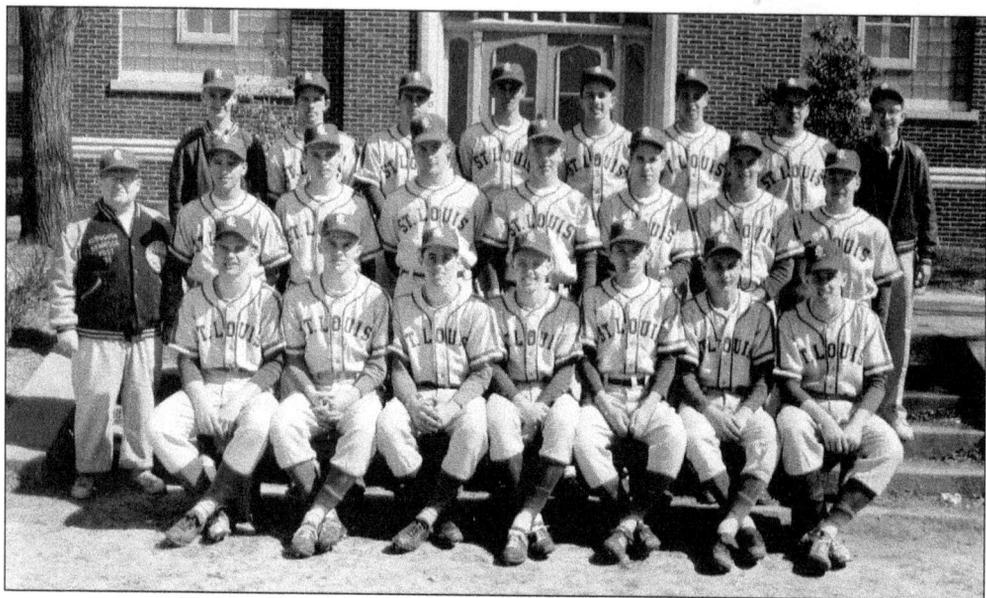

Dr. James Robinson (far left) might have been short in stature, but was long in talent and ability in both academics and sports. A long-time history teacher at St. Louis University High School, he also coached this baseball team to a third-place finish in the Missouri State Baseball championships. As an historian, Dr. Robinson's treatise on the origins of soccer in St. Louis credits his Irish heritage (in the Christian Brothers order specifically) as a major factor in making soccer an integral part of the St. Louis Irish-American community. (Photo from Dave Lossos.)

Tom Stanton was a star athlete in three sports at St. Louis University who went on to play for the Boston Red Sox before becoming a successful coach at St. Louis University High School and Beaumont High School. (Courtesy of Saint Louis University, Pius XII Memorial Library, Archives.)

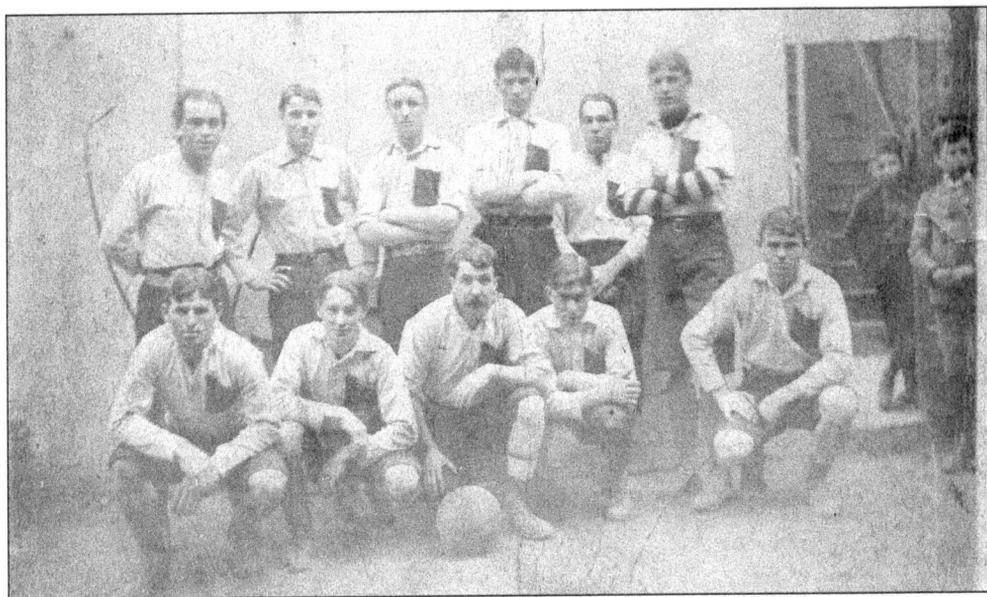

The St. Louis Shamrocks soccer team of 1908 was, from left to right: (top row) Jimmy Daly, John Comerford, Ben Govier, and Billy Kane; (bottom row) the brothers McDonough are on the ends and Dick Jarrett in the center. (Photo courtesy of Barry Kane.)

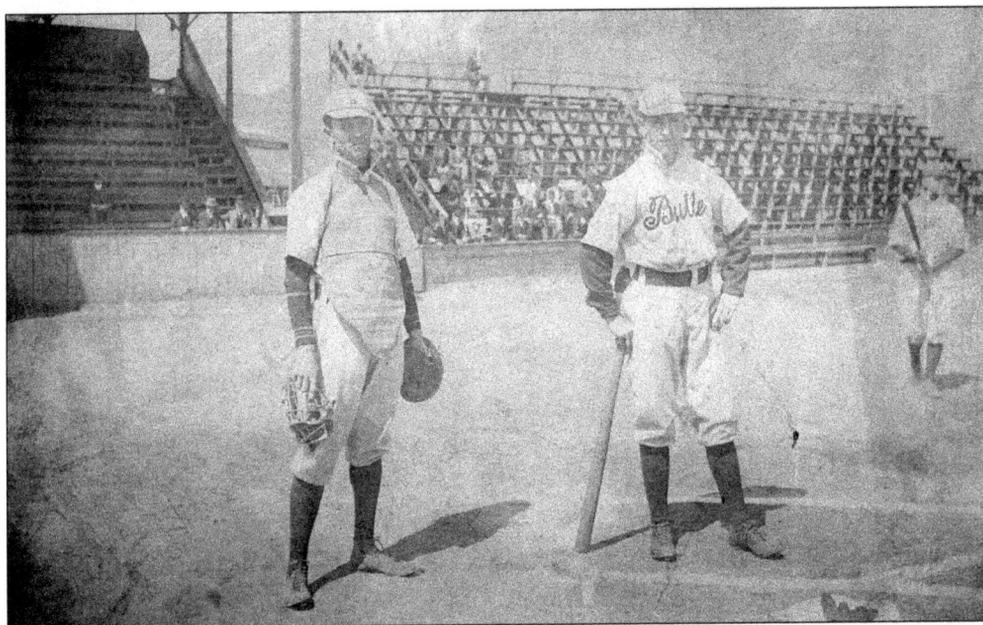

The St. Louis newspaper of September 19, 1938, recorded the death of W. J. Kane: "William J. (Billy Kane), old time St. Louis professional soccer and baseball player died yesterday. He resided at 2515 Mullanphy Street. He played shortstop on the old George Diehls and Ben Miller semi-professional baseball teams in the Trolley League, and was a member of the Shamrock soccer team in 1908 and 1909 and the old St. Leo's soccer team in 1910 and 1911." (Photo courtesy of Barry Kane.)

One of many soccer greats that played on NCAA Championship Saint Louis University soccer teams, Pat Leahy was named Most Outstanding Player in 1969. Leahy went on to a long career as the kicker for the New York Jets NFL team. (Courtesy of Saint Louis University, Pius XII Memorial Library, Archives.)

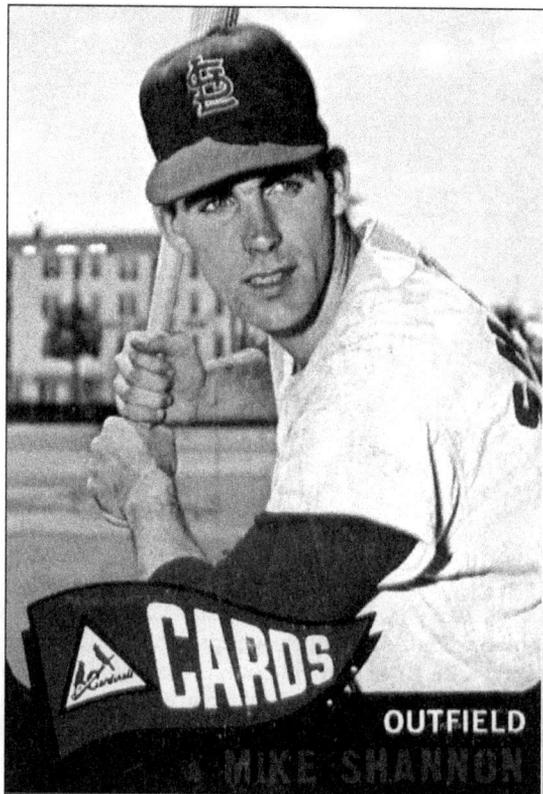

At the beginning of his career, St. Louis native Mike Shannon first endeared himself to St. Louis as a member of the 1964 World Champion St. Louis Cardinals. When his playing days were over Mike moved to the broadcast booth, and continues to delight Cardinals fans with his uniquely colorful commentary. (From Dave Lossos personal Topps baseball card collection.)

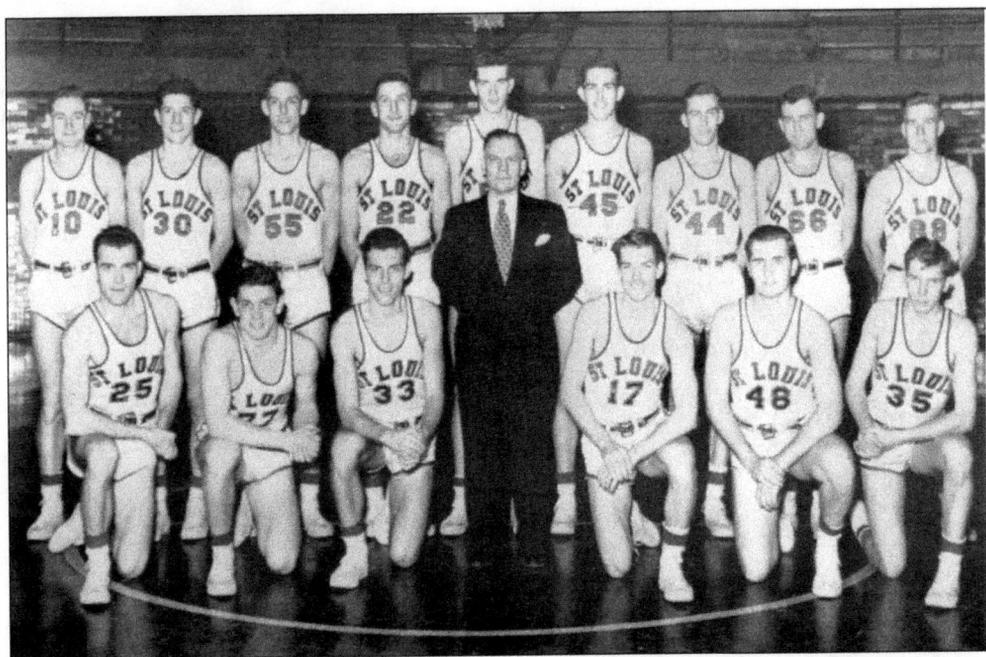

The 1947-48 Billikens of Saint Louis University were led by legendary coach Eddie Hickey, who was in his very first season. Ed Macauley was named first team All-American, and led Saint Louis University to the national basketball championship.

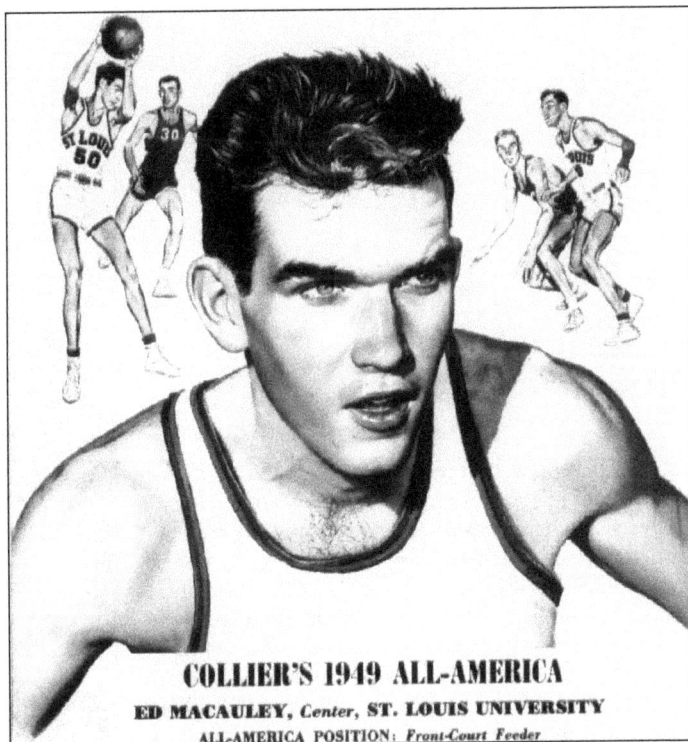

"Easy Ed" Macauley later went on to play professionally for the Boston Celtics and St. Louis Hawks. (Courtesy of Saint Louis University, Pius XII Memorial Library, Archives.)

COLLIER'S 1949 ALL-AMERICA

ED MACAULEY, *Center*, ST. LOUIS UNIVERSITY

ALL-AMERICA POSITION: *Front-Court Feeder*

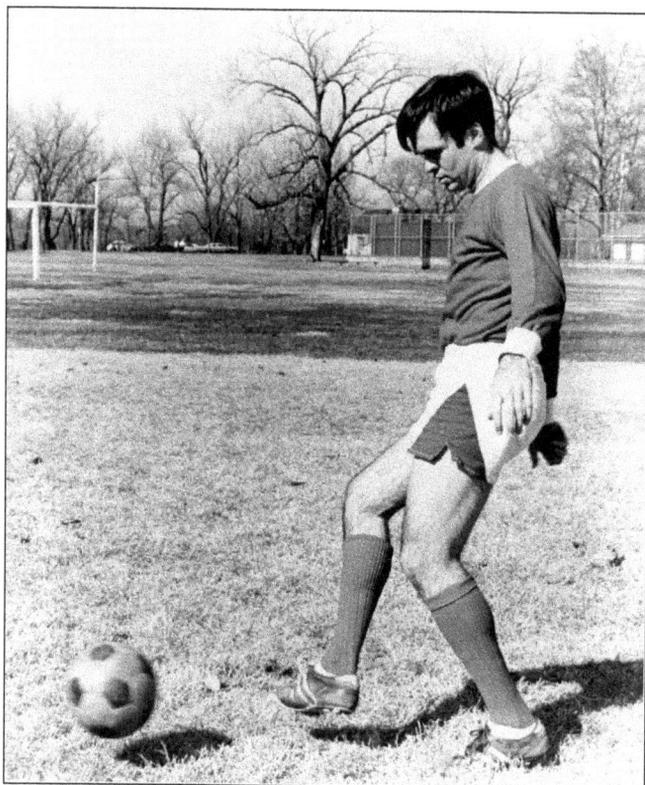

This photo shows a young Pat McBride early in his soccer career. (Photo courtesy of Pat McBride.)

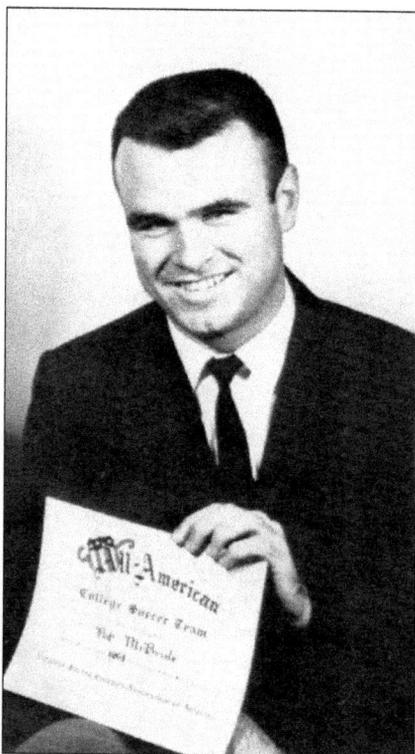

Pat McBride played three times for the U.S. Olympic soccer team in 1964. A graduate of St. Louis University, where he won All-American honors, he turned professional in 1967. He played ten seasons in the NPSL-NASL, all with the St. Louis Stars, and was selected to the World Cup team in 1968 and 1974. When his playing days were over, he coached the St. Louis Steamers in the Major Indoor Soccer League. (Courtesy of Saint Louis University, Pius XII Memorial Library, Archives.)

Five

IRISH NEIGHBORHOODS, CHURCHES, AND SCHOOLS

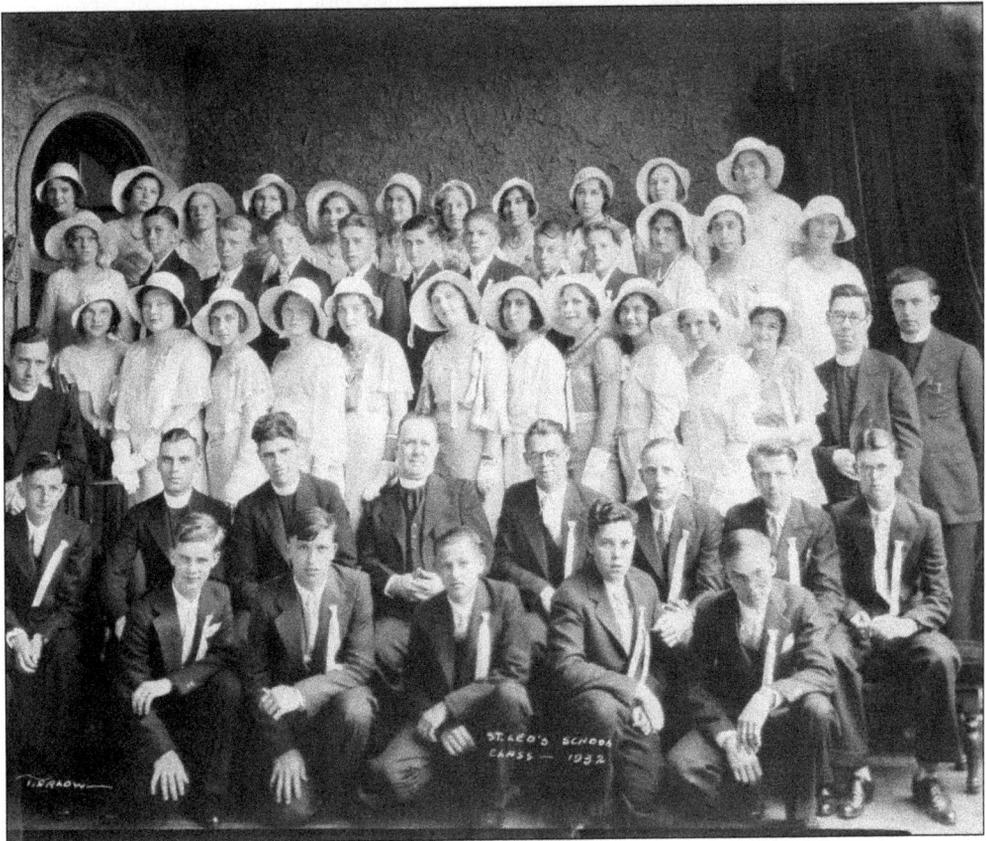

The St. Leo School Class of 1932. (Courtesy of the Archdiocese of St. Louis Archives.)

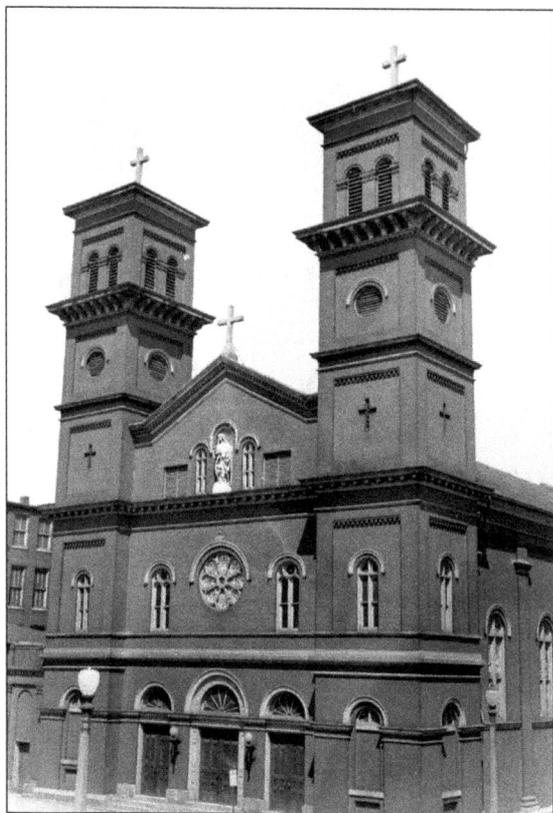

St. John the Apostle and Evangelist Parish, was the eighth Catholic parish in the city, predominately Irish. The church was affiliated with the Archbasilica of St. John Lateran in Rome and could thus hold ordination and consecration services. It was founded by Father Patrick O'Brien (1847–1858), with Rev. Raemon the first pastor, followed by John Bannon (1858–1861), and Patrick J. Ring (1861–1868). From 1868 to 1880 it was the residence of Rt. Rev. P. J. Ryan, bishop of the diocese, and assisted by Rev. E. J. Shea, Rev. W. H. Brantner, and Rev. M. Gleason. Other early pastors included John Hennesey (1880–1889), Philip Brady (1889–1893), and James T. Coffey (1893–1903). By 1930 all family members of the church had moved out. The plaza in front of the church is scheduled to be the site of the Celtic Cross Monument, a project spearheaded by Joe McGlynn, founder of the St. Patrick's Day Parades in St. Louis. (Courtesy of the Archdiocese of St. Louis Archives.)

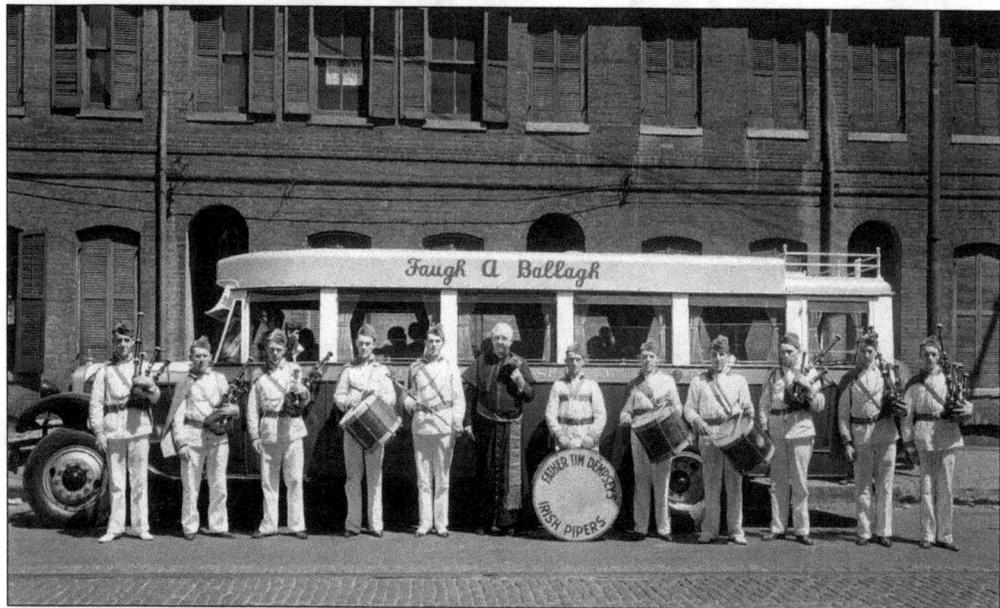

Shown on the cover, this is Father Tim Dempsey with the special bus, "Faugh a Ballagh," used to transport the Irish Pipers from St. Patrick's to various celebrations around town. "Faugh a Ballagh" means "clear the way." The photograph was taken in front of St. Patrick's Church rectory in the early 1930s. (Courtesy of the Archdiocese of St. Louis Archives.)

Visitation Church was organized in 1881 by Rev. Edward Fenlon, and located in the Grand Prairie neighborhood at Easton and Taylor Avenues. Originally it was predominated by Irish parishioners. The new church was dedicated in 1909. (Courtesy of the Archdiocese of St. Louis Archives.)

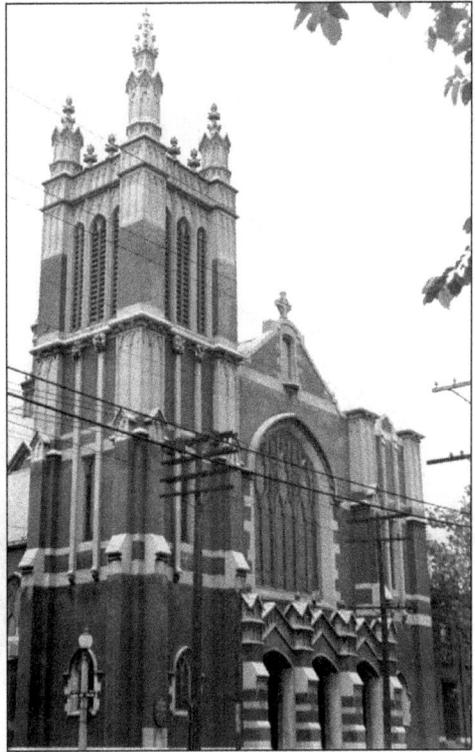

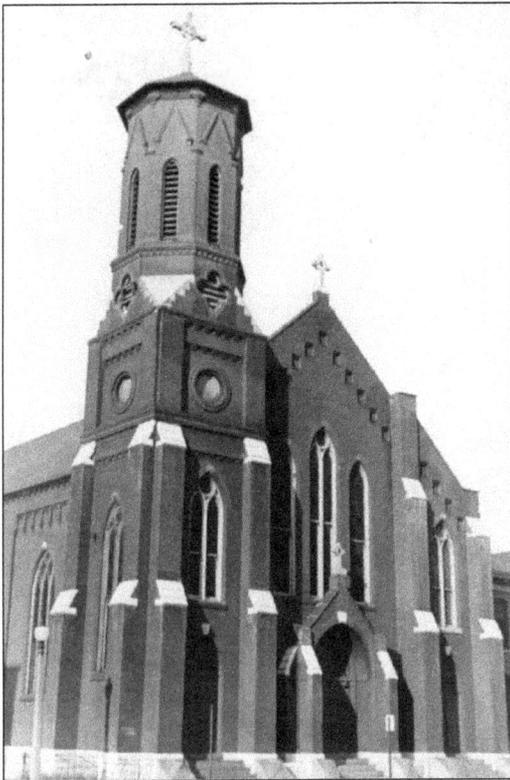

Father John O'Sullivan attended to the parish of St. Malachy Church from the St. Bridget Rectory until the new parish opened in 1859. Father Miles W. Tobyn succeeded him as pastor followed by Father Charles Ziegler (1868–1869). Rev. Thomas Manning was pastor until early 1870. Rev. Henry Kelly's service was from 1870 to 1878. Father Thomas Ambrose Butler took over at Father Kelly's death, and continued until 1884. The church is located at the SW corner of Clark and Ewing, and was razed during demolition for Mill Creek Valley. (Courtesy of the Archdiocese of St. Louis Archives.)

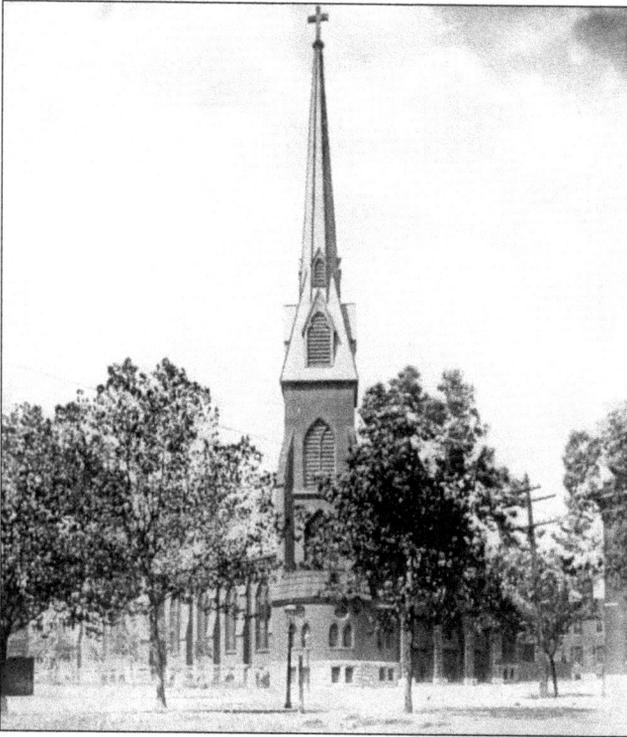

St. Leo's Church, c. 1888, is pictured here. When Rev. J. J. Harty was assistant at St. Bridget's he was commissioned to set up a new parish north of St. Bridget's. He selected the site above at 23rd and Mullanphy Street. (Courtesy of the Archdiocese of St. Louis Archives.)

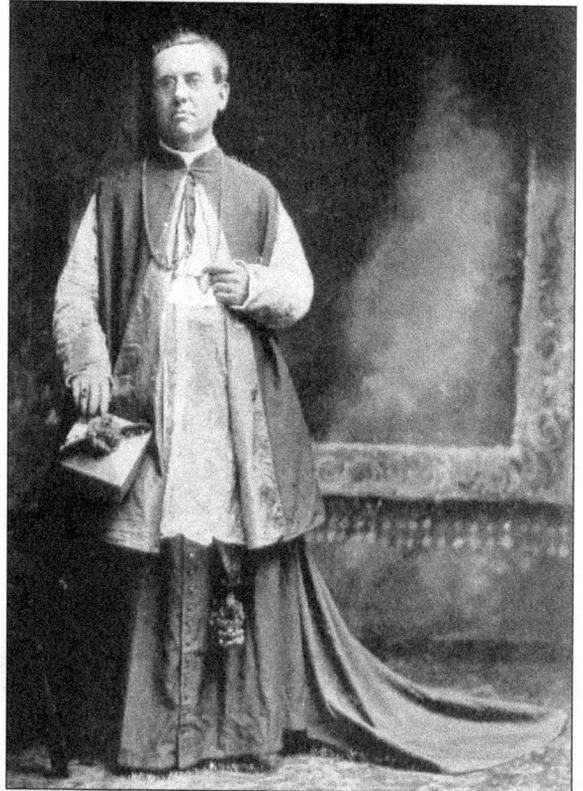

The Most Rev. J.J. Harty went on to become the Archbishop of Manila. (Courtesy of Saint Louis University, Pius XII Memorial Library, Archives.)

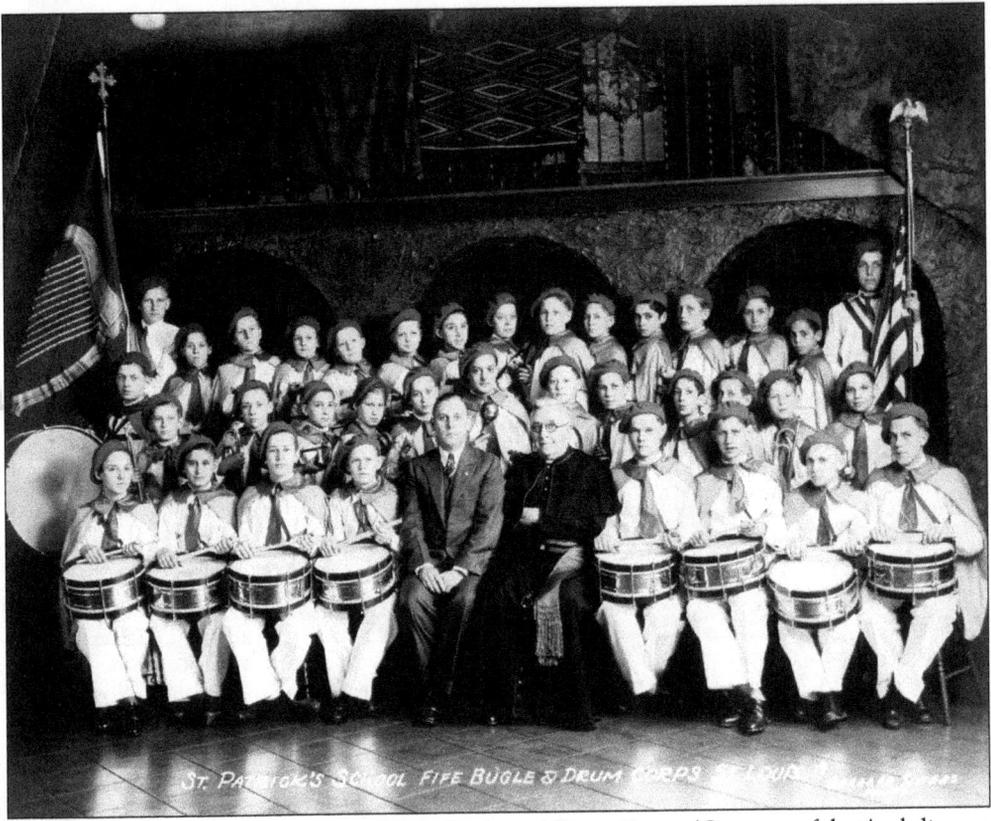

Father Dempsey's St. Patrick's School Fife, Bugle and Drum Corps. (Courtesy of the Archdiocese of St. Louis Archives.)

St. Leo's Parish Kindergarten class in 1903. (Courtesy of the Archdiocese of St. Louis Archives.)

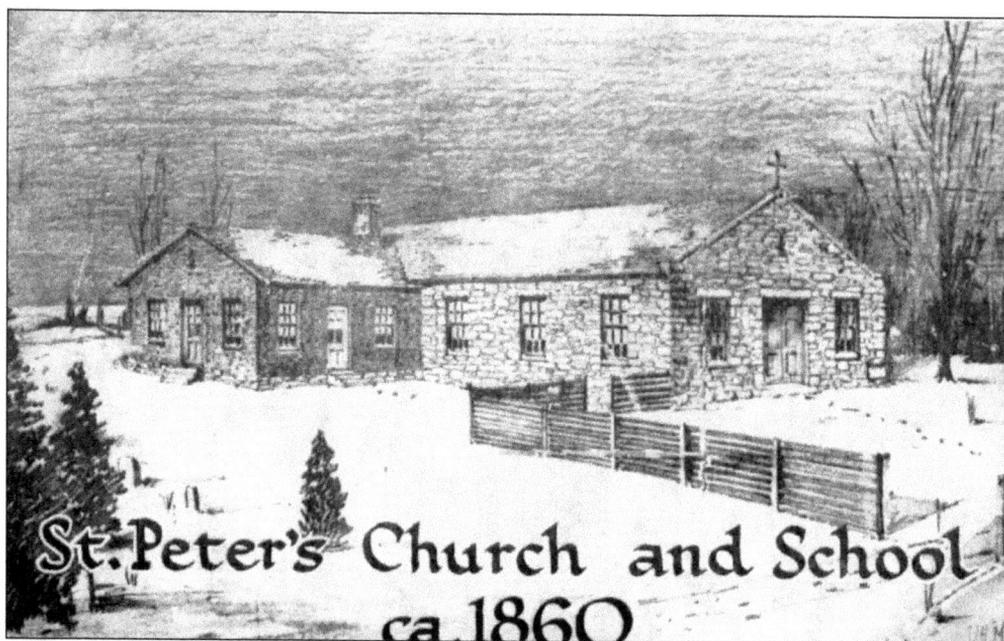

St. Peter Church was a center of Catholicism for both German and Irish St. Louis pioneers. In 1832 Father Charles Van Quickenborne, the head of the Jesuit St. Stanislaus Novitiate in Florissant, began missionary work in the area southwest of St. Louis. The area became known as Gravois Parish. In 1833 the Catholic families of Gravois Parish, including the Holmes, Collins, and Sappington families purchased 80 acres on Geyer Road for a church and cemetery, and they build a church and rectory of American-style, horizontal logs. They deeded St. Peter's Church to Bishop Rosati, who assigned a full-time priest there. In 1834 a stone church was built. (Courtesy of the Archdiocese of St. Louis Archives.)

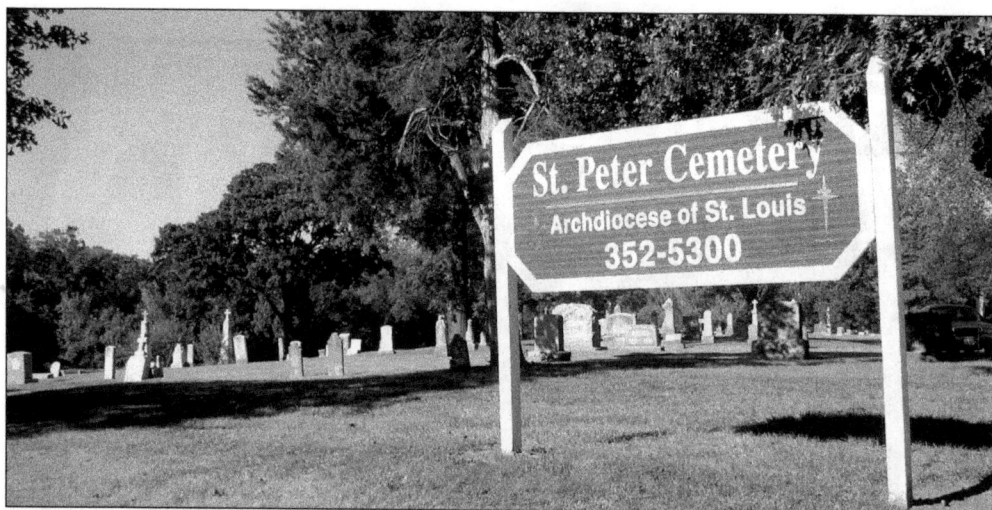

St. Peter's Cemetery in Kirkwood is the oldest Catholic cemetery in St. Louis County. The first recorded burial in the cemetery was that of Unity Breen, wife of Peter Breen, who died January 28, 1835, at the age of 28. In 1851 Archbishop Peter Kenrick sold five acres along the south of St. Peter's churchyard to the Missouri Pacific Railroad, and in 1853 trains began running between St. Louis and the subdivision of Kirkwood. (Photo by Dave Lossos.)

64

In 1865 the Town of Kirkwood incorporated, and in 1867 a new, brick St. Peter's church was built in the center of town at Main Street and Clay Avenue. The old stone church on Geyer Road was destroyed by fire in 1875, and the parish property there remains a cemetery. (Courtesy of the Archdiocese of St. Louis Archives.)

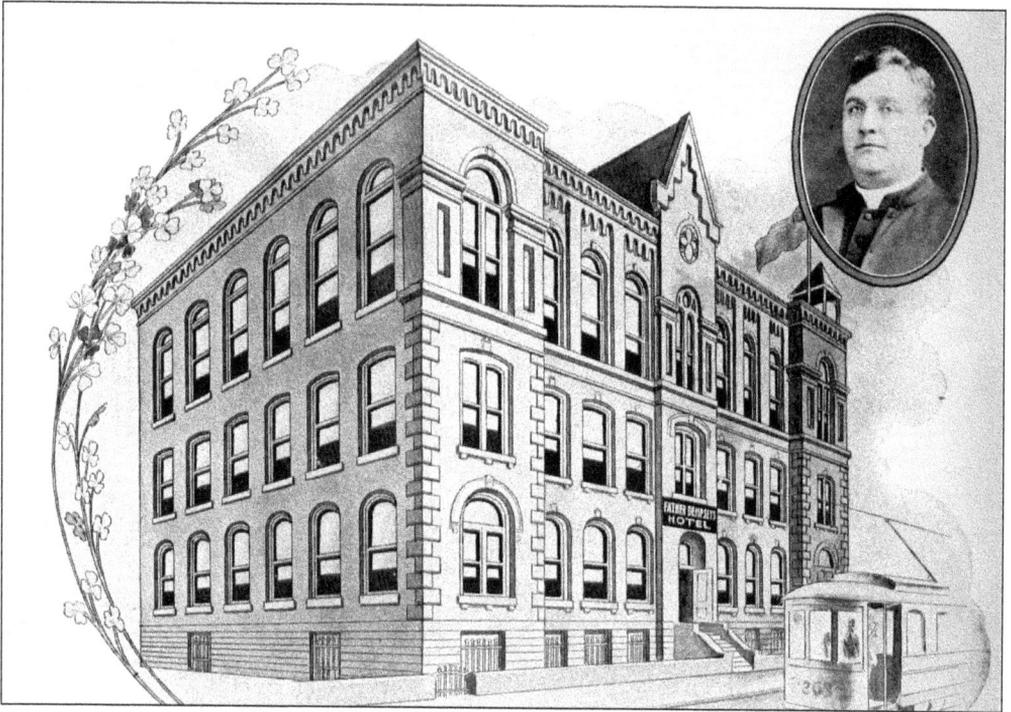

Two of Rev. Timothy Dempsey's endeavors are picture here. The St. Patrick's Hotel for Workingmen . . . (Courtesy of the Archdiocese of St. Louis Archives.)

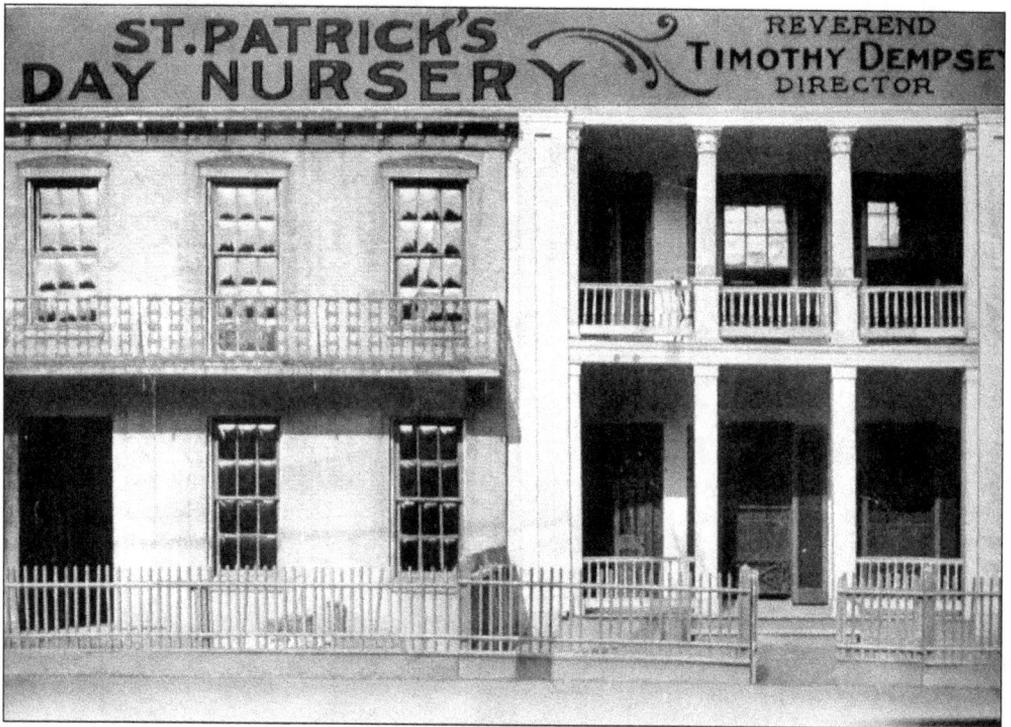

. . . and the St. Patrick's Day Nursery. (Courtesy of the Archdiocese of St. Louis Archives.)

Children of St. Peter's Parish School in 1899 are pictured here. Is the nun facing backward or did she have her face removed from the picture? (Courtesy of the Archdiocese of St. Louis Archives.)

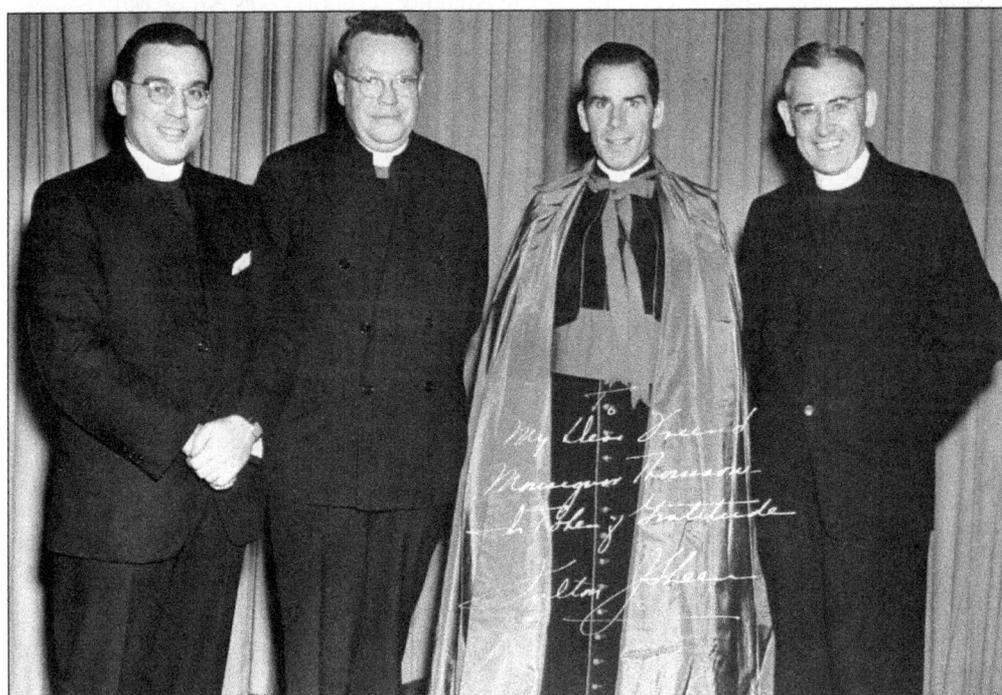

Pictured here are Father Halloran, S.J., Msgr. Thomson, Msgr Fulton J. Sheen, and Father Murphy, S.J. of St. John the Apostle and Evangelist Parish, St. Louis, Missouri. (Courtesy of the Archdiocese of St. Louis Archives.)

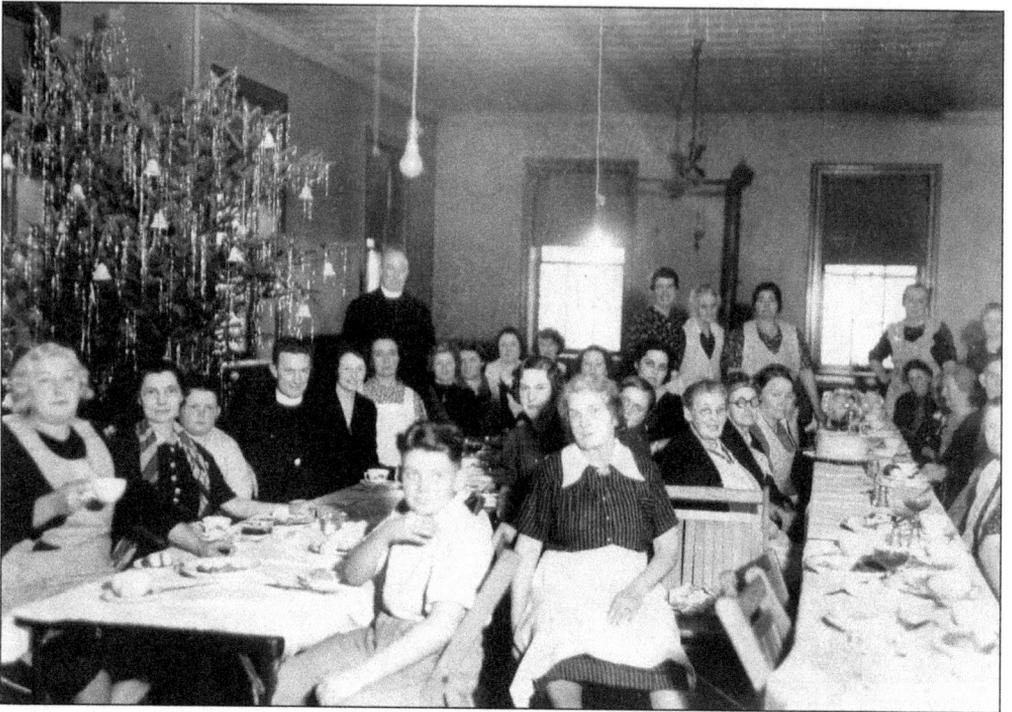

This photo of a festive Christmas Party at St. Patrick's Church shows Fr. James Hartnett seated and Fr. Jim Johnston standing. (Courtesy of the Archdiocese of St. Louis Archives.)

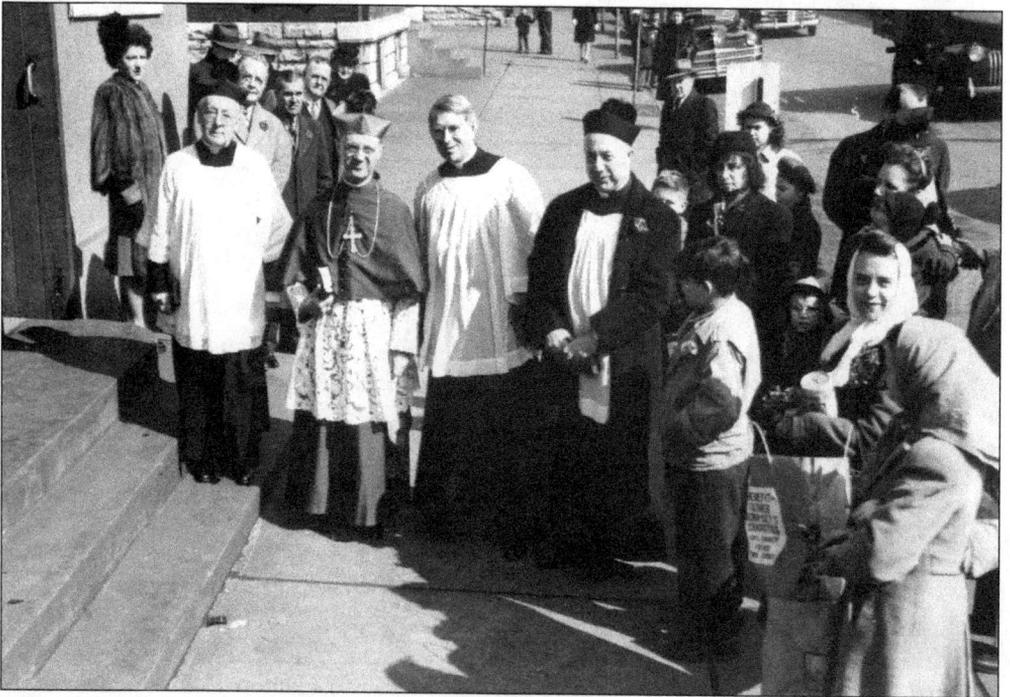

Father Thomas Butler, Cardinal Ritter, Jim Farley, and Msgr. Jim Johnston are seen here on St. Patrick's Day in 1945. (Courtesy of the Archdiocese of St. Louis Archives.)

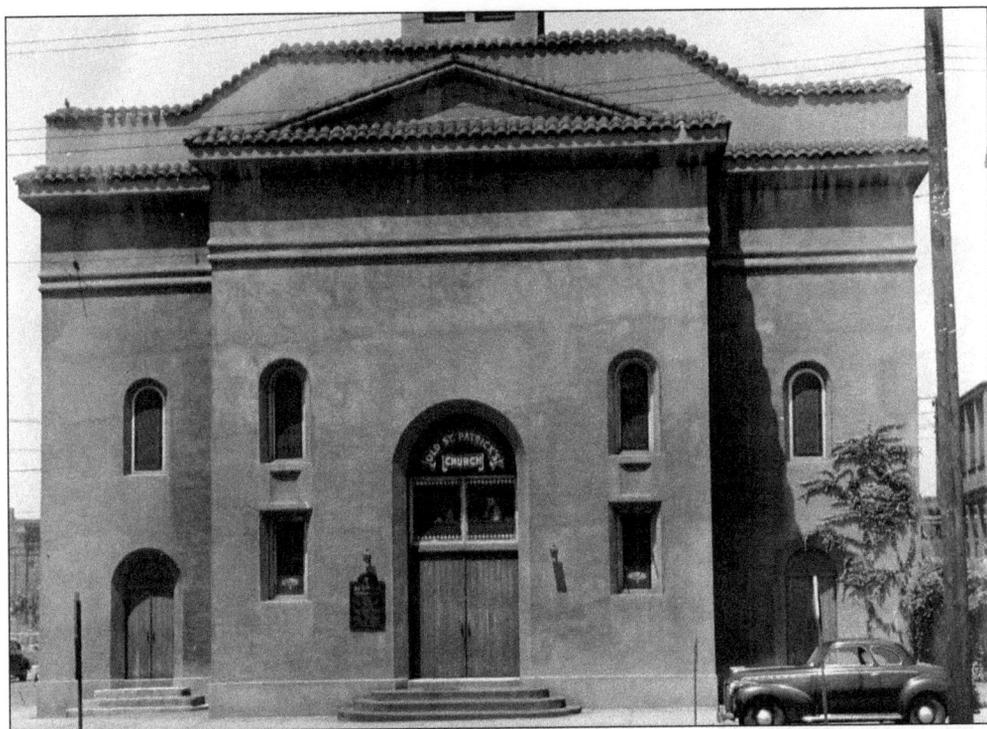

This photo of "Old" St. Patrick's Church was taken on St. Patrick's Day, March 17, 1950. (Courtesy of the Archdiocese of St. Louis Archives.)

Msgr. Jim Johnston, pastor of St. Patrick's Church, poses with a few parishioners on St. Patrick's day *c.* 1945. (Courtesy of the Archdiocese of St. Louis Archives.)

This is St. Patrick's Hotel for Working Women. (Courtesy of the Archdiocese of St. Louis Archives.)

What Father Dempsey's three splendid Institutions did during the year 1917 for sweet charity

WORKINGMEN'S HOTEL REPORT

Total Number of Lodgings Free and Paid	80,633
Average Number of Lodgings each night	221
Strangers entertained	4,858
Free Lodgings Furnished	2,009
Free Meals	7,682
Employment secured for	1,385
Sent to Hospital for Treatment free	25
Deaths	17
Interred in Exiles' Rest	5

WORKINGWOMEN'S HOTEL REPORT

Total Number of Guests entertained	8,891
Number of New Guests	32
Number of Meals Served	10,829
Meals furnished free	293
Employment secured for	42

Here you can see the remarkable statistics of the Father Dempsey charities in the year 1917. (Courtesy of the Archdiocese of St. Louis Archives.)

A St. Patrick's Day Mass at St. Patrick's church is pictured here. It's interesting to note that the mural above the alter was painted by Patrick Rogers, who immigrated with his wife and two children from Ireland. They settled in St. Bridget's Parish near Kerry Patch. (Photo courtesy of the Archdiocese of St. Louis Archives, comments from Patrick Rogers' great granddaughter Joan Hunter.)

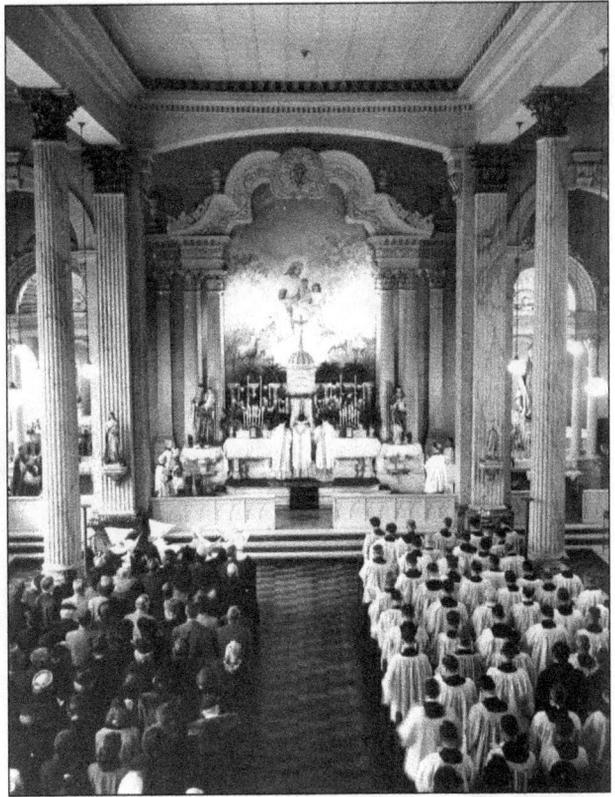

Msgr. Jim Johnston is pictured here with St. Patrick parish parishioners on a St. Patrick's Day in the 1940s. (Courtesy of the Archdiocese of St. Louis Archives.)

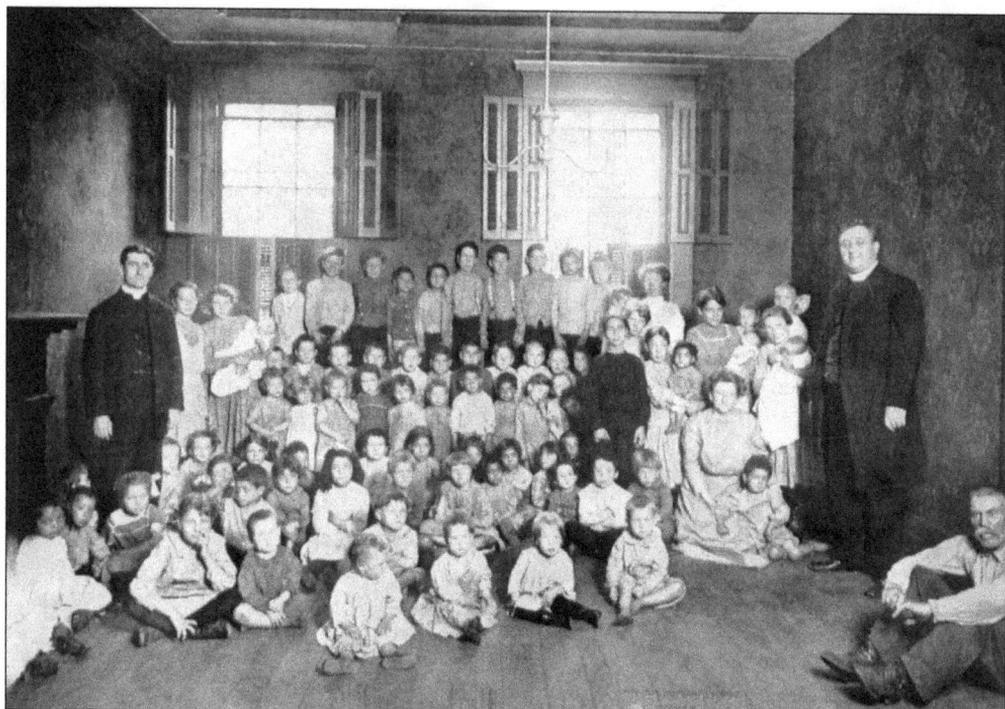

Father Tim Dempsey stands on the right with an unidentified group of children at St. Patrick's Day Nursery. (Courtesy of the Archdiocese of St. Louis Archives.)

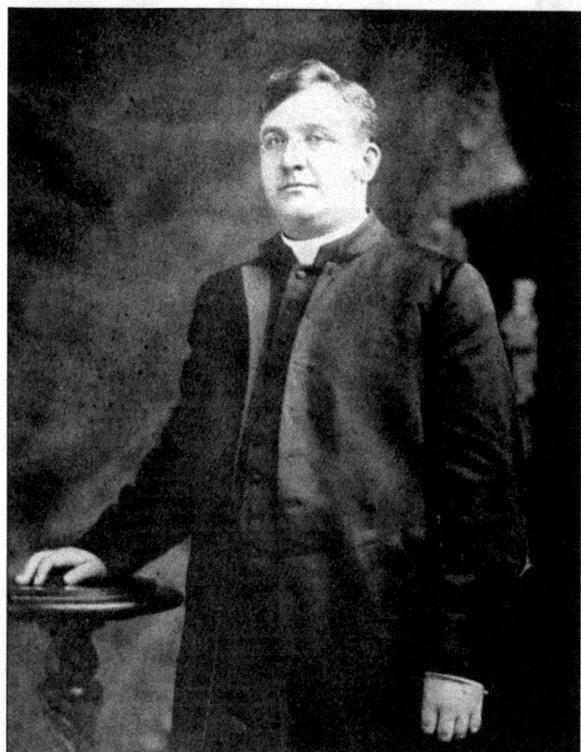

The Rev. Timothy Dempsey stands for a portrait. (Courtesy of the Archdiocese of St. Louis Archives.)

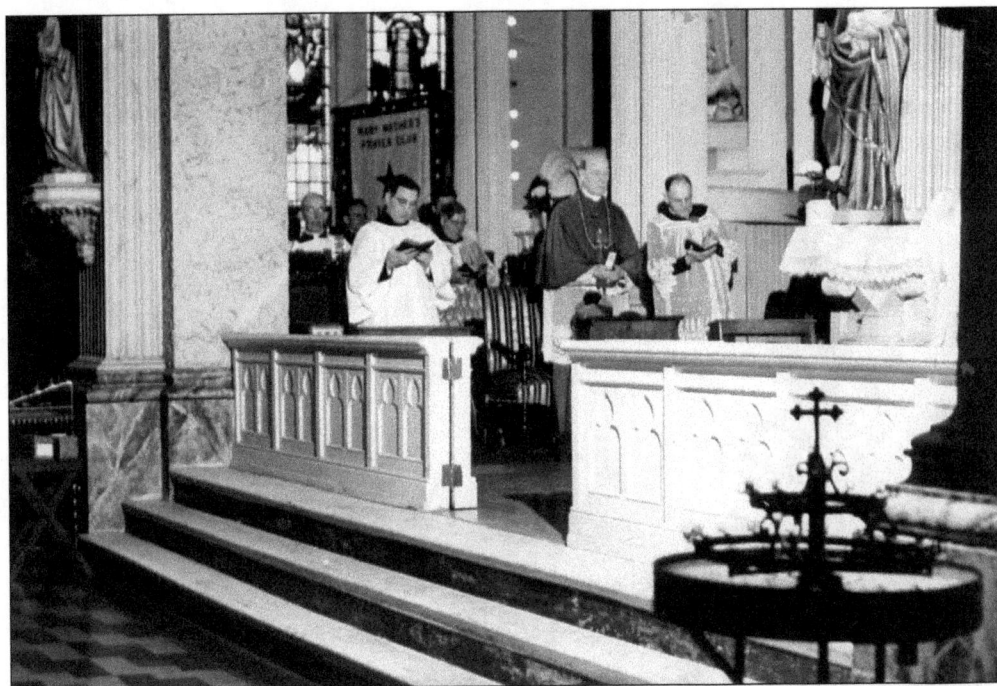

Archbishop John Glennon celebrates Mass at St. Patrick's Church on St. Patrick's Day 1945. (Courtesy of the Archdiocese of St. Louis Archives.)

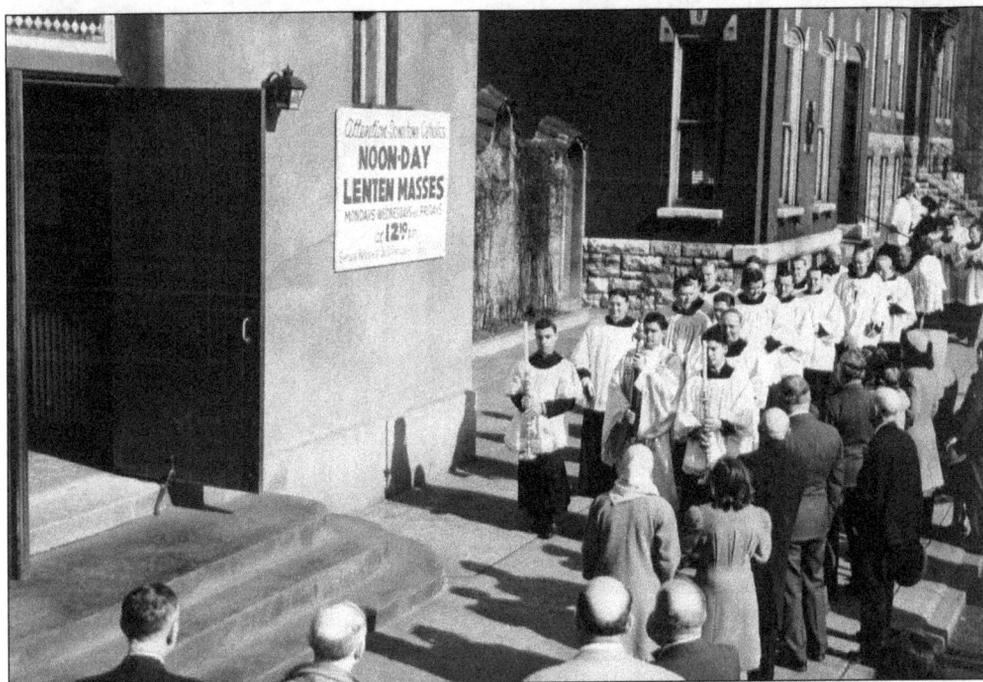

A procession outside of church; the sign on church wall proclaims "Attention Downtown Catholics—Lenten Masses Monday—Wednesdays—Fridays." (Courtesy of the Archdiocese of St. Louis Archives.)

Columbkille Church was organized in 1872 to serve Irish iron workers of the nearby Vulcan Iron Works. Its pastor, the Rev. Michael O'Reilly, was called a "militant defender of the church" because of his defense of his parishioners against slurs of Irish character. Located at 8200 Michigan Avenue in the Carondelet neighborhood, the church was razed in 1952. This area was once known as Kelly Patch, presumably for the large number of Irish named Kelly. (Courtesy of the Archdiocese of St. Louis Archives.)

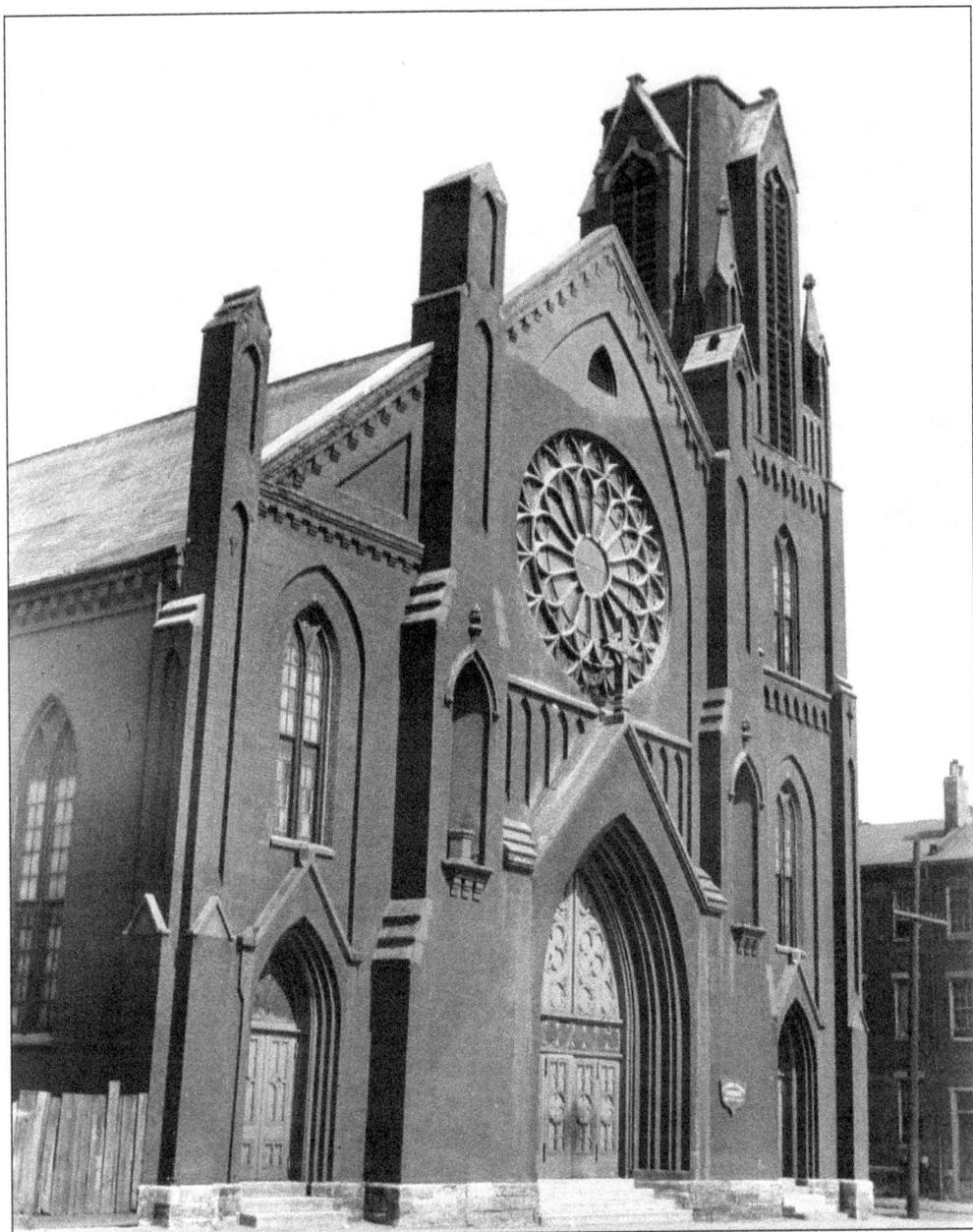

St. Lawrence O'Toole Church was founded by Father James Henry as a mission from St. Patrick Church. The first church was dedicated in 1855 and was replaced by a later structure across the street at the SW corner of 14th and O'Fallon. The assistant in 1875 was Rev. Lawrence Madden. The church was sold in 1948. (Courtesy of the Archdiocese of St. Louis Archives.)

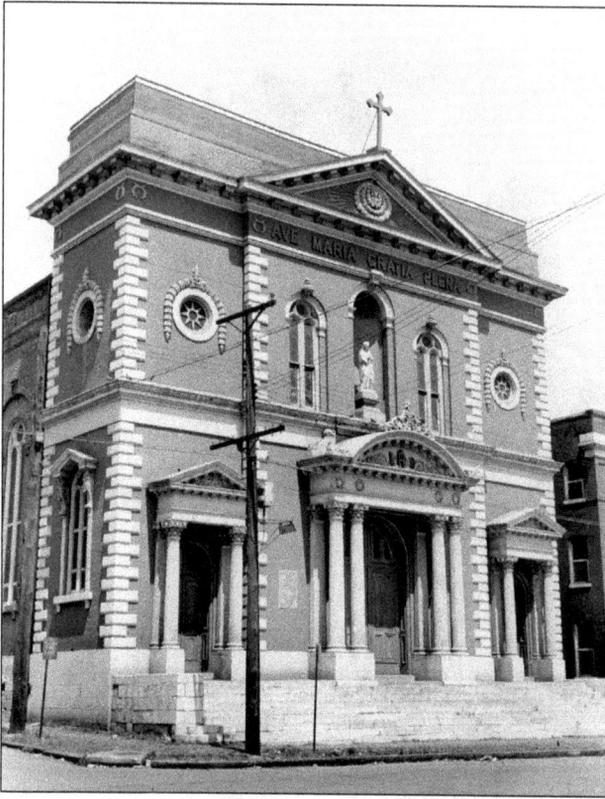

This historic church survived the Civil War and the 1896 tornado, but in 1952 it fell to the wrecking ball. The Annunciation parish was formed in 1861 by the Rev. Patrick J. Ryan, a distinguished priest and orator who later became Archbishop of Philadelphia. The parish was settled by Irish and French who had attended the Old Cathedral. The church sat on a 20 acre tract of land donated by Irish philanthropist John Mullanphy. It was situated at Sixth and LaSalle streets near Chouteau. (Courtesy of the Archdiocese of St. Louis Archives.)

The original church books show the parish passing into the hands of a string of Irish pastors including Revs. Ryan, Phelan, and Brady. (Courtesy of the Archdiocese of St. Louis Archives.)

St. Michael the Archangel Parish Church—the parish was founded in 1849. (Courtesy of the Archdiocese of St. Louis Archives.)

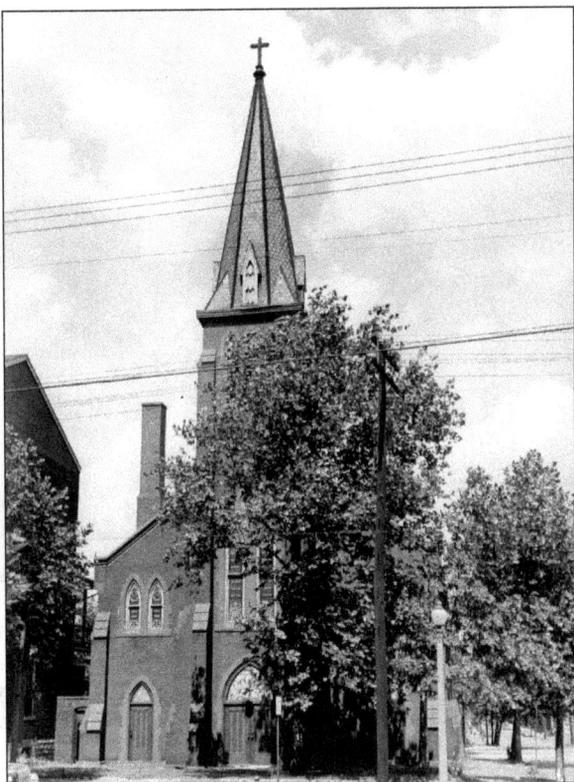

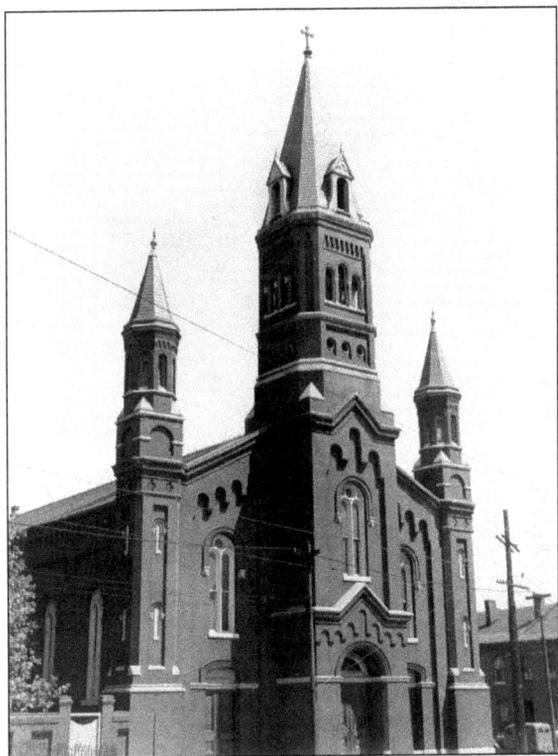

The second St. Bridget's Church was dedicated in 1860. The pastor of the first church, in 1853, was Rev. John C. Fitnam, a native of Cork, Ireland. Fr. Fitnam was previously the pastor at St. Patrick's Church. Rev. David Lillis, successor to Fr. Fitnam, was born in Limerick, Ireland in 1827, and came to St. Louis in 1850. He was ordained in St. Louis by Archbishop Kenrick in 1852. This church was located at 2401 Carr Street, near the famed Kerry Patch. (Courtesy of the Archdiocese of St. Louis Archives.)

St. James the Greater parish was formed in 1860 as a predominately Irish mission of old St. Malachy's parish. Often referred to as the Cheltenham neighborhood, it's even more often called Dogtown. Just as Kerry Patch tied in the church of St. Lawrence O'Toole, so Dogtown proudly boasts the parish of St. James the Greater, whose stately church with its slender copper spire dominates the area from the summit of the hill. (Courtesy of the Archdiocese of St. Louis Archives.)

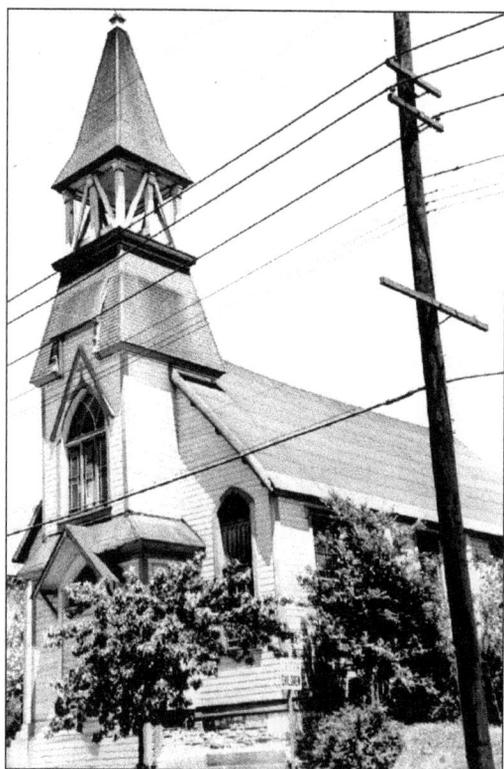

The first St. James the Greater church was as 1368 Tamm Avenue, and was later used as a gym and hall. (Courtesy of the Archdiocese of St. Louis Archives.)

The following excerpt is from March 16, 1967, *St. Louis Globe Democrat*, by John Brod Peters.

"*St. Louis has often been called the 'Rome of the West.' Before the tall buildings took over, the Sunday afternoon sightseer could cruise up and down the river counting the spires and intoning in the process a litany of patron saints. Irish and German immigrants had much to do with making this a city of spires, and no area was more celebrated for the beauty of its churches and the spirit of its people than "Kerry Patch," an Irish neighborhood northwest of downtown St. Louis. The core of the area was bounded on the east and west by Sixteenth and Twenty-Second streets, and on the north and south by Cass avenue and O'Fallon St. Now it is difficult to picture among the warehouses and apartment projects which occupy the area the close knit Irish colony with its houses shoulder to shoulder, the lace-curtained windows*

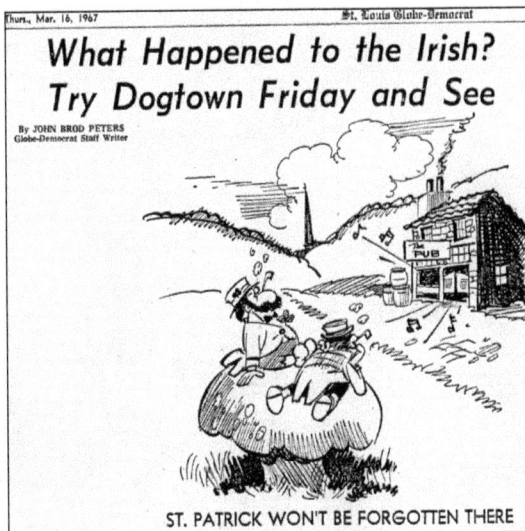

Thurs., Mar. 16, 1967 St. Louis Globe-Democrat

What Happened to the Irish? Try Dogtown Friday and See

By JOHN BROD PETERS
Globe-Democrat Staff Writer

ST. PATRICK WON'T BE FORGOTTEN THERE

looking out on gas-lit streets, the corner pubs, the parochial seal of its churches, the militant politics of its inhabitants—will alive with an indefinable mystique more at home in Galway or Kilkenny than in a French colonial settlement on the mighty Mississippi. But the Irish apparently didn't consider their Kerry Patch a kind of Babylonian captivity. They took to their new soil with a vengeance. Militant societies were formed, and an Irish nationalist rally at the Old Courthouse 100 years ago filled the place to the rafters.

So great was the spirit of the St. Louis Irish, in fact, that Kerry Patch could not contain it's own Hibernian enthusiasm on St. Patrick's Day, the feast of Ireland's apostle and patron. Every March 17, therefore, the whole city enjoyed the invasion of an Irish army in the form of an annual St. Patrick's Day parade. Even the militant Irish, however, couldn't halt the city's westward growth. Business encroached upon Kerry Patch, second and third-generation Irish grew more opulent and less enthusiastic about downtown living. They moved away to new parishes to the west, and the old neighborhood began to go down. One by one the homes disappeared and the parishes declined or closed down. The very "Pride of the Kerry Patch" the church of St. Lawrence O'Toole, was turned into a warehouse, and its high altar received a last-minute reprieve when it was snatched from the wreckers by Msgr. Joseph O'Toole, who carried his boyhood parish altar out to his new pastorate in Glendale. But as the Irish dispersed throughout the metropolitan area, a successor to Kerry Patch arose south of Forest Park. First known by the rather grand name of Cheltenham, the area is now better known as Dogtown (cynical Irish wags affect to prefer "Canine Heights"), a hill bounded by McCausland, Oakland, Hampton and Manchester avenues. No one really knows how the name originated but local pub-owner Randal Dwyer who is something of a Dogtown historian—believes that it stems from the time of the St. Louis World's Fair in 1904 when poor Irish squatters, living in makeshift shanties in Forest Park, were forced by the fair to move southward to the neighboring hill. Just as Kerry Patch tied in the church of St. Lawrence O'Toole, so Dogtown proudly boasts the parish of St. James the Greater, whose stately church with its slender copper spire dominates the area from the summit of the hill. Until recently, every pastor of the parish had been born on Irish soil, and much of the spirit of the neighborhood derives from the stout Hibernian piety of these stalwart and outspoken leaders—men as ready to pronounce upon social and political matters as on things spiritual, as though serene in the typically Irish assumption that Holy Orders somehow confers a universal doctorate. Their uncompromising sincerity so greatly inspired their people that parish teenagers are as likely to meet at Mass as they are on the dance floor or the playing field—and are likely to do all three under church auspices."

The old Jackson School at Maiden Lane and Reservoir (aka Hogan) was a Kerry Patch public school that opened in 1859. This photo shows it about 1895, about five years before it moved to a new location. (Photo courtesy of St. Louis Public Schools Records Center/Archives.)

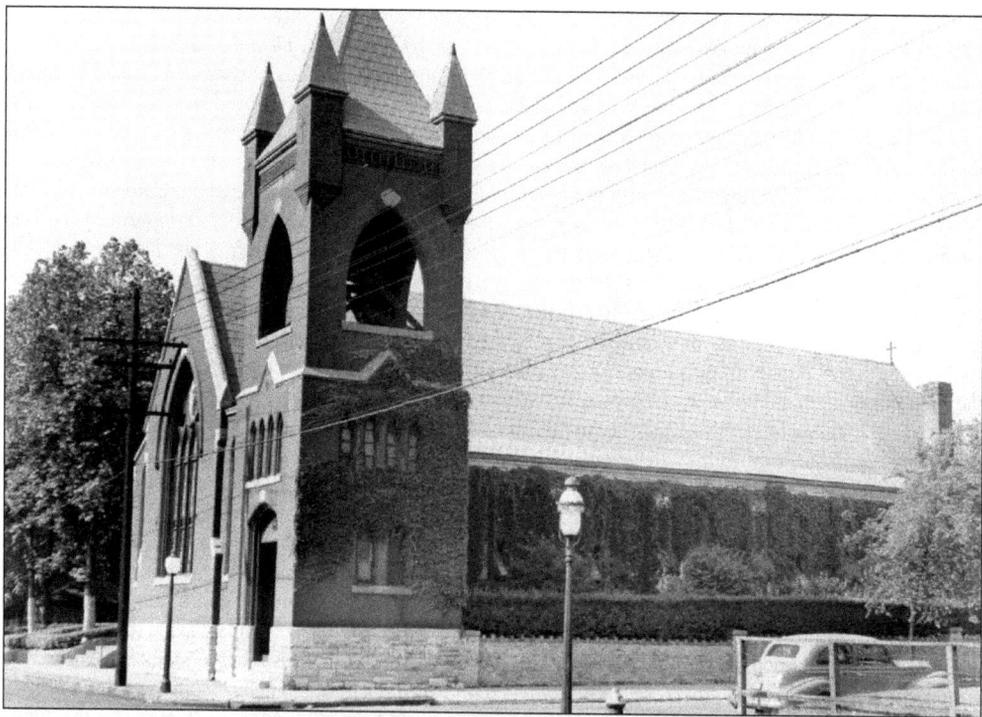

The Irish parish of St. Cronan's, at Boyle and Swan Avenues, was founded in 1879. Part of St. James the Greater territory, this new parish was started by Rev. Thomas A. Butler. Services were first held in a hall until a church was built. On April 9, 1879, the cornerstone for a small brick church was laid at Boyle and Swan. (Courtesy of the Archdiocese of St. Louis Archives.)

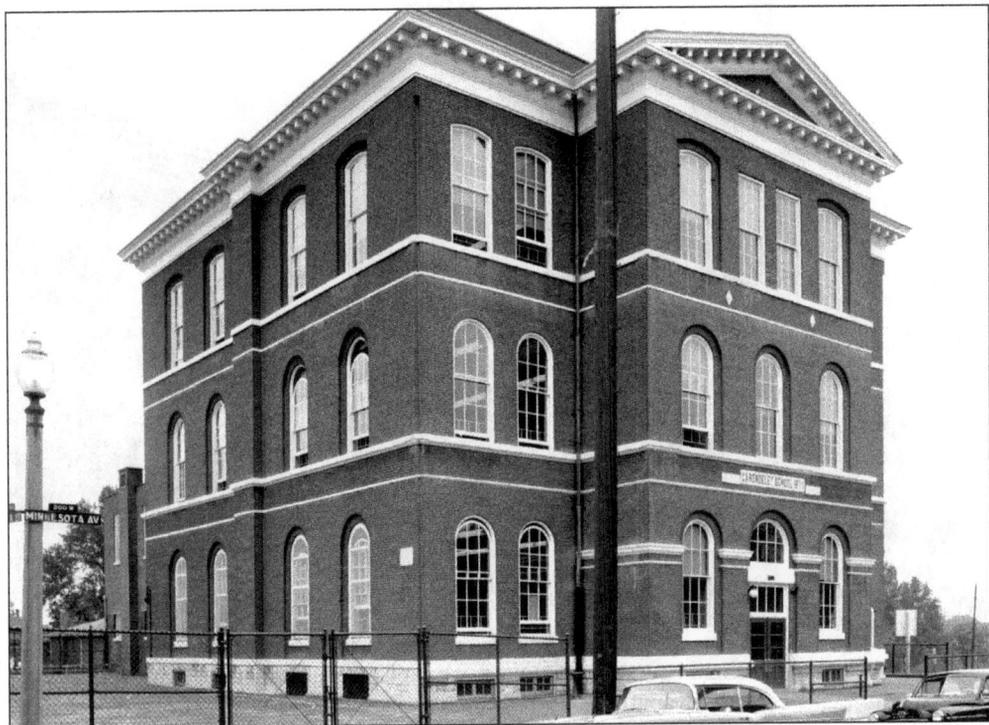

Carondelet School at 8221 Minnesota Avenue was opened in 1871, and served residents of Kelly Patch in South St. Louis. Three stories high, it had twelve rooms, and a seating capacity of 700 students. This picture was taken in 1957 (note the brand new Chevy parked in front). The school closed in 1976 and the building was sold. (Photo courtesy of St. Louis Public Schools Records Center/Archives.)

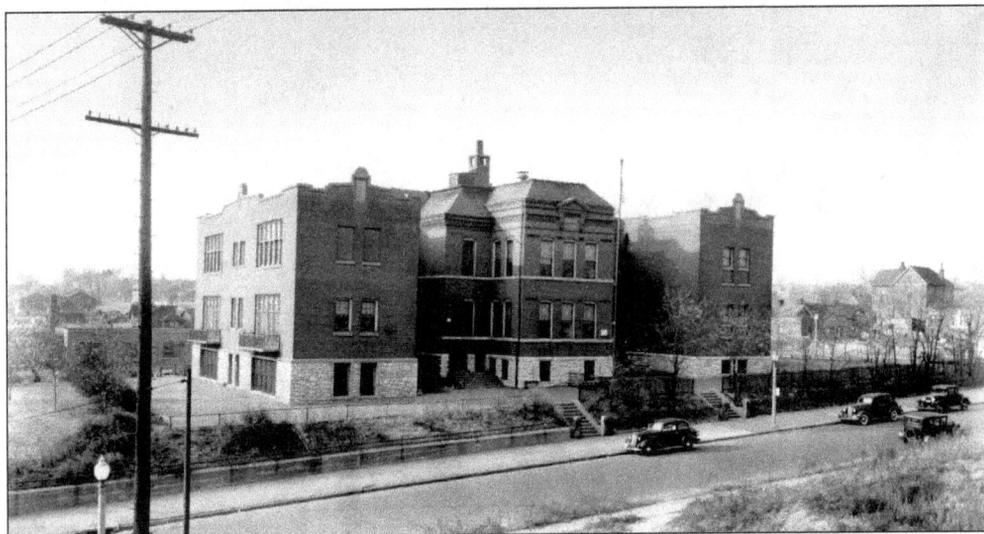

Gratiot School, at 1615 Hampton, opened it's doors in 1882. Originally to be named Cheltenham School for the neighborhood it supported, the name was changed to Gratiot at the last moment. A number of Irish attended from the Dogtown area. (Photo courtesy of St. Louis Public Schools Records Center/Archives.)

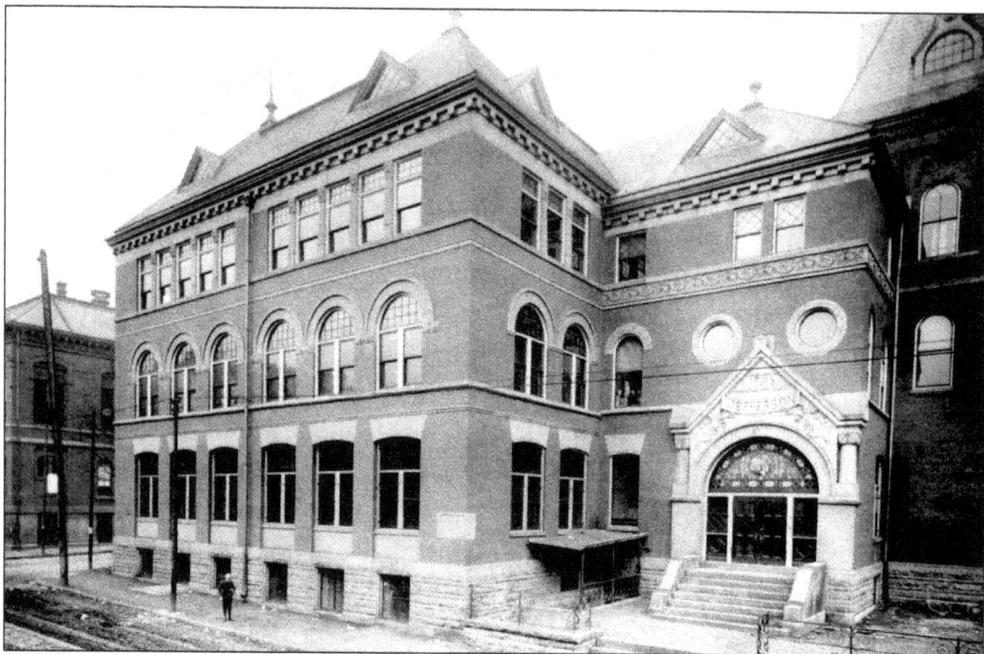

The original Jefferson School opened at 903 Wash Street (later known as Cole Street) in 1848. This was during a period of growth in the Irish community of St. Louis' Kerry Patch. The new building shown here was erected in 1872. This picture was taken about 1900. The school closed in 1959. (Photo courtesy of St. Louis Public Schools Records Center/Archives.)

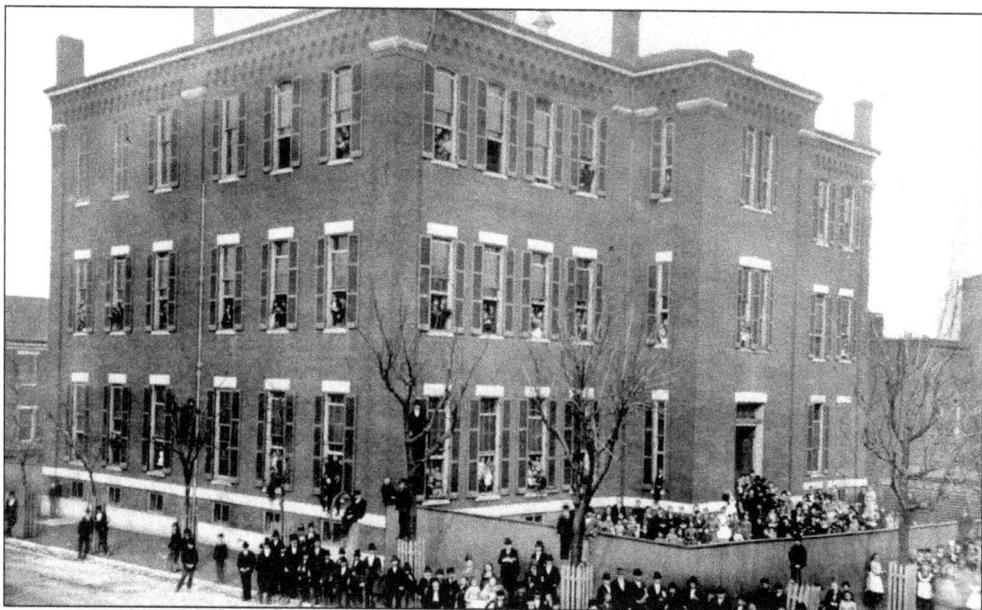

Franklin School was opened in January of 1858 at the corner of Christy Avenue (later called Lucas) and Eighteenth Street. With 23 rooms, and a seating capacity of 1,100 students, it was the largest school in the city, and served many residents of Kerry Patch. This picture was taken about 1875, and shows a very unusual pose for a school picture—note the students in the trees. (Photo courtesy of St. Louis Public Schools Records Center/Archives.)

Pictured is the first St. Louis Public School Kindergarten Class, 1873, at Des Peres School. The original school was located at the corner of Fourth and Illinois (later known as Iron), and served the families of the Irish ironworkers in the "Kelly Patch" area of Carondelet. (Photo courtesy of St. Louis Public Schools Records Center/Archives.)

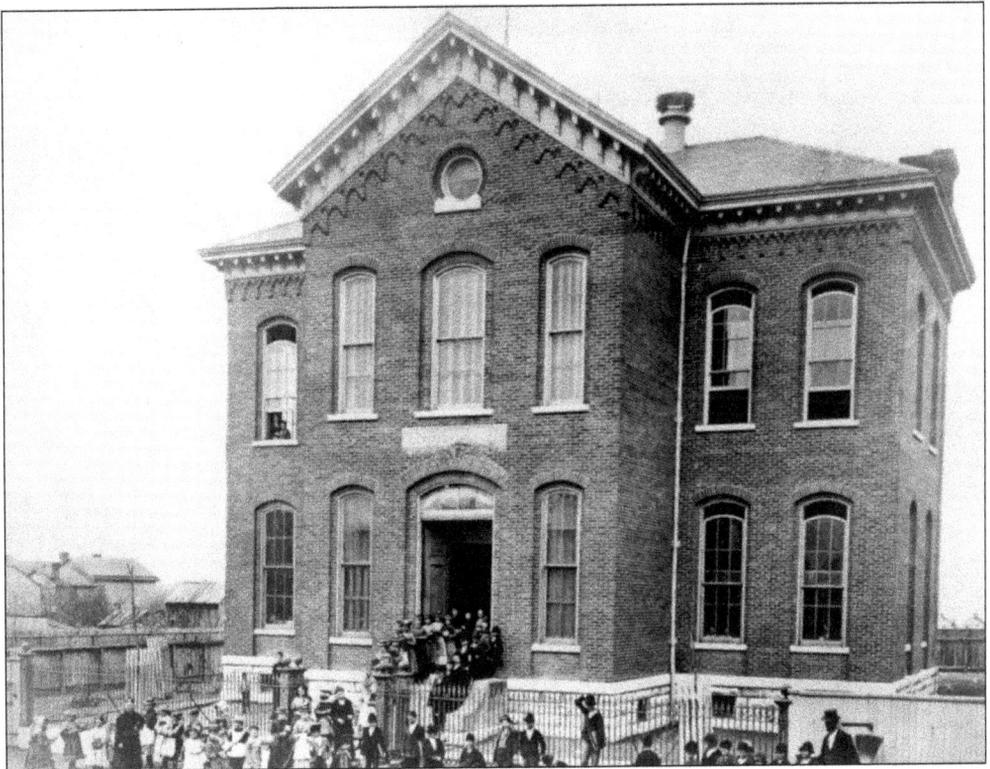

By 1893 the Des Peres School had moved to this location at 6307 Michigan. This building now houses the Carondelet Historic Center. (Photo courtesy of St. Louis Public Schools Records Center/Archives.)

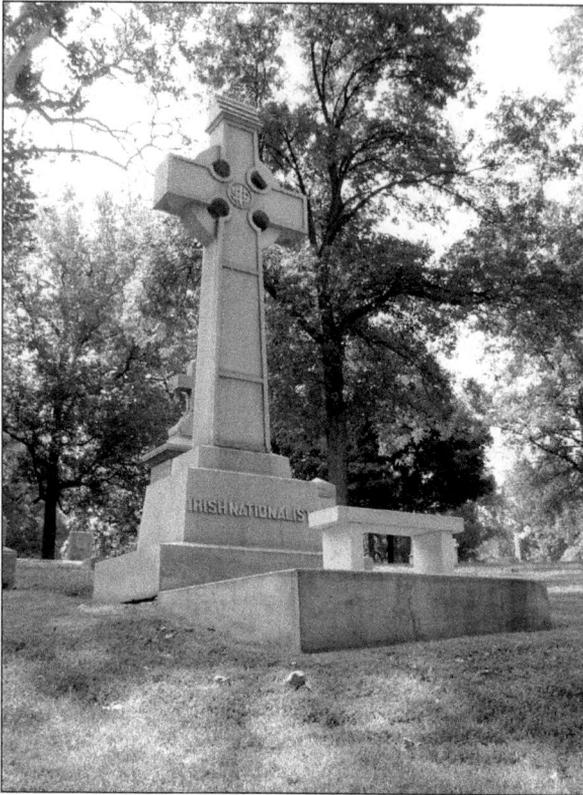

Calvary Cemetery is St. Louis' largest Roman Catholic cemetery. In Section 17 stands this monument dedicated to the Irish Nationalists. (Photo by Mary Lossos.)

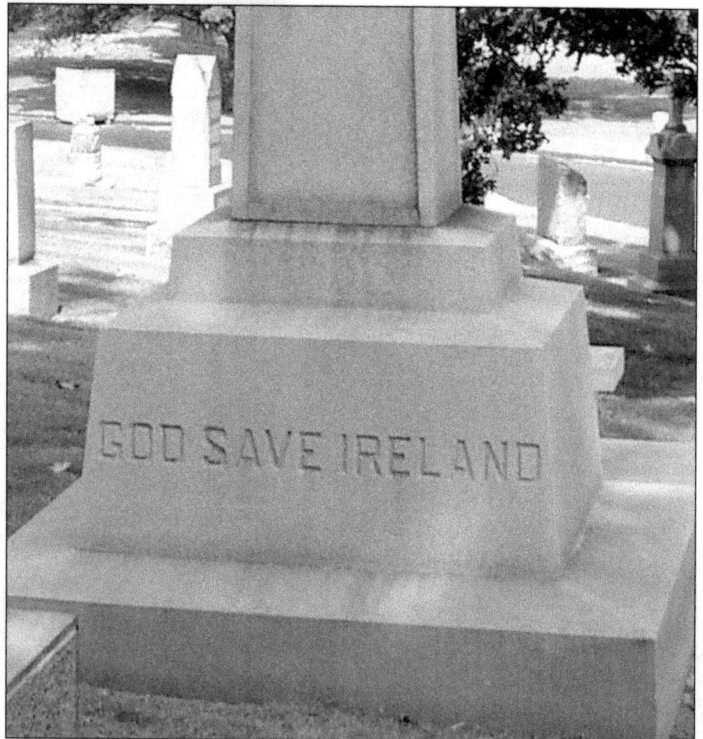

The inscription on the reverse side says simply "God Save Ireland." (Photo by Mary Lossos.)

Six

THE EVERYDAY IRISH

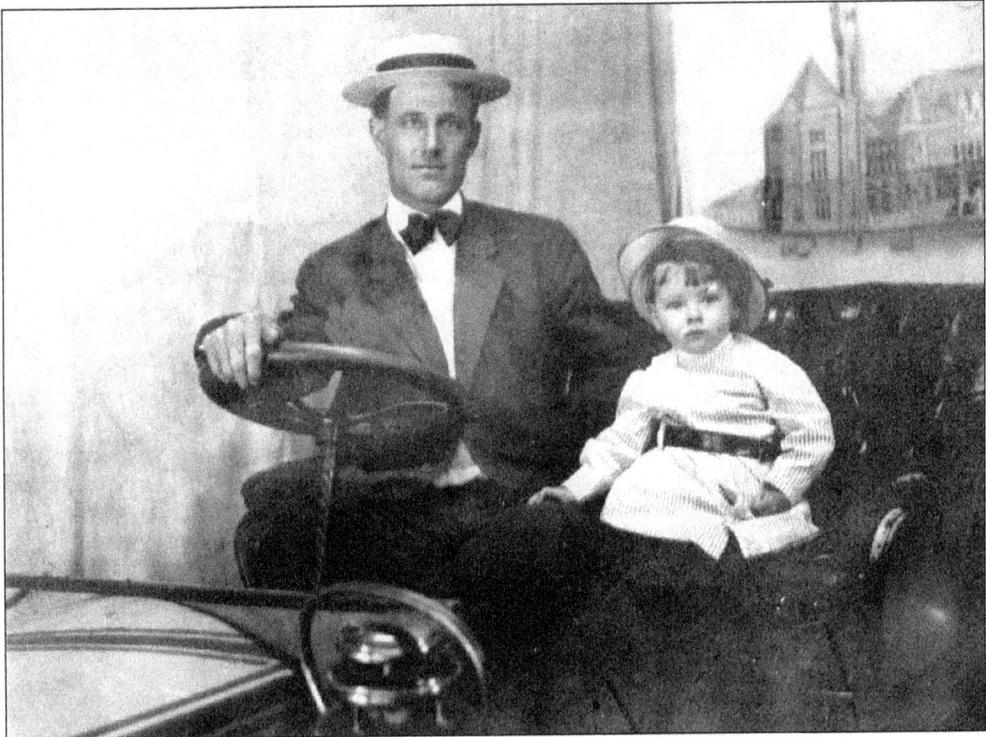

William J. Kane and his son Joe—William was the son of Patrick and Winnefred (Finne) Kane, both native born Irish that immigrated prior to the Civil War. (Photo courtesy of Barry Kane.)

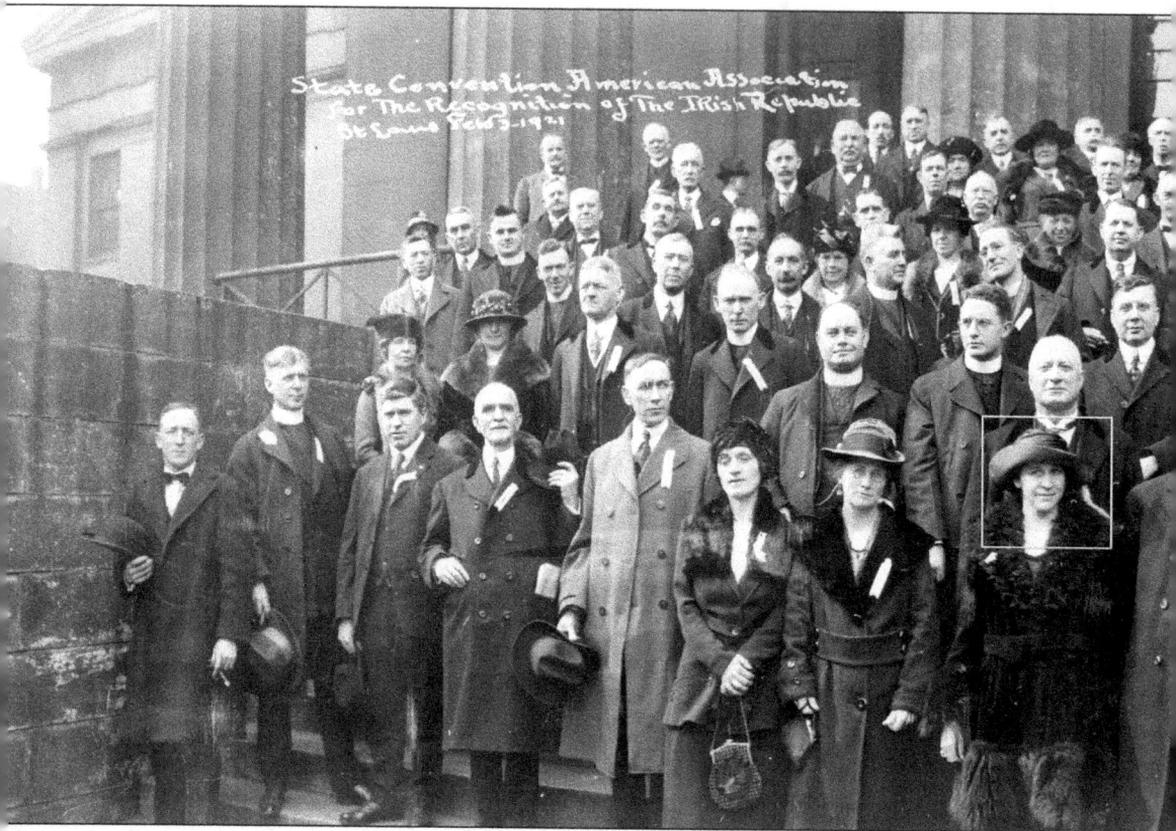

This is a group photo showing some of the participants in the state convention of the American Association for the Recognition of the Irish Republic. The photo was taken on February 3, 1921, on the steps of the Old Courthouse in downtown St. Louis. According to an article appearing in the *St. Louis Globe-Democrat*, February 4, 1921, Miss Mary MacSwiney (identified in picture by square), sister of the late Lord Mayor of Cork, who died of self-imposed starvation while in a British prison, was in St. Louis for just a few days, and addressed large crowds everywhere she went, enlisting support for recognition of the Irish Republic by the Government of the United States.

Miss MacSwiney arrived in St. Louis the afternoon of February 3rd, and was met at Union Station by a committee composed of chairman Mrs. M.J. Cullinane and members Mrs. W. H. Davis, Miss Katherine Riordan, Mrs. Belle Tracy, Mrs. James Grace, Mrs. M.J. Leonard, and Mrs. F. Barry.

At one venue, the Odeon, Dr. R.E. Kane, who presided, said that more persons were turned away than the house could accommodate. The Odeon seats 1800 persons. Every seat was occupied. Five hundred persons stood for two and one-half hours in the corridor outside the doors until addressed by Miss MacSwiney. Veterans of Irish meetings said that it was by all means the most successful affair of the sort ever held in St. Louis.

--Miss MacSwiney was warmly received. Mayor Kiel welcomed her in behalf of the city. Dr. Kane introduced her to her audience.

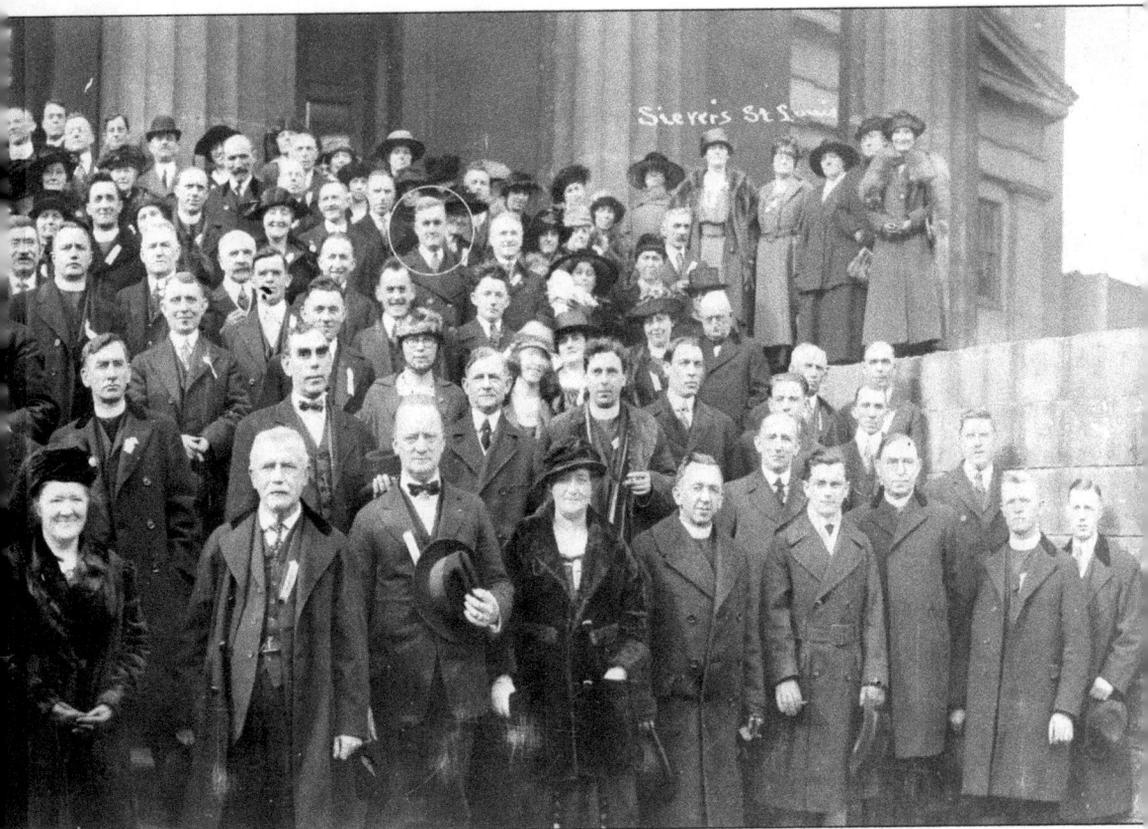

Miss MacSwiney closed her speech with the following:

"I am not asking you to do justice to Ireland for Ireland's sake only. I am asking you just to do justice to Ireland for America's sake, to redeem the pledges which America made to humanity. I am speaking to you from the soul of liberty-loving Ireland to the soul of liberty-loving America. And on the day that America ceases to practice freedom which she has always preached, on the day that America ceases to extend her hand of friendship and hospitality to oppressed people, on that day, indeed, America will lose her soul. And nations it may be said, as of individuals—what will it profit them to gain the whole world and suffer the loss of their soul. And so I beg you tonight to bear on your Congress, on your government, such a force that the government will realize that the voice of the people has indeed spoken, and the voice of the people is the voice of God."

Very Rev. C. S. Ryan, superior of Kenrick Seminary, supplemented Miss MacSwiney's appeal for recognition of the Irish Republic by quoting historic precedents wherein the Unites States had recognized governments which, he said, were far from being as effective or so representative of the people as that of the Irish Republic.

On February 4th she spoke at a luncheon at the headquarters of Catholic Women's Association, 505 North Seventh Street. At 3:30 o'clock she made a talk at the club of the Queen's Daughters at 3730 Lindell Boulevard. During the afternoon she visited Washington University, the New Cathedral, Mullanphy Hospital, St. Luke's Hospital, St. Mark's Hospital, St. John's Hospital, and other places of interest. She was then received by Archbishop Glennon. (Photo courtesy of Kathleen Barrett Price, daughter of Thomas Patrick Barrett (circled) whose parents were born in County Mayo, Ireland.)

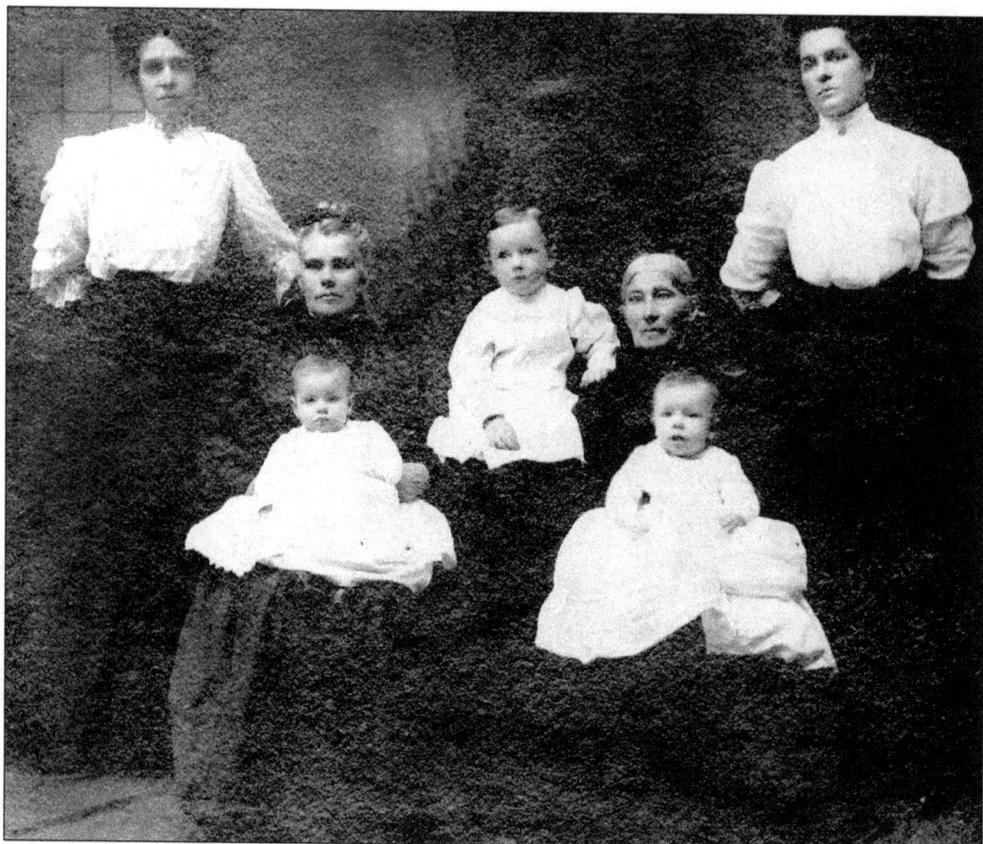

This photo was taken in 1908 at the Hays Studio in St. Louis. Standing on the left is Elizabeth McLoughlin and standing on right is Nellie McLaughlin Daly. Seated on the left is Ellen Sargeant McLoughlin and on the right is "Grandma" Vogelsang. The children, from left to right, are Joseph Kane, John Felix Daly, and William Daly, Jr. (Photo courtesy of Barry Kane, son of Joseph Kane above.)

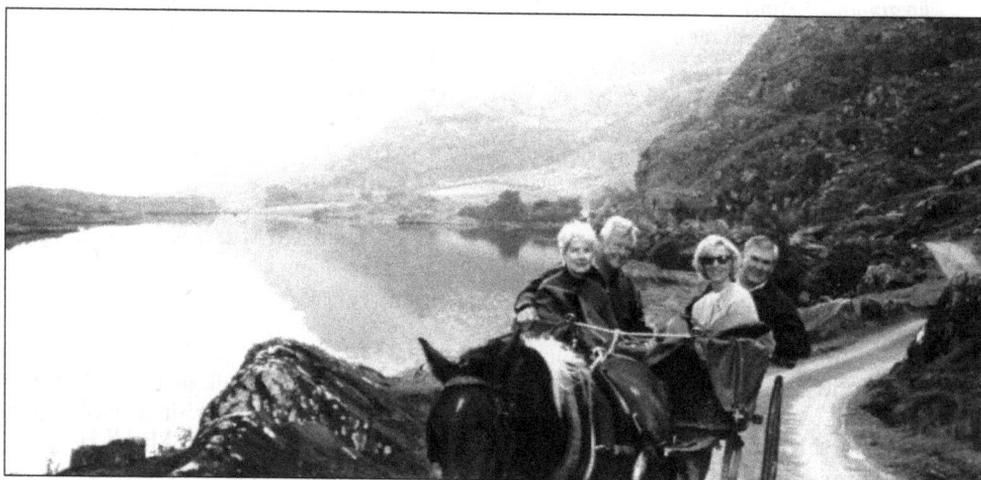

St. Louisans Judy and Barry Kane, and Dixie and Bob Rogers enjoy a pony-cart ride in the Gap of Dunloe in the Ring of Kerry during their 1998 visit to Ireland. (Photo courtesy of Barry Kane.)

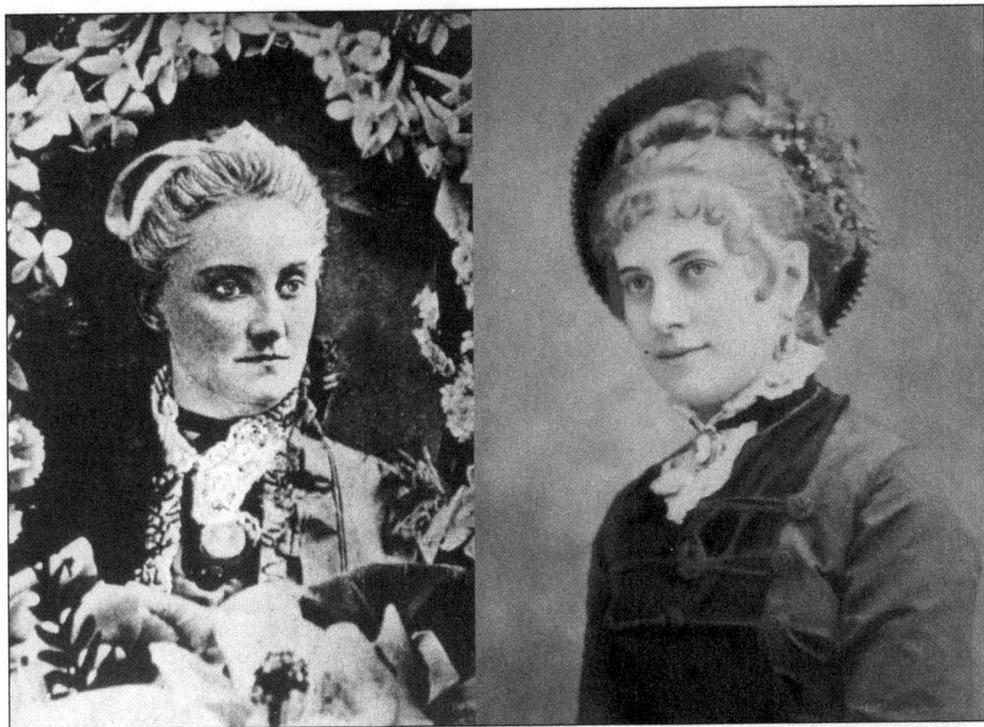

Pictured on the left is Helen Barbour Dunlap, born 1833 in Belfast, County Antrim, Ireland. She was the first wife of Dr. Thomas O'Reilly, and the mother of Andrew and Thomas O'Reilly. Helen died in 1877. On the right is Mary Archer Quirk, born August 13, 1856 in Kilkenney, Ireland. She was Dr. Thomas O'Reilly's second wife, marrying in St. Louis on June 27, 1878. (Photo provided by Mary Elliott O'Reilly, great-granddaughter of Dr. Thomas and Mary Archer O'Reilly.)

Dr. Thomas O'Reilly (gentleman on the right) being driven down Biddle Street, c. 1880. (Photo provided by Mary Elliott O'Reilly, great-granddaughter of Dr. Thomas O'Reilly.)

This is a photo of Mary Mahaffey (August 16, 1839–October 30, 1920), wife of John McCullough (December 9, 1828–July 23, 1884) from the County Down, Ireland. The McCullough family attended the First Presbyterian Church in St. Louis. Mary's son, George McCullough (November 3, 1868–September 2, 1938), was the Church's President of Board of Trustees. (Photograph provided by John A. McCullough, great grandson of Mary Mahaffey McCullough.)

A letter from a St. Louis Irish Protestant to parents still in Ireland:

St. Louis, MO, April 20, 1866
Dear Father and Mother,
I now write you these few lines to let you know that we are all well. Hoping this will find you enjoying the same blessing. Alex is well and working every day. Our youngest child Ellen died when she was fourteen months old.

I have quit Mr. McCaw's and am working for my self and doing very well so far. I was expecting to hear of you all being run off by the Fenians. They are making a great excitement here. Alex and I send you a check enclosed in this letter for twelve pounds. When you write let me know how you are all getting along and how the times are in Ireland now and if you have any Fenians around you. House rents and markets are very high here but the money is very plenty and wages very good. Alex is still living with me.

Alex and Mary join with me in sending our love to you all.
I have nothing more of any importance to write to you, hoping this will find you all in good health.

I remain your affectionateson
John McCullough

(Information and letter provided by great-grandson, John A. McCullough, former resident of St. Louis, living in California.)

James Archer O'Reilly tries his hand at photography. This photo was taken October 23, 1888 when he was about nine years old. Instead of photography he chose medicine, like many of his family before him. He became an orthopedic surgeon, trained at Harvard College and Harvard Medical School. Dr. O'Reilly was born with only one and a half legs, and the one foot was clubbed. He founded the Crippled Children's Society, the forerunner of today's Easter Seals Society. (Photo provided by Mary Elliott O'Reilly.)

Under the gaze from the portrait of Dr. James Archer O'Reilly, M.D. the family gathers— O'Reilly's son Dr. Daniel Elliott Archer, M. D., wife Jane Elliott Sever O'Reilly, and granddaughter Jane Conway O'Reilly in the front; granddaughter Mary Elliott O'Reilly, grandson J. Archer O'Reilly III, and son James Archer O'Reilly, Jr. in the back. This photo was taken shortly after the death of Dr. James Archer O'Reilly in December 1947 in St. Louis. (Photo provided by Mary Elliott O'Reilly, granddaughter of Dr. James Archer O'Reilly, M.D.)

John McCullough was born near Banbridge, County Down, Ireland in 1828. He immigrated to America about 1852 and settled in St. Louis where he married Mary Mahaffey, also from County Down, in 1857. John was a grocer by trade, working most of the time for Daniel McCaw and then his son, Alexander McCaw. The McCullough's and McCaw's appear to have had a previous relationship in Ireland. John and Mary lived in Kerry Patch on N. 17th St. between Cass Ave. and Mullanphy St. from about 1861 until about 1875. During this period, they had nine children, losing five of them at young ages from one month to 14 months, perhaps indicative of the living conditions in Kerry Patch. John McCullough died in 1884, and he was buried at Bellefontaine Cemetery where 23 family members are resting in the McCullough family and associated family lots. Note: This picture of John and Mary's children shows Samuel (1863–1927) on the left and Eliza (1861–1904) on the right holding George (1868–1938). (Photo, c. 1870, provided by John A. McCullough.)

This 1926 photo shows George Robert McCullough (the little boy in the above picture) standing with his wife Nellie Mace McCullough in front of their Buick and house on Westminster Avenue. (Photograph provided by John A. McCullough, grandson of George Robert McCullough.)

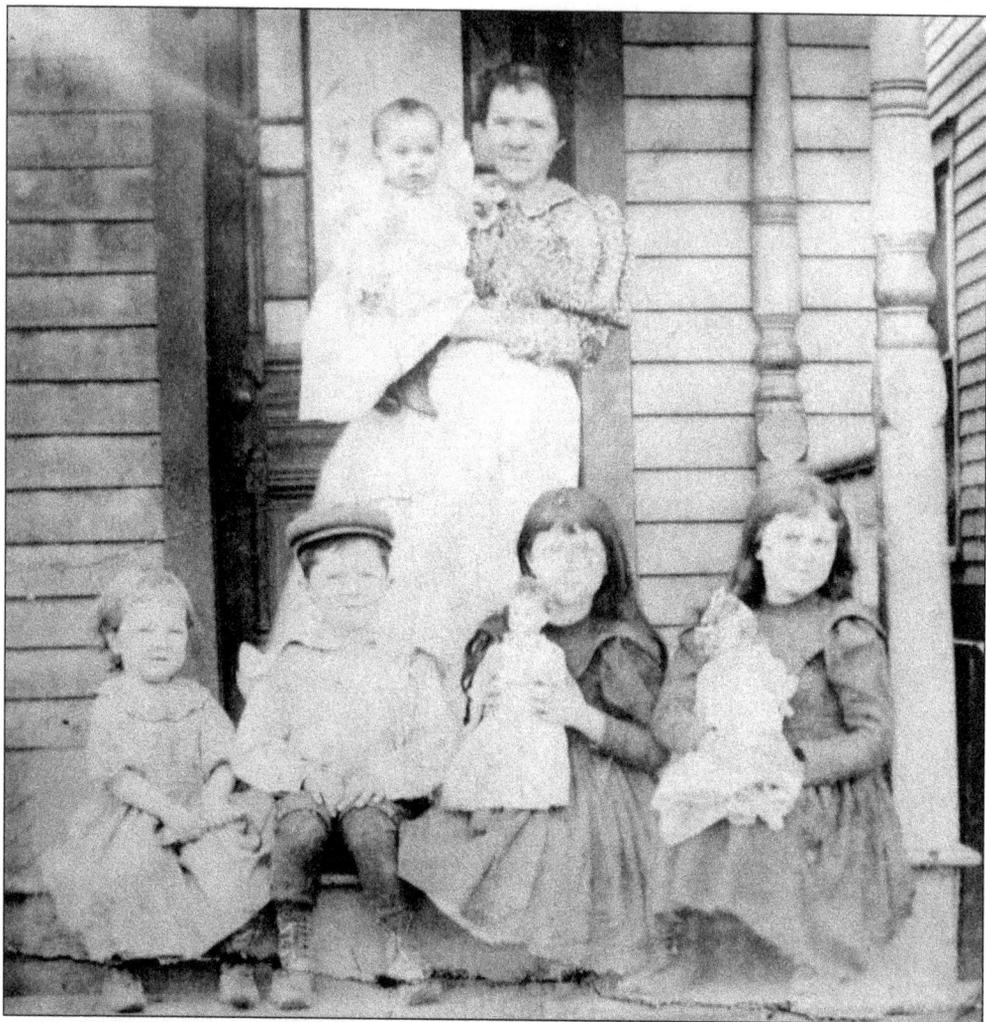

Genny Reynolds McGlynn holds her youngest child, Robert, in her arms, with siblings Daniel, Joseph, Elizabeth, and Ellen seated in front of her. This photo was taken at their home in the Metro East area of St. Louis in 1898. Joseph, the young lad shown here, is the father of Joe McGlynn, the founder of the annual St. Louis' St. Patrick Day Parades. (Photo courtesy of Joe McGlynn.)

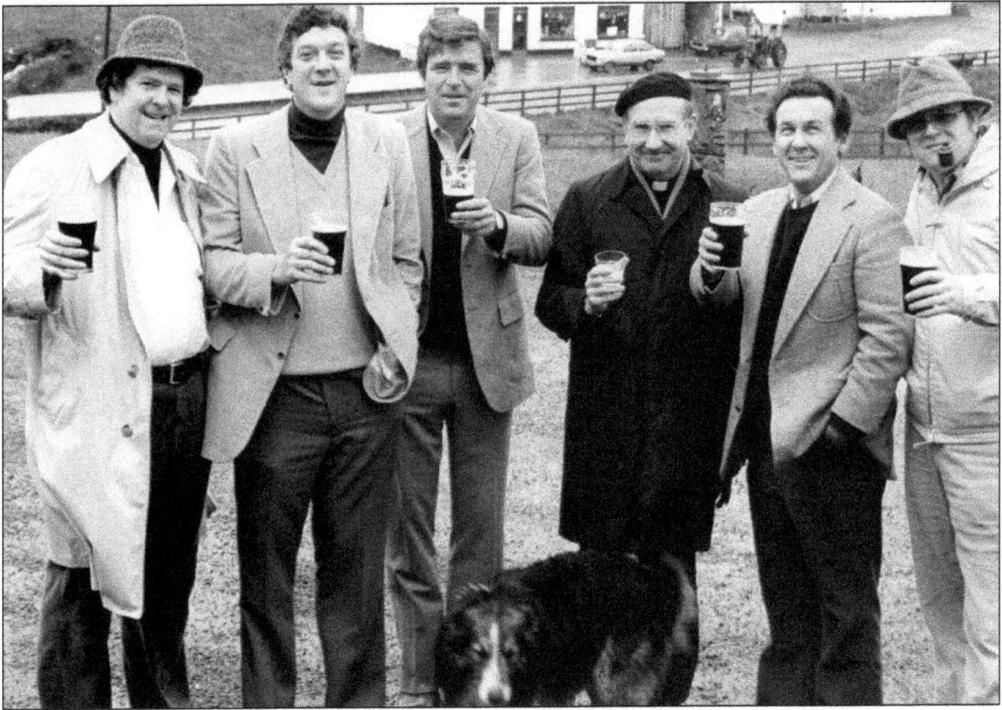

A group from St. Louis visiting Feakle, County Clare, Ireland in 1980. Ron Barlow, Joseph B. McGlynn, Jr., Dick Ford, Father Dan O'Connell, Eddie O'Donnell, and Jack Barlow. (Photo courtesy of Joe McGlynn.)

Father Daniel C. O'Connell, S.J., stands on the O'Connell Bridge in Dublin, Ireland, 1980. Father O'Connell became the 28th President of Saint Louis University on October 20, 1974, a position he held through early 1978. (Photo courtesy of Joe McGlynn.)

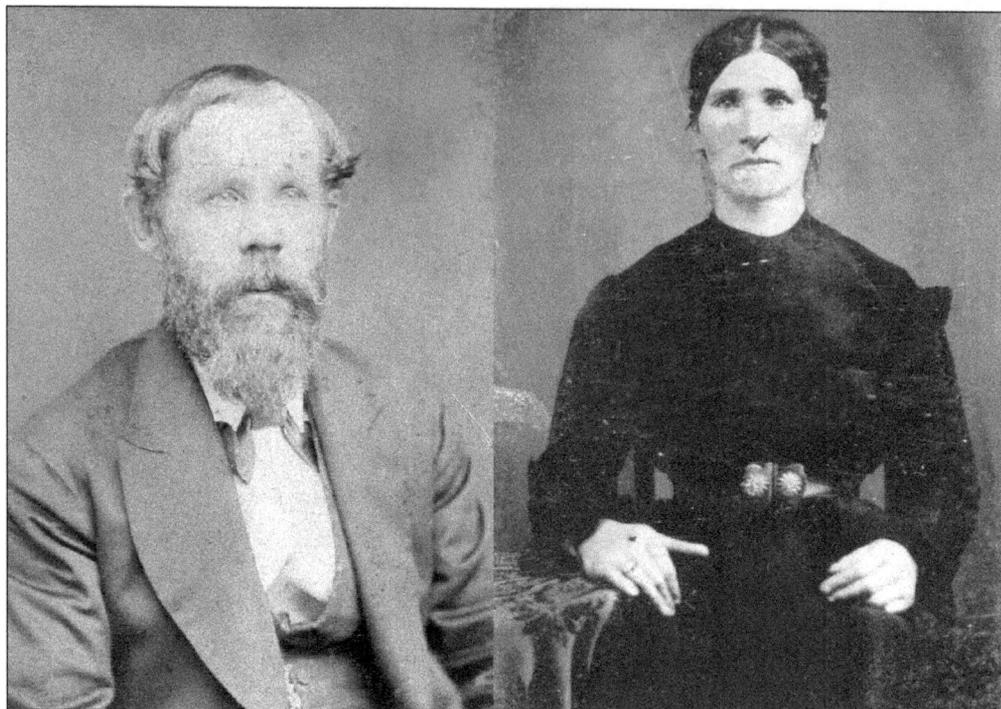

The Vogelsangs were born in Ireland and immigrated to St. Louis sometime during the Irish Famine of the late 1840s. (Photos courtesy of Barry Kane.)

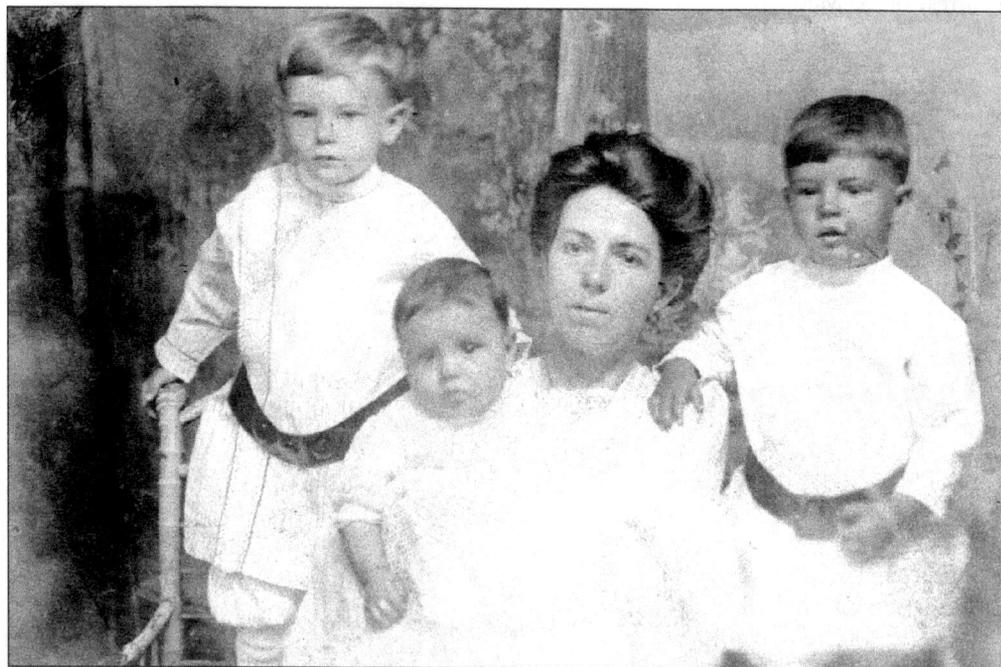

Elizabeth McLoughlin Kane with her three children Joe, Leo, and Ruth. "Lizzie" was the granddaughter of Samuel and Mary (Vogelsong) Sargeant, Irish immigrants to St. Louis. (Photo courtesy of Barry Kane.)

Native St. Louisan Maggie McCarthy was the daughter of Irish immigrants Patrick and Mary McCarthy. Raised in the vicinity of Kerry Patch, Maggie married at 18, and started a family of her own. (Photo, c. 1911, courtesy of Elsie Bonkrud, daughter of Maggie McCarthy Abeln Barrett.)

In June 1956 the whole family of descendants of Maggie McCarthy Abeln Barrett gathered at the house of her daughter, Elsie Bonkrud. Maggie is seated in the center of the picture. (Photo courtesy of Elsie Bonkrud, daughter of Maggie McCarthy Abeln Barrett.)

The Irish heritage continues in Tina and Pat Cooper and their sons Ian and Noah. (Photo courtesy of Tina Cooper, great granddaughter of Maggie McCarthy Abeln Barrett.)

Native St. Louisan Claire Rowland is pictured here with her parents, Kurt and Beth. Beth and Claire are 9th and 10th great granddaughters, respectively, of one of the first Irish immigrants in America. David Okillia, born in Gallagh, Ireland, was left an orphan during his voyage to Cape Cod from his native Ireland in 1652. He is first recorded in the Plymouth Colony Records in 1655 as an indentured servant. His period of indentureship expired in 1657, for he became a landowner in Yarmouth, Massachusetts in that year. He is the patriarch of many American Kelly's. The Rowlands are pictured in Claire's favorite playground, Tower Grove Park. (Photo courtesy of Lori Maze.)

Anna Kane was the daughter of Irish immigrants Patrick and Winnefred (Finne) Kane. Born in St. Louis in 1881, she entered the Sisters of Charity, a Catholic religious order. "Sister Laurencia Kane" worked as a nurse at St. Vincent's Tuberculosis Hospital in Norfolk, Virginia. After only five years at that facility she contracted TB, and two years later succumbed to the disease in 1913. She was only 32 years old. (Photo courtesy of Barry Kane.)

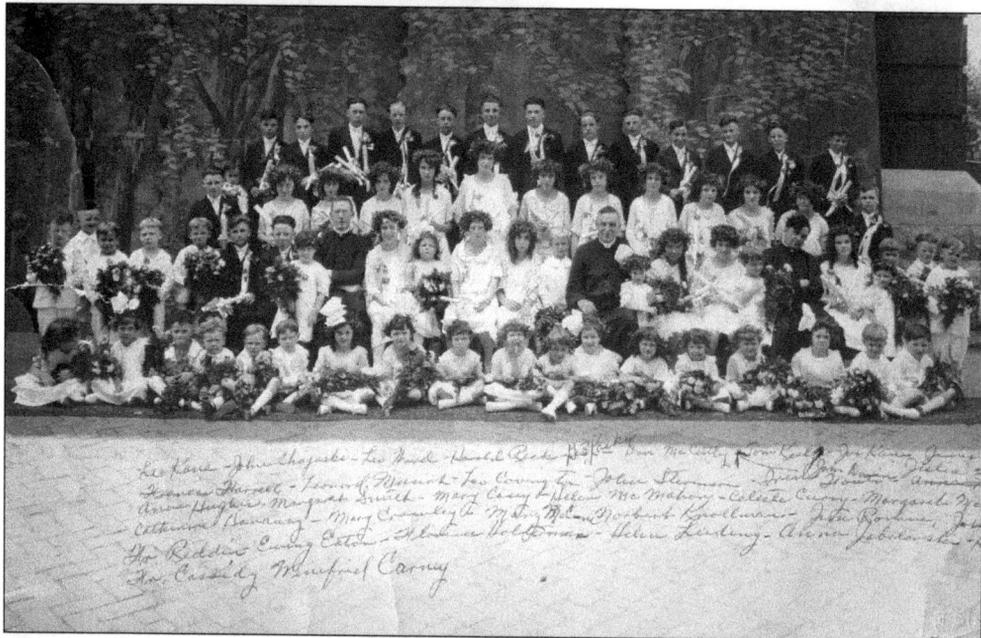

The entire school turned out in their finest for St. Leo's class photo. Photo taken about 1915. It can be noted that graduation day was also a great day for the Irish florist as well! One member of this class was Leo Ward, who later became an executive with the St. Louis Baseball Cardinals organization. (Photo courtesy of Barry Kane.)

Henry James McQuillen is on the left at age five. On the right is his three year old brother William Patrick McQuillen. This picture was taken in St Louis in 1899. In spite of their innocent appearance in this photo, these two brothers were to become very well known gangsters of the bootleg era. Henry was shot and killed in 1932 at Thirteenth and Cass, and William became known as "Bow Wow" in later life. He was a member of the Egan Rats and later the Cuckoo gangs. (Photo courtesy of Jim Brasher, grandson of Henry J. McQuillen.)

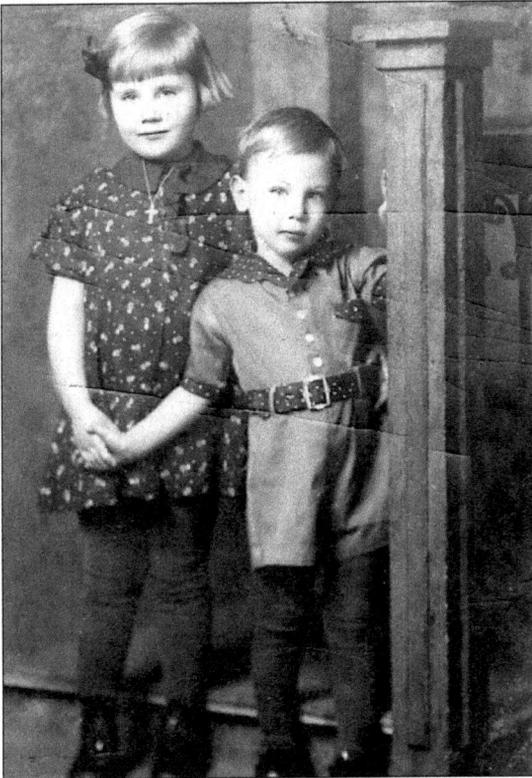

Sharon and James Brasher were living in the Kerry Patch on North Market when this picture was taken in 1938. They are the grandchildren of Henry McQuillen pictured above. (Photo courtesy of Jim Brasher.)

Pictured here are three of the St. Louis born children of Samuel and Mary (Vogelsong) Sargeant, Irish immigrants to St. Louis in the early 1850s. Above left, Rob Sargeant, was Mayor of Valley Park. His brother, Philip, is on the right above. At left, Ellen Frances (Sargeant) McLoughlin, born in 1853 in St. Louis, is holding one of her ten grandchildren. (Photos courtesy of Barry Kane.)

Among Father William Barnaby Faherty's most memorable years were those that he spent in Florida working on a NASA history of the Apollo Space Program. Commissioned by NASA, the final product (*Moon Port: Launch Facilities at Kennedy Space Center*) was published in 1978 and received rave reviews by scientists and laymen alike. It went into paperback in reprints. His second space history, *The Florida Space Coast: The Impact of NASA on the Sunshine State*, was named the book of 2002 by the Missouri Writer's Guild. (Photo courtesy of Faherty family collection.)

The Faherty "clan" is, from left to right: (front row) Louise Harris, Father William Barnaby Faherty, S.J., and Dr. Dan Faherty; (second row) Dr. Bernadette Harris, Mrs. Dan (nee Joan Dailey) Faherty, Sheila Harris, Dick Fredrick, Anne Faherty, Dr. Anthony Harris, and Angela Harris. This photo was taken at the Golden Anniversary celebration of Fr. Faherty's priesthood, June 27, 1994. The paternal grandparents (William Faherty and Ellen McDonough) of the three Faherty siblings in the front row were both born in County Galway, Ireland. (Photo courtesy of Faherty family collection.)

Father William Barnaby Faherty, S.J., talks with Anthony Quinn, movie director Henri Verneuil, and Charles Bronson on the set near Durango, Mexico, during the filming of MGM's movie entitled *Guns of San Sebastian*, which was based on Father Faherty's novel *A Wall for San Sebastian*. (Photo courtesy of Faherty family collection.)

Father Faherty takes a break with the female lead actress in the film, Anjanette Comer. The film was released in 1969. (Photo courtesy of Faherty family collection.)

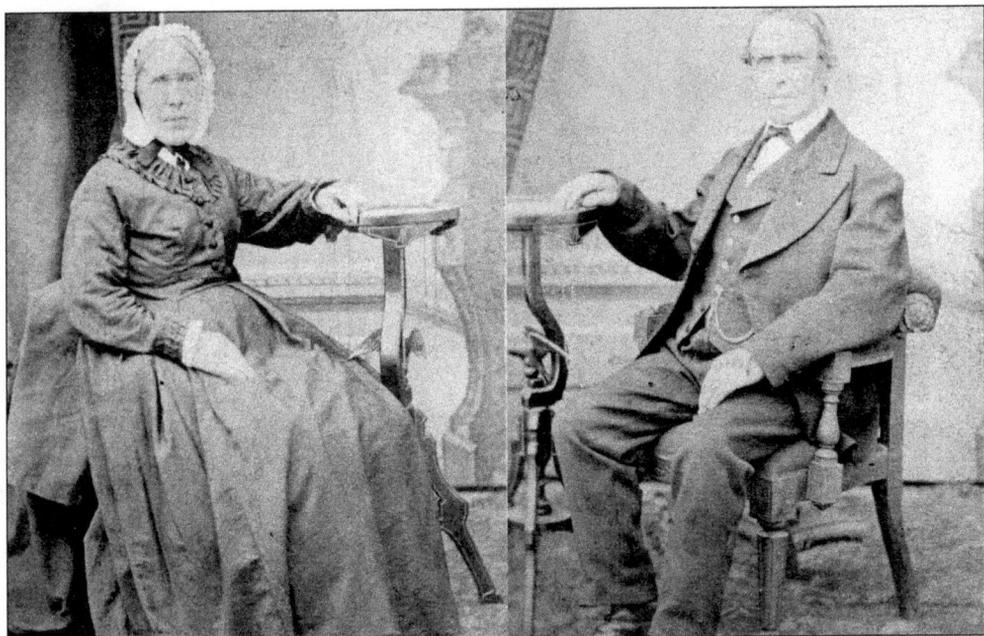

Margaret McGinnis and Michael Finnegan were born in Ireland, and arrived in St. Louis in June 1868. He worked at the "gas works" as did sons Edward, Arthur, John, and son-in-law Hugh Callahan. The photo was taken before Margaret's death on December 16, 1886. (Photo courtesy of Georgia Clark.)

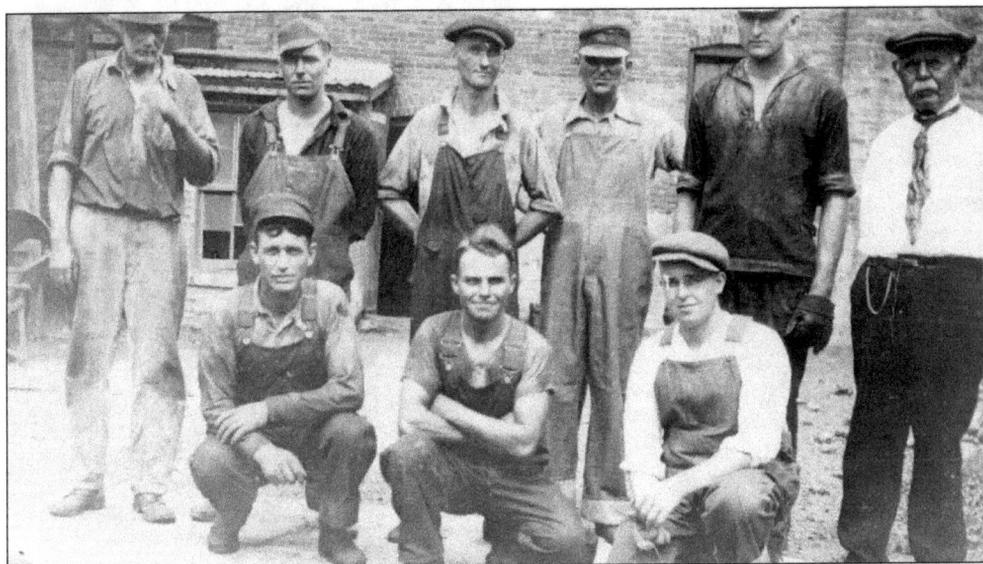

Arthur J. Finnegan, Sr. (far right) , was born about 1849 or 1850, possibly in Dundalk, County Louth, and immigrated to St. Louis in 1868. He was the son of Michael Finnegan and Margaret McGinnis. He worked for the gas company for many years starting out as a laborer, then becoming a foreman and later was a superintendent of the Community Power and Light Company. He married Rose Floyd on February, 17 1878 at Annunciation church. They had eight children. This photo was probably taken in the late 1920s or 1930s. He died January 1, 1935. (Photo courtesy of Georgia Clark.)

Michael Joseph Finnegan, the first born of Irish immigrants Arthur J. Finnegan and Rose Floyd, is pictured here with his sister, Margaret Rose Finnegan. Michael enlisted in the US Navy and served from 1899–1903, taking part in the Philippine Insurrection. He married Margaret Mary "Maggie" Hebron on April 21, 1904 at Annunciation Church and they had six children. Mike worked as an ironworker and joined the St. Louis Police Department in 1908, retiring in 1946. (Photo courtesy of Georgia Clark.)

During Mike Finnegan's long career the St. Louis Police Department saw a dramatic change in uniforms. On the left is Mike early in his career, and on the right one of him probably in the 1940s. (Photos courtesy of Georgia Clark.)

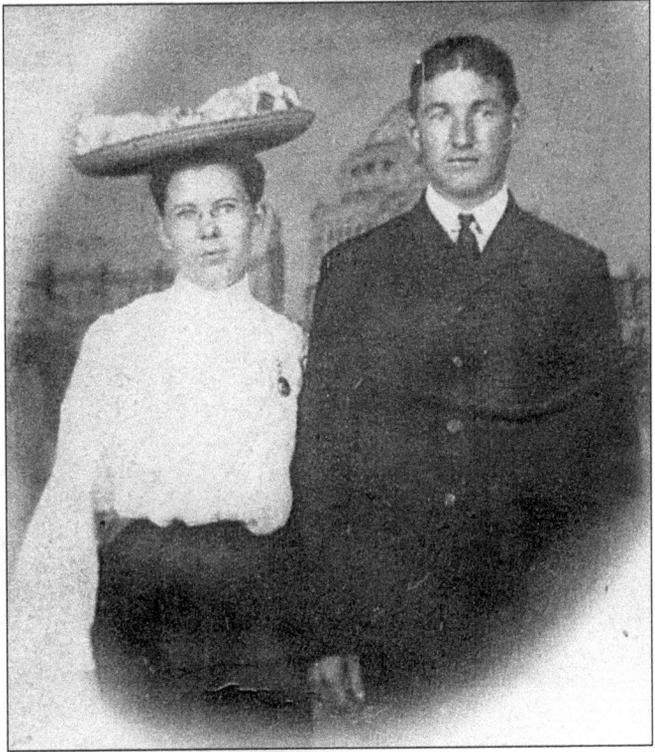

This picture postcard shows Mary Agnes Finnegan and husband Edward Finnegan about the time of their marriage (1905). Mary was the second child and oldest daughter of Arthur Finnegan and Rose Floyd. Edward Finnegan had emigrated from Ireland about 1901 or 1902. (Photo courtesy of Georgia Clark.)

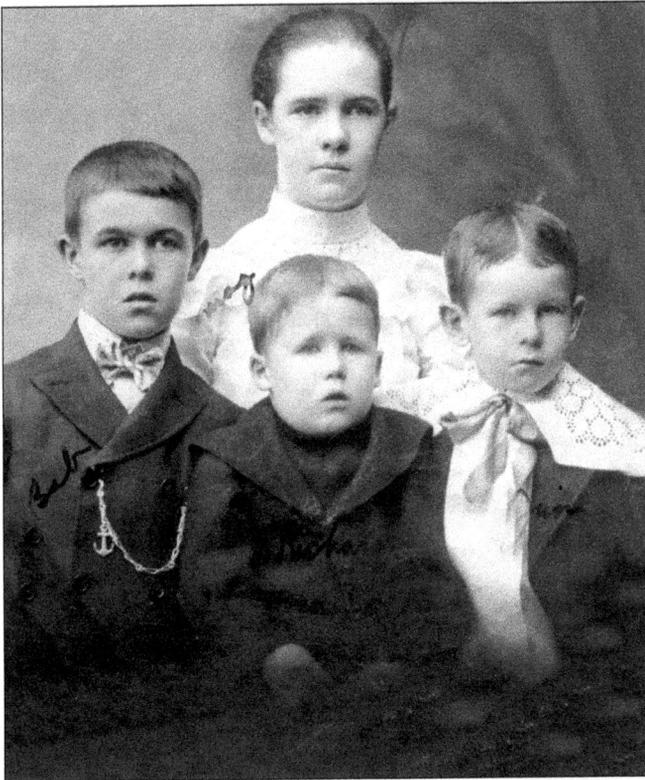

This portrait of the four Finnegan children is dated about 1899. Clockwise from the top are Margaret Rose, Arthur Joseph, Jr., Richard Finnegan, and Robert. They are the children of Arthur J. Finnegan, Sr. and Rose Floyd, both Irish immigrants to St. Louis. (Photo courtesy of Georgia Clark.)

107

Margaret "Maggie" Finnegan is pictured here c. 1913 with three of her children, Estelle, Ida, and Arthur. Ironically, neither Maggie nor her husband Michael ever learned to drive an automobile. (Photo courtesy of Georgia Clark.)

Joseph Robert Emmet Finnegan, third from right (laughing), son of Michael Finnegan and Maggie Hebron, is shown at Christian Brothers College (CBC) in 1940. Emmet joined the St. Louis police department shortly after this picture was taken, but spent the next four years in the U. S. Army. Upon returning to St. Louis, he continued with the police department until 1959. (Photo courtesy of Georgia Clark.)

Robert Finnegan, son of Arthur Finnegan and Rose Floyd, joined the St. Louis Fire Department in 1911 and retired in 1956, having risen to the rank of Deputy Chief and Battalion Chief. (Photo courtesy of Georgia Clark.)

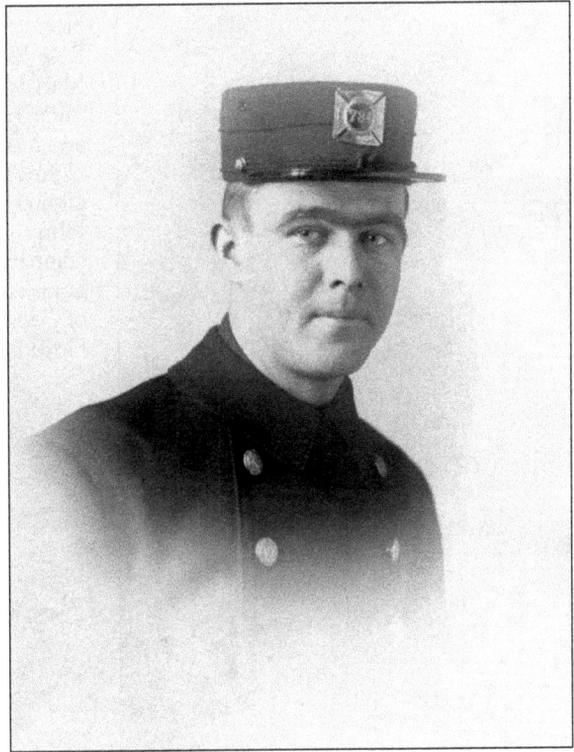

Margaret Hebron (nee O'Donnell) is seen with her daughter Rita in this postcard picture taken in June 1910. Margaret was the wife of Andrew Hebron, the son of Irish immigrant parents Patrick Abram and Anna Price. (Photo courtesy of Georgia Clark.)

From left to right are Elizabeth "Lizzie" Floyd, Rose Floyd Finnegan, and Mary "Mizzie" Floyd. Mary and Elizabeth are Rose's half-sisters. Rose immigrated in 1872 from Ireland, Lizzie in 1884, and Mary in 1894. Mary Floyd married John Connelly on January 15, 1906 at Annunciation Church. They lived on Morrison Avenue. John (also an Irish immigrant) started a roofing company which is still in business in the St. Louis area—Connelly Roofing. (Photo courtesy of Georgia Clark, great grand-daughter of Rose Floyd Finnegan.)

Elizabeth "Lizzie" Floyd was "in service," working for various families in St. Louis. In her later years she lived with her sister Mary, then later with Mary's son Robert Connelly. (Photo courtesy of Georgia Clark.)

Seven

IRISH CELEBRATIONS, MUSIC, AND DANCE

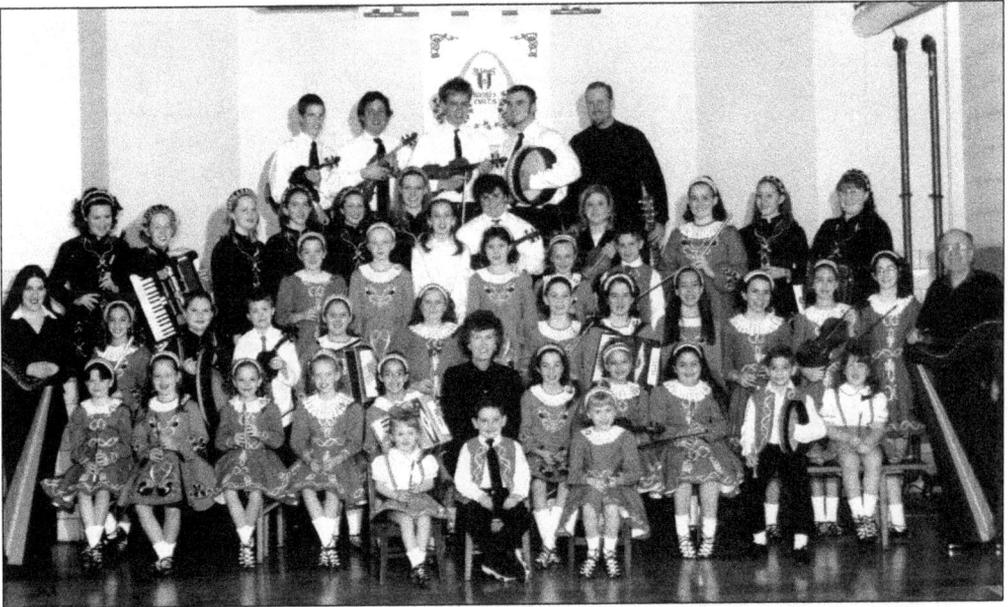

St. Louis Irish Arts is seen in this 2002 photograph, which shows that SLIA continues to thrive after 30 years. It is the largest branch of Comhaltas Ceoltoiri Eireann in North America, providing education and entertainment to the community both locally and nationwide. (Photo courtesy of Helen Gannon.)

The St. Patrick's Day Parade of 1971 had several dignitaries marching, including Jack Lynch (Prime Minister of Ireland), Joseph B. McGlynn, Jr. (Parade organizer), Al Cervantes (St. Louis Mayor), Lawrence K. Roos (St. Louis County Supervisor), Joseph Badaracco (President, St. Louis Board of Alderman), and U. S. Senator Jack Danforth. (Photo courtesy of Joe McGlynn.)

Pictured in the 1972 St. Patrick's Day Parade are Tim Corcoran (Consul General from Chicago), Joe McGlynn, Erskine Childers (Deputy Prime Minister of Ireland), and Bob Staed. (Photo courtesy of Joe McGlynn.)

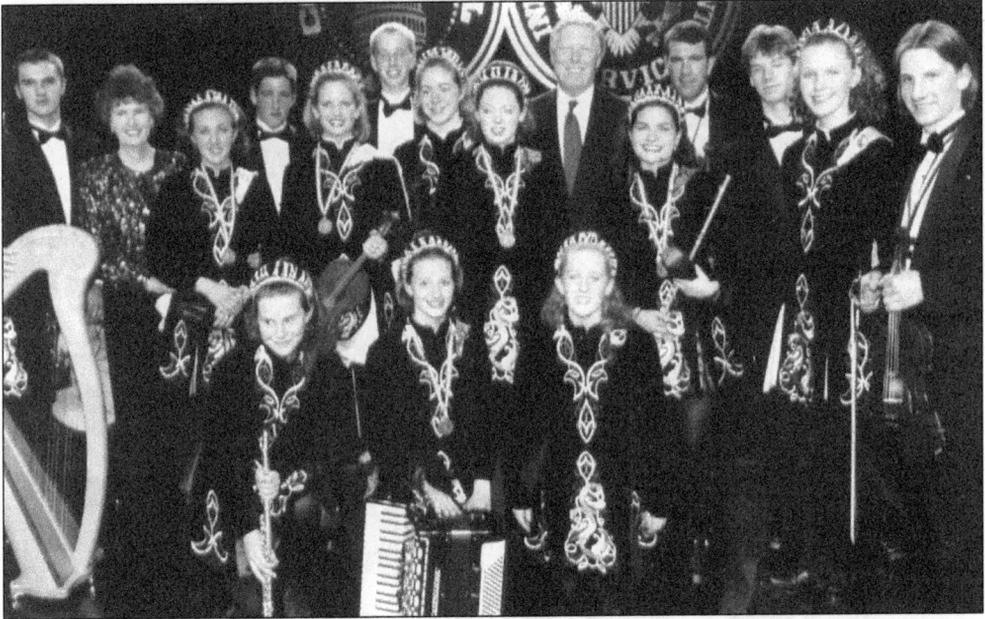

The St. Louis Irish Arts in 1999, pictured with Congressman Richard Gephardt in Washington, D.C. They are entertaining the members of Congress at the Ronald Reagan Center. Several of these young people have received the congressional Gold Medal, the highest honor awarded to civilians for community service, personal development, physical fitness, and an expedition that takes them out of their comfort zone. (Photo courtesy of Helen Gannon.)

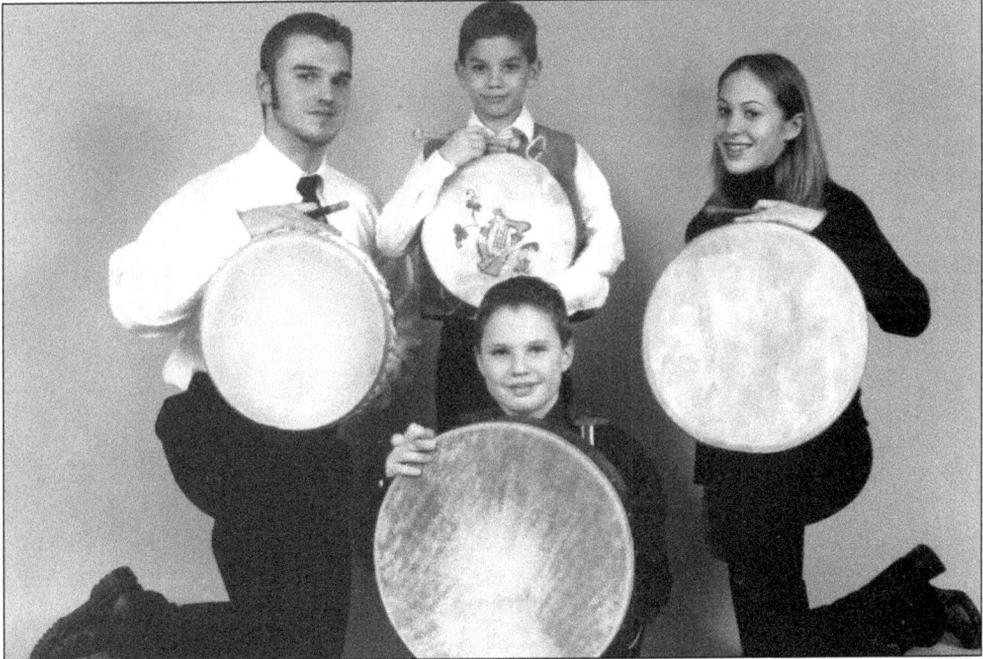

Bodhran second place World Champion Chris Weddle poses with students David Tresslar, Jill Sutter, and Lee Ward. The photo was taken at Immaculate Conception, the new home of St. Louis Irish Arts in Maplewood. (Photo courtesy of Helen Gannon.)

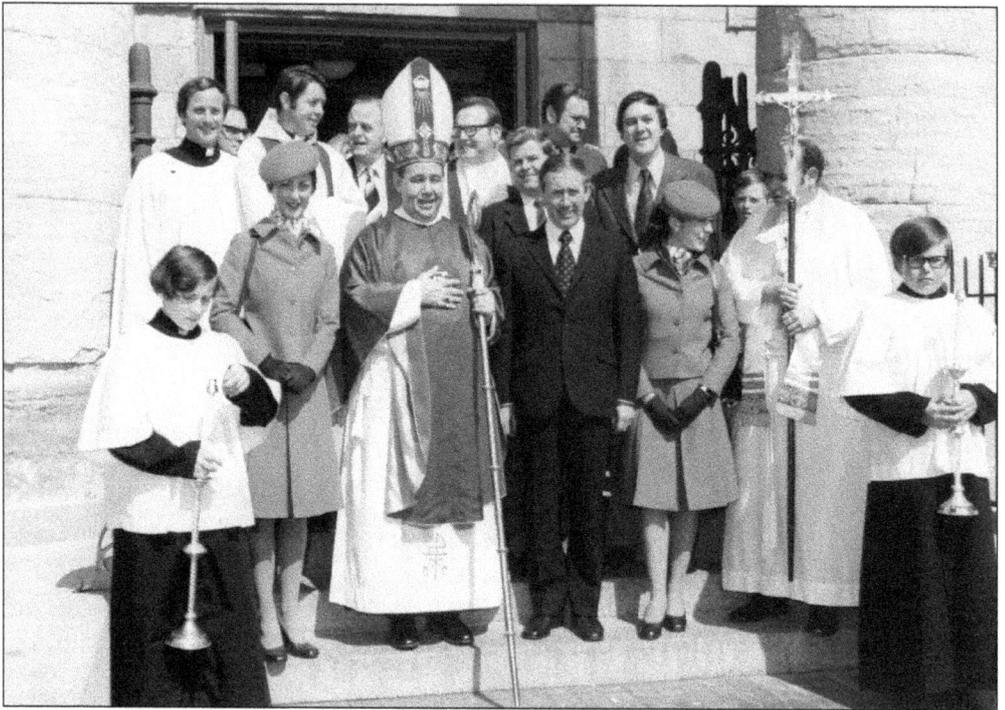

Bishop McNicholas and Dick Burke (a member of Irish Parliament) are flanked by Aer Lingus flight attendants in this photo, taken at the old Cathedral downtown during the 1975 St. Patrick's Day celebration. (Photo courtesy of Joe McGlynn.)

Joe McGlynn and Mark Durkan MLA (Deputy First Minister of Northern Ireland) are pictured here at the 2002 St. Louis St. Patrick's Day Parade. (Photo courtesy of Joe McGlynn.)

Congressional Gold Medal recipients Kelly Winter, Kerry Moran, Shannon Spellman, and Katie DeGreeff have their picture taken with advisor Helen Gannon and Missouri Congressman Richard Gephardt in Washington, D.C. (Photo courtesy of Helen Gannon.)

St. Louisans Helen and Patrick Gannon pose with Albert Reynolds, prime minister of Ireland (1992–1995). (Photo courtesy of Helen Gannon.)

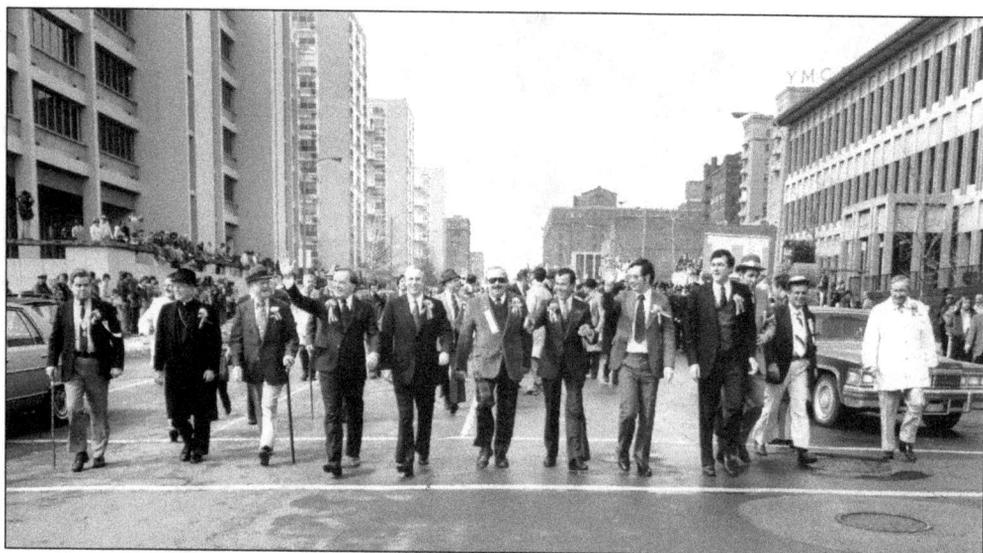

Pictured at the 1978 Parade in downtown St. Louis are George Clough, Bishop Drury, Jim Kirkpatrick (Missouri Secretary of State), Jim Conway (St. Louis Mayor) , Joe Malone (Irish Tourist Board), Andy Walsh (Parade Chairman), Dennis Day (actor/singer), Irish Consul from Chicago, Joe McGlynn, Terry Boyle (striped tie), and Jack Keane (President of Ancient Order of Hibernians, white coat). (Photo courtesy of Joe McGlynn.)

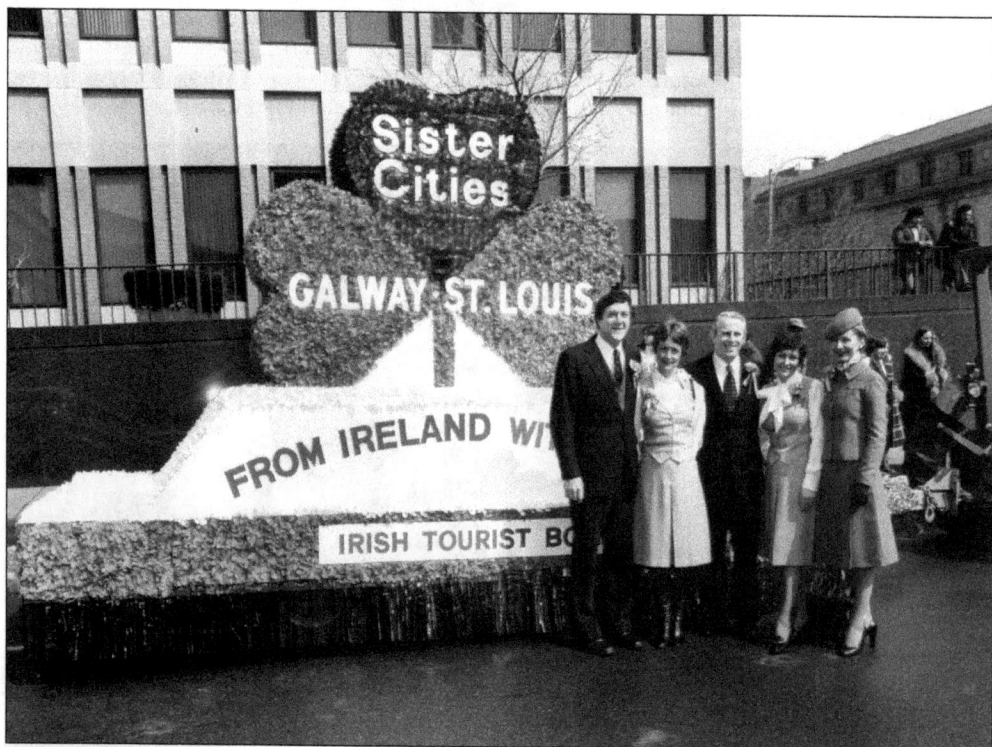

The St. Louis Galway Sister Cities float is pictured at the 1978 St. Louis St. Patrick's Day Parade. Pictured at center is Joe Malone, the Guest of Honor and International chairman of the Irish Tourist Board. (Photo courtesy of Joe McGlynn.)

Flute Players from St. Louis Irish Arts include Mary Walsh, Sarah Hale, Kathleen Tresslar, and Justine Ward (seated). (Photo courtesy of Helen Gannon.)

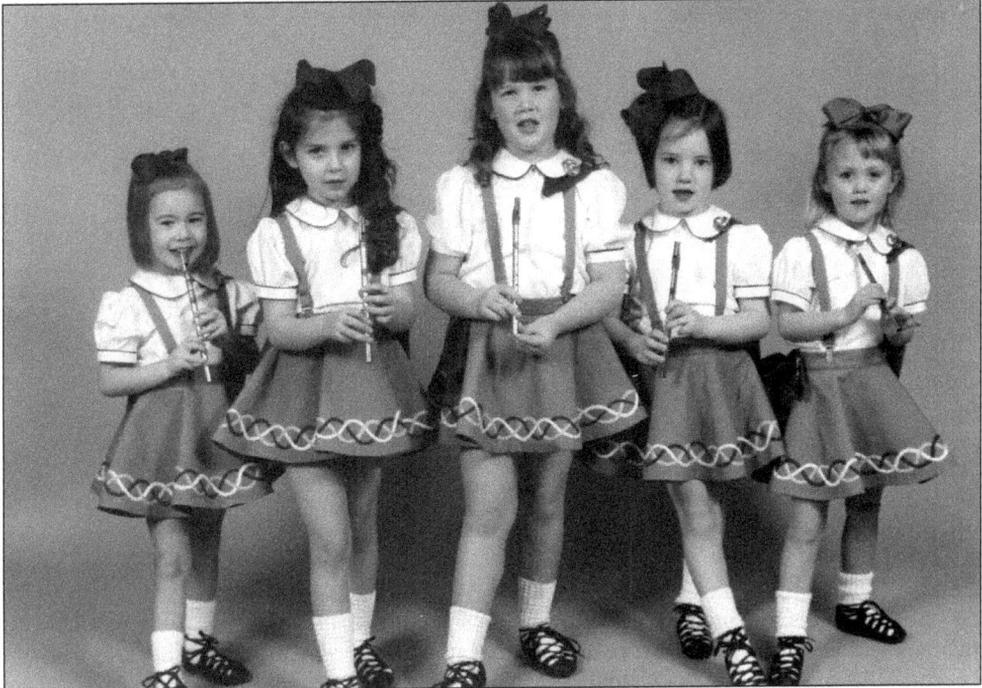

The "Babies" can even learn to play the tin whistle and dance a step at Irish Arts. This was at Powell Symphony Hall during a performance with the Chieftons. Pictured from left to right are four-year-old Riley Gannon, Natalie McLoughlin, Mary Ann Cahoon, Aisling O'Brien, and Mary Walsh. (Photo courtesy of Helen Gannon.)

Shown here at the St. Louis airport are a few participants in the St. Patrick's Day Parade. From left to right are Joe McGlynn (Parade organizer), entertainer Dennis Day (wearing University City Fire Department hat), Pat McCarthy, and George Clough (national president of the Ancient Order of Hiberians). (Photo courtesy of Joe McGlynn.)

Several dignitaries line up at the St. Patrick's Day Parade of 1974. They include, from left to right, Bob Staed, Larry Roos (St. Louis County Supervisor), Mayor Poelker, Senator Thomas Eagleton, Joseph B. McGlynn, (Parade organizer), Martin Keaveney (Mayor of Sligo), Bishop Joseph McNicholas, Bishop Thomas Drury, Joe Badaracco (President, Board of Alderman), and Dick Rabbitt (Missouri House Speaker). Behind Joe McGlynn's right shoulder is Kevin Gormley (Aer Lingus). Wearing the beaver skin hats in background are the Notre Dame Fighting Irish Guard. (Photo courtesy of Joe McGlynn.)

Pictured from left to right are the St. Louis Irish Arts Senior Team of Dancers: (front row) Amber Nelson, Shannon Spellman, Eileen Gannon, Kelly Winter, Katie Favazza, and Sally Sutter; (back row) Katie DeGreeff, Shannon Flecke, Mallory Swift, and Kerry Moran. (Photo courtesy of Helen Gannon.)

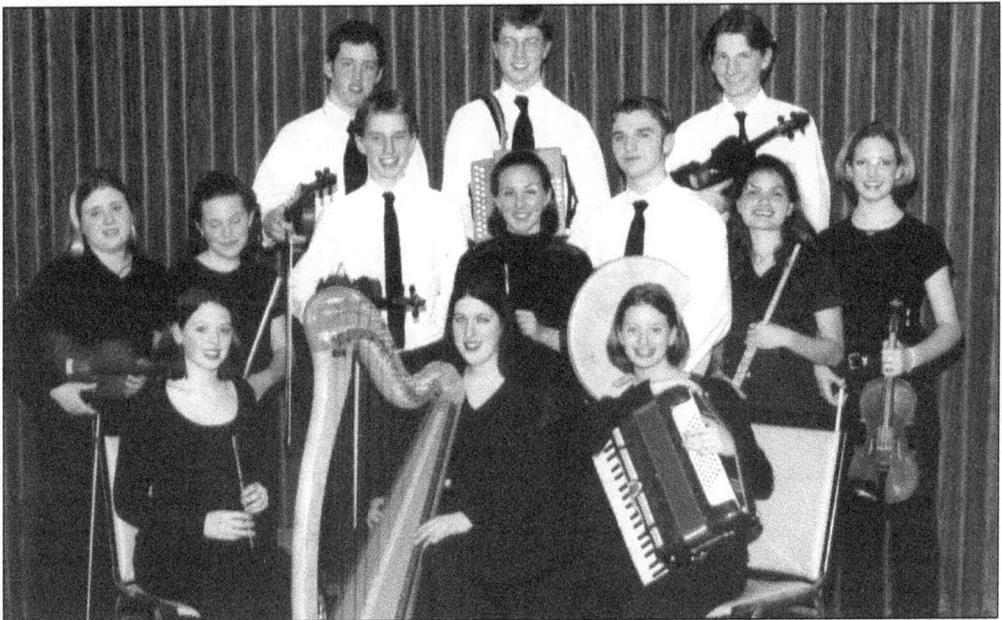

This photo shows St. Louis' qualifying Fleadh Cheoil in Cleveland in 1998. The winning "Groupai Cheoil" traveled to Ireland to compete in World Championships. Pictured, from left to right, are: (front row) Katie DeGreeff, Eileen Gannon, and Kelly Winter; (middle row) Linda Herndon, Sarah Hale, Terry O'Connor, Shannon Spellman, Christopher Weddle, Amber Nelson, and Kerry Moran; (back row) Ian Walsh, Brian Hart, and Kevin Buckley. (Photo courtesy of Helen Gannon.)

This photo shows Helen Gannon by the River Shannon with the courthouse in the background beside King Johns Castle in Limerick where Helen was born and raised. The photograph was taken in 1996. She emigrated from Limerick to St. Louis in 1967 with her husband, Dr. Patrick Gannon. (Photo courtesy of Helen Gannon.)

Helen Gannon, President of St. Louis Irish Arts, greets Albert Reynolds, Taoiseach (Ireland's Prime Minister) in St. Louis in 1992. (Photo courtesy of Helen Gannon.)

Young Irish dancers from the Mayer School of Irish Dance perform at the 12th Annual Irish Country Fair held September 7, 2003 at St. James the Greater School located in the historic Dogtown area of St. Louis. (Photo by Dave Lossos)

The Ancient Order of Hibernians was one of the sponsors of the 12th Annual Irish Country Fair held September 7, 2003 at St. James the Greater School. As one of their banners proclaim, the A. O. H. celebrated it's 50th anniversary in 1998. (Photo by Dave Lossos.)

St. Louis Fire Chief Sherman George, an annual participant at the Parade, is pictured here in 2003. (Photo courtesy of Joe McGlynn.)

Terry Walsh (on left) and Pat Brannon prepare to kick off the 2003 St. Patrick's Day Parade. (Photo courtesy of Joe McGlynn.)

Dr. P.J. Gannon with his wife Helen and daughter Eileen. Eileen was the All Ireland Champion on Harp in 2000. PJ and Helen are expatriate Irish who had arrived in St Louis to work in the medical profession. PJ, a professor of psychiatry, was a native of Dunmore, County Galway, an area steeped in traditional music. His wife Helen, a nurse, grew up in Limerick. (Photo courtesy of Helen Gannon.)

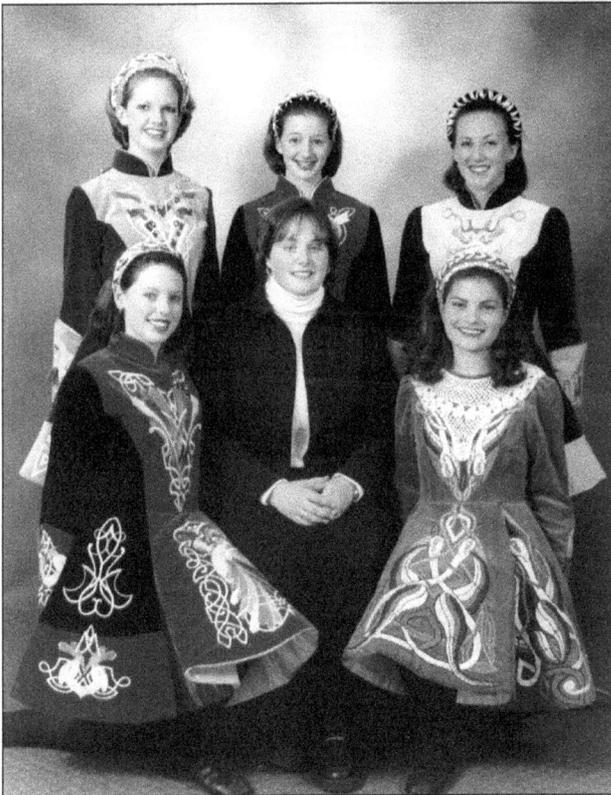

Pictured are St. Louis Irish Arts Dancers, from left to right: (front row) Katie DeGreeff, Erin Kelly, and Amber Nelson; (back row) Kerry Moran, Kelly Winter, and Shannon Spellman. (Photo courtesy of Helen Gannon.)

123

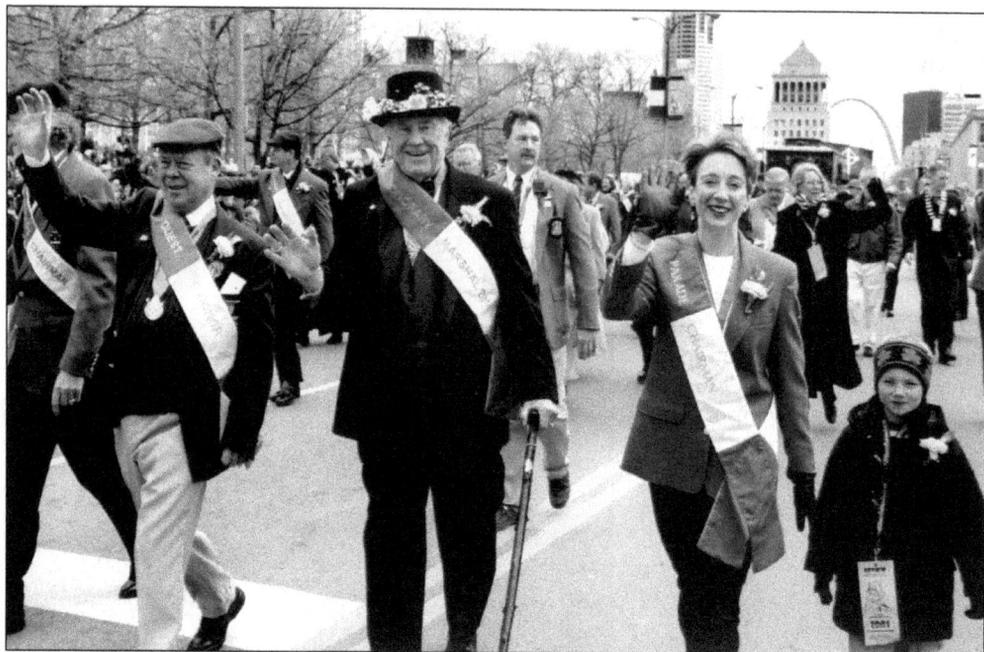

Sean McEniff, a business leader from Donegal, Ireland, was a guest of honor at the 2001 St. Patrick's Day Parade. Also pictured are Jim Hanifan, offensive line coach for the Rams (former head coach of the Cardinals), Mo McGlynn (Parade Chairperson), and her son Connor. (Photo courtesy of Joe McGlynn.)

Maureen McGlynn is pictured with her sons Connor and Aidan at the St. Patrick's Day parade in downtown St. Louis. (Photo courtesy of Joe McGlynn.)

Father William Barnaby Faherty, S.J. (wearing the black hat) was the Grand Marshall for the St. Louis St. Patrick's Day Parade in 1998. To Father Faherty's left are Mr. James McDaid (Ireland's Commissioner of Tourism, Sports and Recreation), Joseph McGlynn, Jr., and his wife Helen. (Photo courtesy of Faherty family collection.)

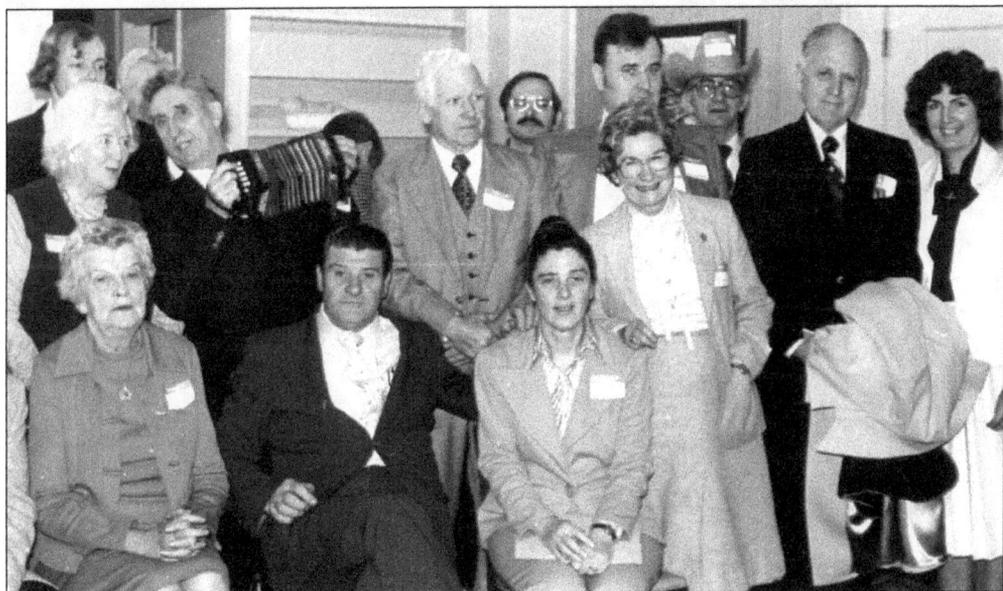

This photograph was taken in Chicago at the gathering of the officers of the Midwest branches of Comhaltas in the mid 1970s. From left to right are: (seated) Mary Sullivan (St. Louis Irish Arts Founding Member), Tom Masterson (Chicago), and Lucy Fallon (Minneapolis); (second row) Helen Gleason (SLIA), Cuz Teahan (Irish Musicians, Chicago), Bill Kelly (SLIA Founding Member), Kevin Conway (Irish Musicians, Chicago), Mike Flannery (Chicago), and Helen Gannon (Midwest Chairperson, St. Louis). (Photo courtesy of Helen Gannon.)

The three Gannon boys Sean (7), Niall (5), and Liam (4) learned to be traditional musicians the Susuki Way in those early years when teachers of traditional music were hard to find. Niall Gannon is passing on the tradition today through St. Louis Irish Arts and turning out some awesome musicians. (Photo courtesy of Helen Gannon.)

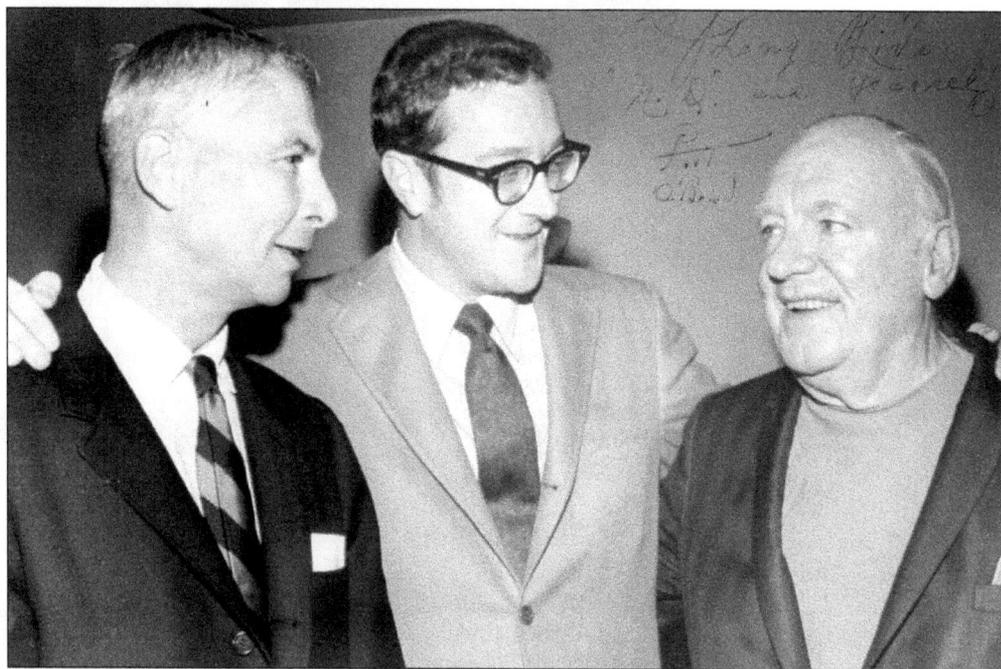

Jack Rockne (son of Knute Rockne), Joe McGlynn, and Pat O'Brien are pictured in this photo taken in 1969, with Jack and Pat in St. Louis for the kick-off luncheon to launch the parade for the following March 17, the first since the early 1900s. Most attendees were Notre Dame Alumni. The newspapers and TV stations all were on hand as well. (Photo courtesy of Joe McGlynn.)

126

ACKNOWLEDGMENTS

First of all, thanks to all those that contributed to this effort by supplying me with some of their personal, and extraordinary, photos. That includes Barry Kane, Elsie Bonkrud, Father William Barnaby Faherty, S.J., Georgia Clark, Helen Gannon, Jim Brasher, Joan Hunter, Mary Lossos, Joe McGlynn, John McCullough, Kathleen Price, Lori Maze, Mary O'Reilly, Pat McBride, Paul Rohde, and Tina Cooper.

As much as the above individuals' contributions helped, without the various archives in the St. Louis area welcoming me with open arms, the number of photos needed for this book would still have fallen short of my goal. With that in mind, special thanks go to the following:

St. Louis Archdiocesan Archives, namely the Director of Archives Audrey Newcomer and Archives Assistant Helen Gollihur

Saint Louis University, Pius XII Memorial Library, Archives, namely John Waide, University Archivist, and his staff

St. Louis Public Schools Archives, namely Sharon Huffman, Record Center Supervisor/Archivist

Lastly, I'd like to express my thanks to my wife, Mary, for not only her proof-reading, but for her tolerating my temporary obsession in putting this book together.

This book is dedicated to my wonderful Irish grandchildren: Ian Cooper, Claire Rowland, and Noah Cooper.

BIBLIOGRAPHY

Cornwell, Charles H. *St. Louis Mayors Brief Biographies*. St. Louis, 1965.

Cox, James. *Old and New St. Louis: a Concise History of the Metropolis of the West and Southwest, with a Review of its Present Greatness and Immediate Prospects*. St. Louis, 1894.

Dolan, Ellen Meara. *The Saint Louis Irish*. St. Louis, 1967.

Dry, Camille N. *Pictorial St. Louis—the great metropolis of the Mississippi Valley: a topographical survey drawn in perspective, A. D. 1875*. St. Louis, 1997.

Fennelly, Mary. *Limerick Lives*. Limerick, 1996.

Fox, Tim. *Where We Live—A Guide to St. Louis Communities*. St. Louis, 1995.

Faherty, S. J., William Barnaby. *The St. Louis Irish—An Unmatched Celtic Community*. St. Louis, 2001.

Faherty, S. J., William Barnaby. *Saint Louis Portrait*. Oklahoma, 1978.

Hagen, Harry M. *This is our Saint Louis*. St. Louis, 1970.

Hannon, Robert E. *St. Louis: Its Neighborhoods and Neighbors, Landmarks and Milestones*. St. Louis, 1986.

Huffman, Sharon and Phyllis West. *St. Louis Public Schools—160 Years of Challenges, Change, and Commitment to the Children of St. Louis (1838–1998)*. St. Louis, 1998.

Hyde, William and Howard L. Conard. *Encyclopedia of the History of St. Louis: a Compendium of History and Biography for Ready Reference*. New York, Louisville, St. Louis, 1899.

Hughes, Christine Human. *Guide to St. Louis Catholic Archdiocesan Parish Records*. St. Louis, 2001.

Larkin, Lew. *Missouri Heritage*. Columbia, Missouri, 1968.

Lossos, Dave. *Index to Pictorial St. Louis—the great metropolis of the Mississippi Valley: a topographical survey drawn in perspective, A. D. 1875*. St. Louis Privately printed, 1999.*

Lossos, Dave. *Republication (and index) of the 1821 St. Louis Directory and Register*. St. Louis Privately printed, 2001.*

Lossos, Dave. (Project Coordinator for StLGS), reprint and index of *Pitzman's New Atlas of the City and County of Saint Louis Missouri—1878*. St. Louis, 1997.

Lossos, Dave. *Early St. Louis area Places of Worship*. St. Louis Privately printed, 2002.*

Kirschten, Ernest. *Catfish and Crystal*. Garden City, NY, 1960.

Reavis, Logan Uriah. *St. Louis: The Future Great City Of The World*. St. Louis, 1871.

Scharf, J. Thomas. *A History of St. Louis City and County*. Philadelphia, 1883.

Stevens, Walter B. *St. Louis: The Fourth City, 1764–1909*. St. Louis, 1909.

Thomas, William L. *History of St. Louis County, Missouri*. St. Louis, 1911.

Van Ravenswaay, Charles. *Saint Louis—An Informal History of the City and its People, 1764–1865*. St. Louis, 1991.

Wayman, Norbury L. *History of St. Louis Neighborhoods—Old North St. Louis Yeatman*. St. Louis, 1978.

*Also available online at the "Genealogy in St. Louis" website located at
http://genealogyinstlouis.accessgenealogy.com/

www.ingramcontent.com/pod-product-compliance
Lightning Source LLC
Chambersburg PA
CBHW050637110426
42813CB00007B/1842